设计学院
设计基础教材

Design Elementary Textbook by Design College
Pattern Elements

图案基础

（第二版）

倪峰　周小瓯　编著

中国建筑工业出版社

图书在版编目（CIP）数据

图案基础 / 倪峰，周小瓯编著. —2版. —北京：中国建筑工业出版社，2009（2020.12重印）
设计学院 设计基础教材
ISBN 978-7-112-11226-5

Ⅰ. 图… Ⅱ. ①倪…②周… Ⅲ. 图案学 – 高等学校 – 教材 Ⅳ. J51

中国版本图书馆CIP数据核字（2009）第151465号

策　　划：江　滨　李东禧
责任编辑：陈小力　李东禧
责任设计：崔兰萍
责任校对：兰曼利　梁珊珊

设计学院设计基础教材

图案基础
(第二版)
倪峰　周小瓯　编著
*
中国建筑工业出版社出版、发行（北京西郊百万庄）
各地新华书店、建筑书店经销
北京三月天地有限公司制版
天津图文方嘉印刷有限公司印刷
*
开本：880×1230毫米　1/16　印张：6¼　字数：245千字
2009年11月第二版　2020年12月第十五次印刷
定价：**39.00**元
ISBN 978-7-112-11226-5
　　　　　(18495)

设计学院设计基础教材编委会

第二版序

"设计学院设计基础教材丛书" 第一版14册自2007年面世以来，受到广大专业教师和学生的欢迎，作为教材，整体销售情况还是可以的。然而，面对专业设计市场和专业设计教学的日新月异发展，教材编写也是一个会留下遗憾的工作。所以我们作者感到，教材的编写需要不断地将现实中的新内容补充进去才能跟上专业市场和专业教学不断变化、不断进步的趋势；不断将具有前瞻性的探索内容补充进去，才能对专业市场和专业教学具有指导和参考意义。根据近一两年专业教材市场的变化，在与中国建筑工业出版社编辑沟通讨论后，大家一致认为有必要对原版教材内容进行结构修订、内容更新，删减陈旧资料，增加新的教学、科研成果，并根据实际情况，将原丛书14本调整为现在的12本。

修订不单是教材内容更新，"设计学院设计基础教材丛书" 第二版对教材作者队伍也提出了教学经验、教材编辑经验、职称、学位等诸方面的更高要求。因此，为了保证教材的学术价值，每本书的作者中均有一位是具有副教授以上职称或博士学位教师资格的，作者全部在专业教学一线工作，教龄从几年到二十几年不等。本套丛书的作者都具有全日制硕士或博士学位，他们先后毕业于清华大学美术学院、中央美术学院、中国美术学院、浙江大学、广州美术学院，四川美术学院，湖北美术学院等国内名校，有的还曾留学海外，并多次出国进行学术交流。目前主要工作在清华大学美术学院，中央美术学院，中国美术学院，浙江大学，四川美术学院，广州美术学院等国内知名院校，许多作者身居系主任、分院领导职位。

在丛书面世后的两年间，我们作了大量的跟踪调查。从专业教师和学生两个角度去征求对本丛书的使用意见，为现在的修订做准备。本套教材第一版面世两年来，从教材教学使用中得来的经验和教训以及发现的问题是很具体的。所以，这次我们对丛书的修订工作是有备而来。我们不会回避或掩饰以前的不足、存在的问题，我们会不断地总结成功的经验和失败的教训，并为我们以后的编辑工作提供参考。我们的愿望是坚持不断做下去，不断修订，不断更新、增减，把这套丛书做得图文质量再好一点、新的专业信息再多一点……把它做成一个经典的品牌，使它的影响力惠及国内每一所开设设计专业的学校，为专业教师和学生创造价值。要做到这一点，很不容易，因为仅靠宣传是不够的，而只有真正有价值的思想才能传播得遥远。要做到这一点，我们还有很多路要走！

我们在不断努力！

上海师范大学美术学院 教授

江滨

第一版序

设计学院设计专业大部分没有确定固定教材，因为即使开设专业科目相同，不同院校追求教学特色，其专业课教学在内容、方法上也各有不同。但是，设计基础课程的开设和要求却大致相同，内容上也大同小异。这是我们策划、编撰这套"设计学院设计基础教材"的基本依据。

据相关统计，目前国内设有设计类专业的院校达700多所，仅广东一省就有40多所。除了9所独立美术学院之外，新增设计类专业的多在综合院校，有些院校还缺乏相应师资，应对社会人才需求的扩招，使提高教学质量的任务更为繁重。因此，高质量的教材建设十分关键，设计类基础教学在评估的推动下也逐渐规范化，在选订教材时强调高质量、正规出版社出版的教材，这是我们这套教材编写的目的。

目前市场上这类设计基础书籍较为杂乱，尚未形成体系，内容大都是"三大构成"加图案。面对快速发展的设计教育，尚缺少系统性的、高层次的设计基础教材。我们编写的这套14本面向设计学院的设计基础教材的模型是在中国美术学院设计学院基础部教学框架的基础上，结合国内主要院校的基础教学体系整合而来。本套教材这种宽口径的设计思路，相信对于国内设计院校从事设计基础教学的教师和在校学生具有广泛适用性和参考价值。其中《色彩基础》、《素描基础》、《设计速写基础》、《设计结构素描》、《图案基础》等5本书对美术及设计类高考生也有参考价值。

西方设计史和设计导论（概论）也是设计学院基础部必开设的理论课，故在此一并配套列出，以增加该套教材的系统性。也就是说，这套教材包括了设计学院基础部的从设计实践到设计理论的全部课程。据我们调研，如此较为全面、系统的设计基础教材，在市场上还属少见。

本套教材在内容上以延续经典、面向未来为主导思想，既介绍经过多年沉淀的、已规范化的经典教学内容，同时也注重创新，纳入新的科研成果和试验性、探索性内容，并配有新颖的图片，以体现教材的时代感。设计基础部分的选图以国内各大美术学院设计学院基础部为主，结合其他院校师生的优秀作品，增加了教学案例的示范意义。

本套教材的主要作者来自于清华大学美术学院、中央美术学院、中国美术学院、浙江大学、四川美术学院、广州美术学院等国内知名院校，这些作者既有丰富的教学经验，又都有专著出版经验，有些人还曾留学海外，并多次出国进行学术交流。作者们广阔的学术视野、各具特色的教学风格，都体现在这套教材的编写中。

鲁晓波

清华大学美术学院副院长

目录

第1章 图案设计概论

1.1 图案的定义

图案是与人们生活密不可分的艺术性和实用性相结合的艺术形式。"图案"一词，是20世纪初从日本转译而来，与英文"design"一词有直接联系。图案是指在实用美术、装饰美术、建筑美术等方面关于形式、色彩和结构的预先设计。它包括几何图形、视觉艺术、装饰艺术等。如今，在电脑设计上，我们把各种矢量图形也称之为图案。图案的定义有广义和狭义之分，广义的图案是指为达到一定的目的而进行的设计方案和设计图样；狭义的图案是针对平面设计而言，是指平面的、纹样的、符合美的规律的构成。

1.2 图案的起源

原始的工艺形式是随着石制工具的创造和使用而形成的。人类祖先为了生存，在劳动过程中创造了多种生产工具和生活器具，先是在长期的劳动实践中，感到造型规整的器具在视觉和触觉上能产生快感，而且更便于使用，于是出现了造型对称或均衡的石刀、石斧，这就是工艺品的开始。后来，人类在与自然的接触过程中，发现动物的牙齿、骨头和毛发等加工后可当工具使用，而且用它们做装饰品不但美观还能体现人类的勇气和力量，于是就在上面制作多种线条和划痕，使其看起来更有特色，这就是装饰的雏形。随着对自然界的动物、水纹、山川、沙漠、树木等形态的了解加深，人们将这些自然形态结合劳动场景描绘在洞穴和崖壁上，这样就产生了图案（图1-1、图1-2、图1-3、图1-4）。后来，在祭祀、礼仪等活动中，为了表示对宗教的虔诚和图腾崇拜，又产生了远古氏族的图腾符号和标志，图案也随之丰富起来。

在新石器时代中、晚期出现的"彩陶"，图案类型十分丰富，其主要特点是具有简朴的造型和抽象的纹饰。这时的装饰艺术已经非常成熟，人们惯常用红、黑等色来绘制，陶器上的纹饰千变万化、优美动人。纹样有人面纹、鱼纹、蛙纹、鸟纹等（图1-5、图1-6）。后来出现的青铜器造型雄浑凝重，有兽面纹、凤纹、人面纹、动物纹等（图1-7、图1-8、图1-9）；汉代出现的画像砖、画像

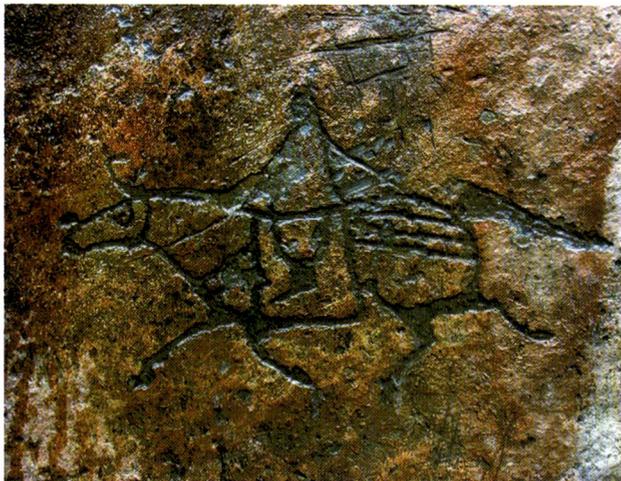

图1-1 砧子山古岩画，位于内蒙古赤峰达里诺尔湖北岸。砧子山属自然遗迹，是火山喷发时形成的山体之一，完整地存留有古岩画7组，共35个部分，画上的人物、动物栩栩如生

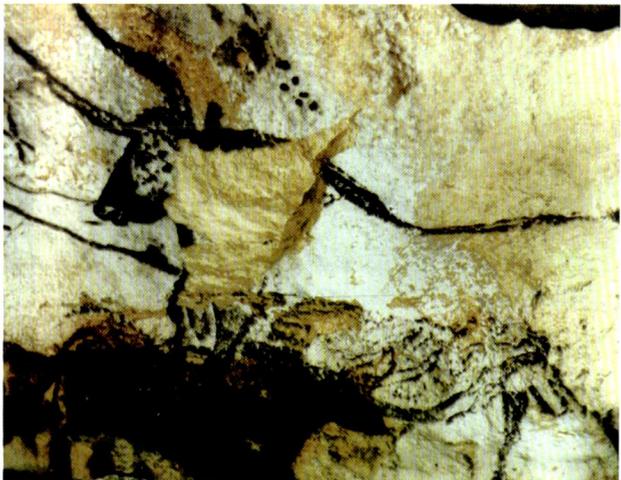

图1-2 拉斯科洞穴壁画是旧石器时代人类留下的艺术珍品，位于法国韦泽尔峡谷。这些画大约创作于1.5~1万年前，所画的主题多为动物，线条简洁有力，姿态生动，色彩多为黑褐色，外加简单的明暗描绘，表现出自然而粗拙的风格

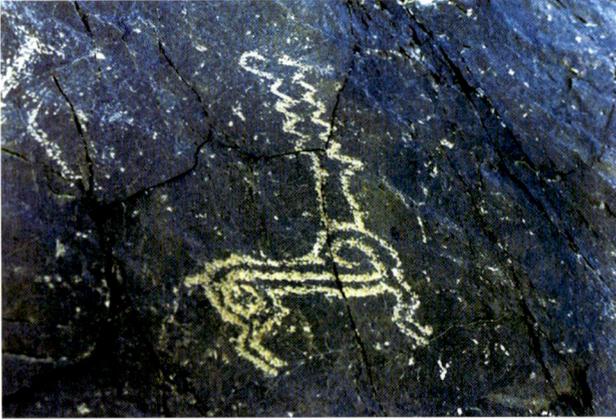
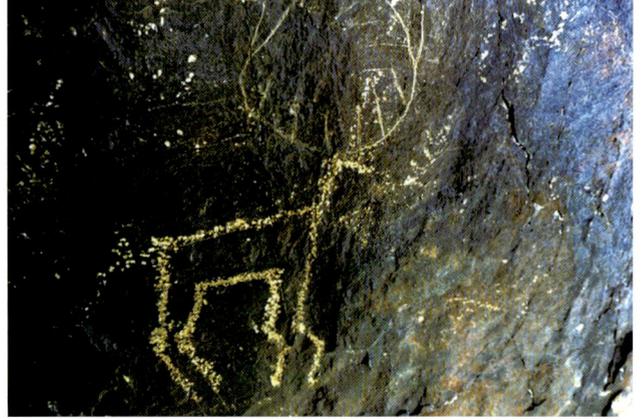

图1-3、图1-4 西藏西北部的阿里日土岩画，这些岩画是用坚硬的石头或其他硬物在岩面或岩石上刻凿而成，线条笔画有深有浅，还有少数彩绘画面。岩画内容十分广泛，有狩猎、宗教祭礼、骑乘、放牧、农耕、日、月、山、牛、马、羊、驴、羚羊、房屋、人物等

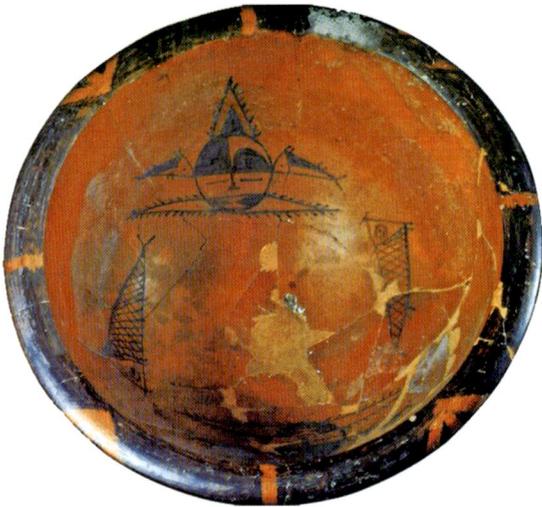
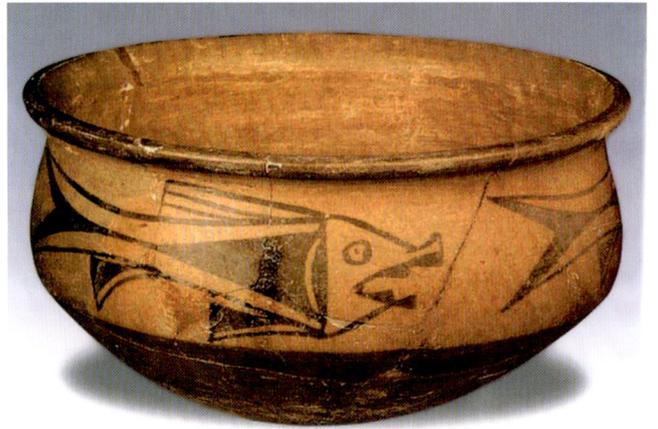

图1-5　人面鱼纹彩陶盆　仰韶文化是距今约5000～7000年前中国新石器时代的一种文化。红陶器上常有彩绘的几何形图案或动物形花纹，是仰韶文化的最明显特征，故也称彩陶文化

图1-6　鱼纹彩陶盆

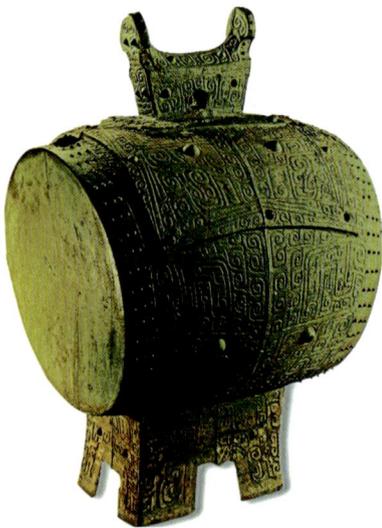
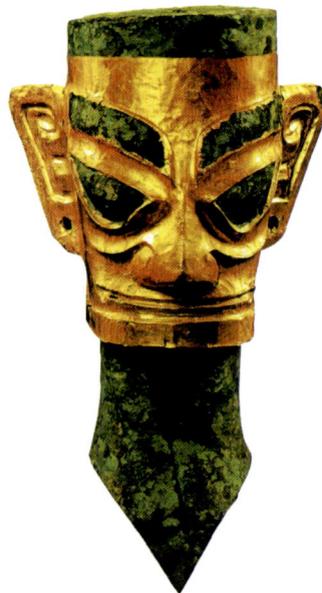
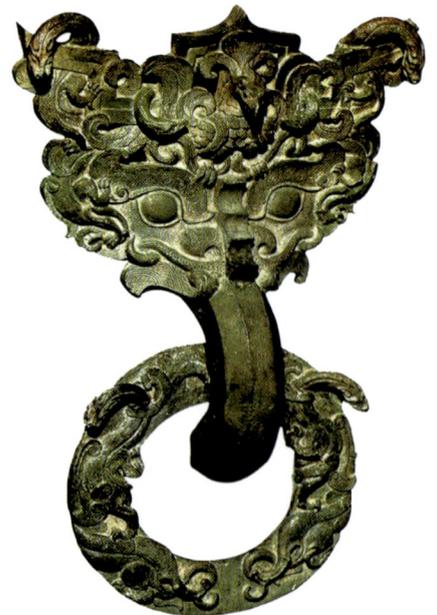

图1-7　商代青铜兽面纹鼓　　　　　图1-8　三星堆金面罩青铜人头像　　　　　图1-9　汉代青铜铺首衔环

石整体形象粗犷大器，表现出了强烈的动感、速度和恢宏的气势美（图1-10、图1-11）；举世瞩目的敦煌石窟艺术历经千年的创造，在400多个石窟里留下了无数绚丽多彩的图案彩绘（图1-12、图1-13、图1-14、图1-15）；

还有集外来风尚和传统风格于一身的宋代瓷器图案（图1-16、图1-17），追求喻意和完整造型的明清吉祥图案等。历代画师和工匠们用双手和智慧为我们展示了一幅绚丽的图案历史画卷。

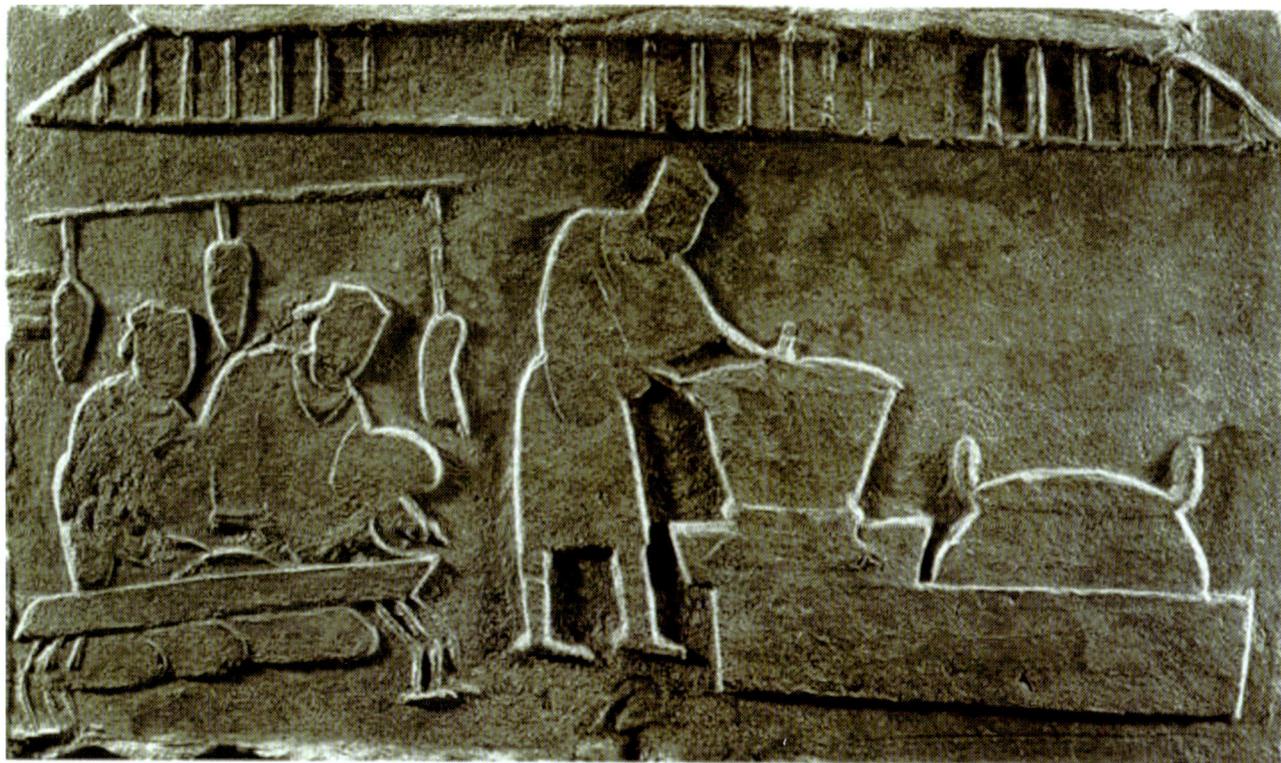

图1-10　汉画像砖一

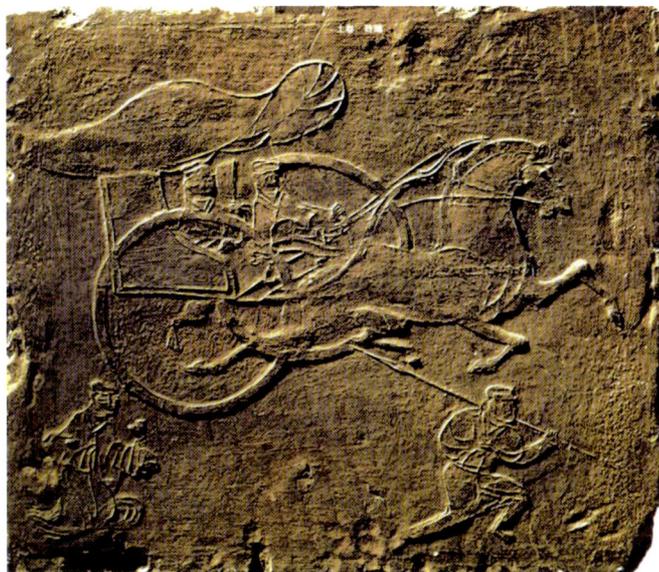

图1-11　汉画像砖二

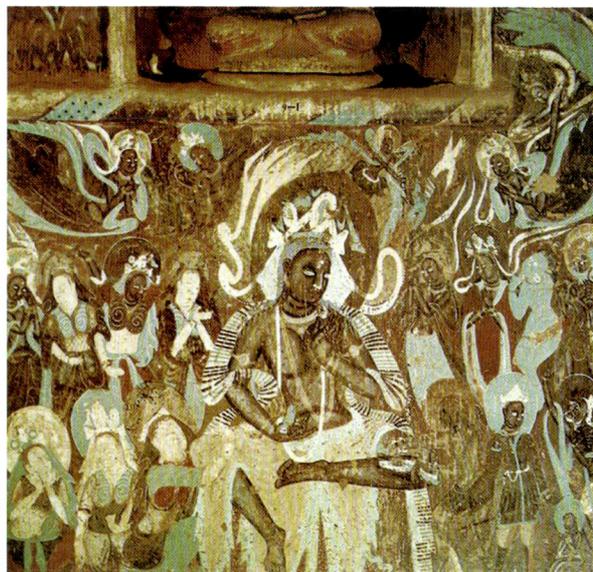

图1-12　敦煌壁画一

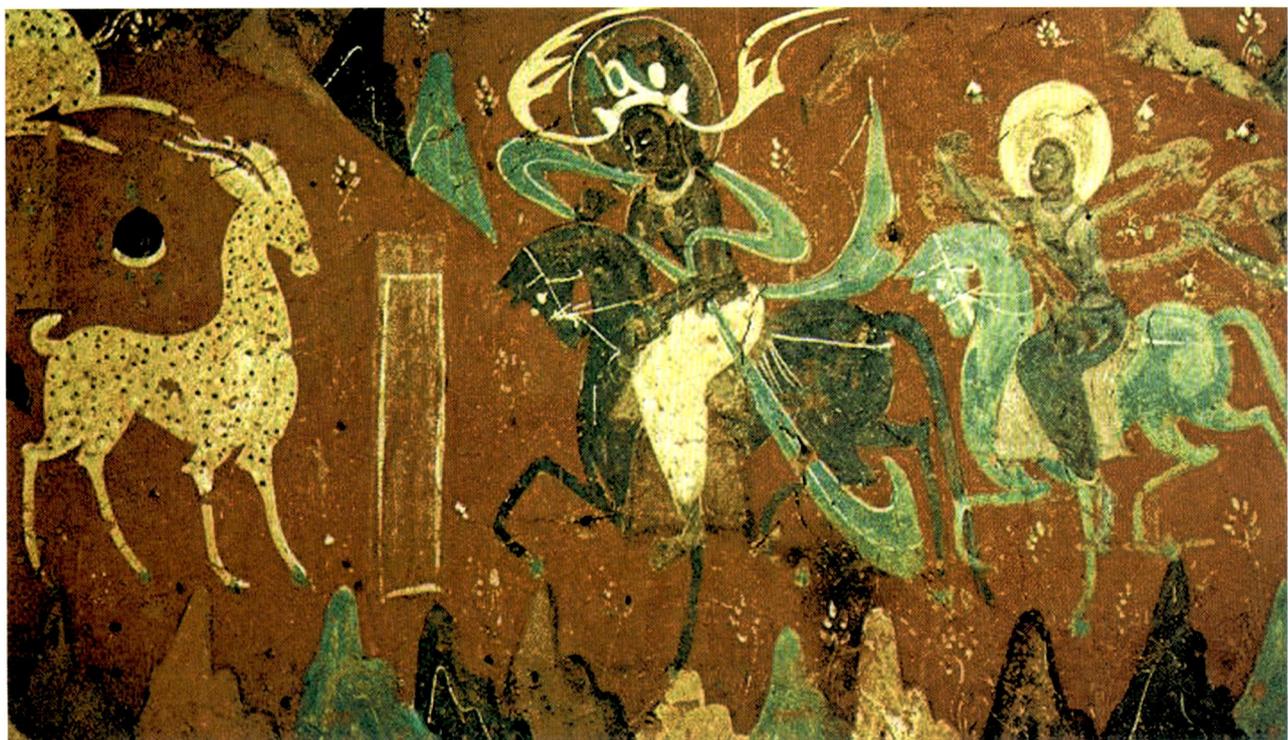

图1-13 敦煌壁画二

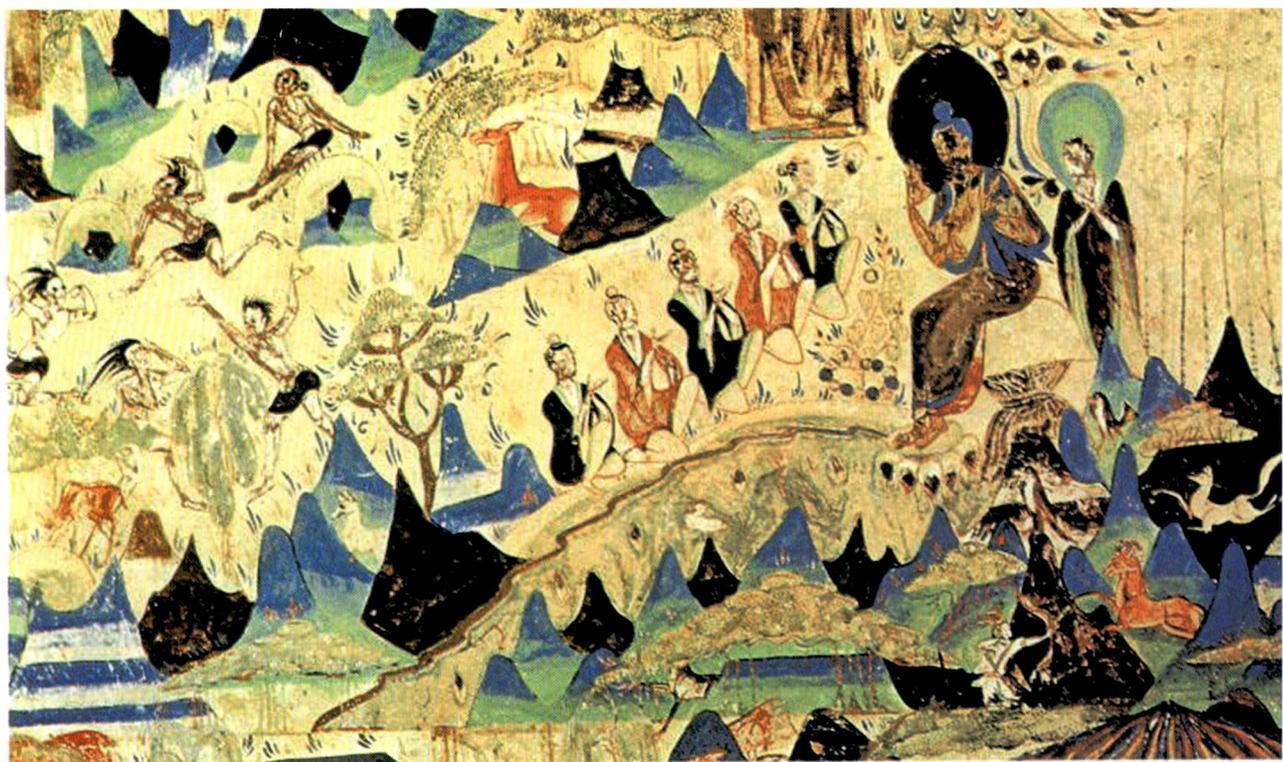

图1-14 敦煌壁画三

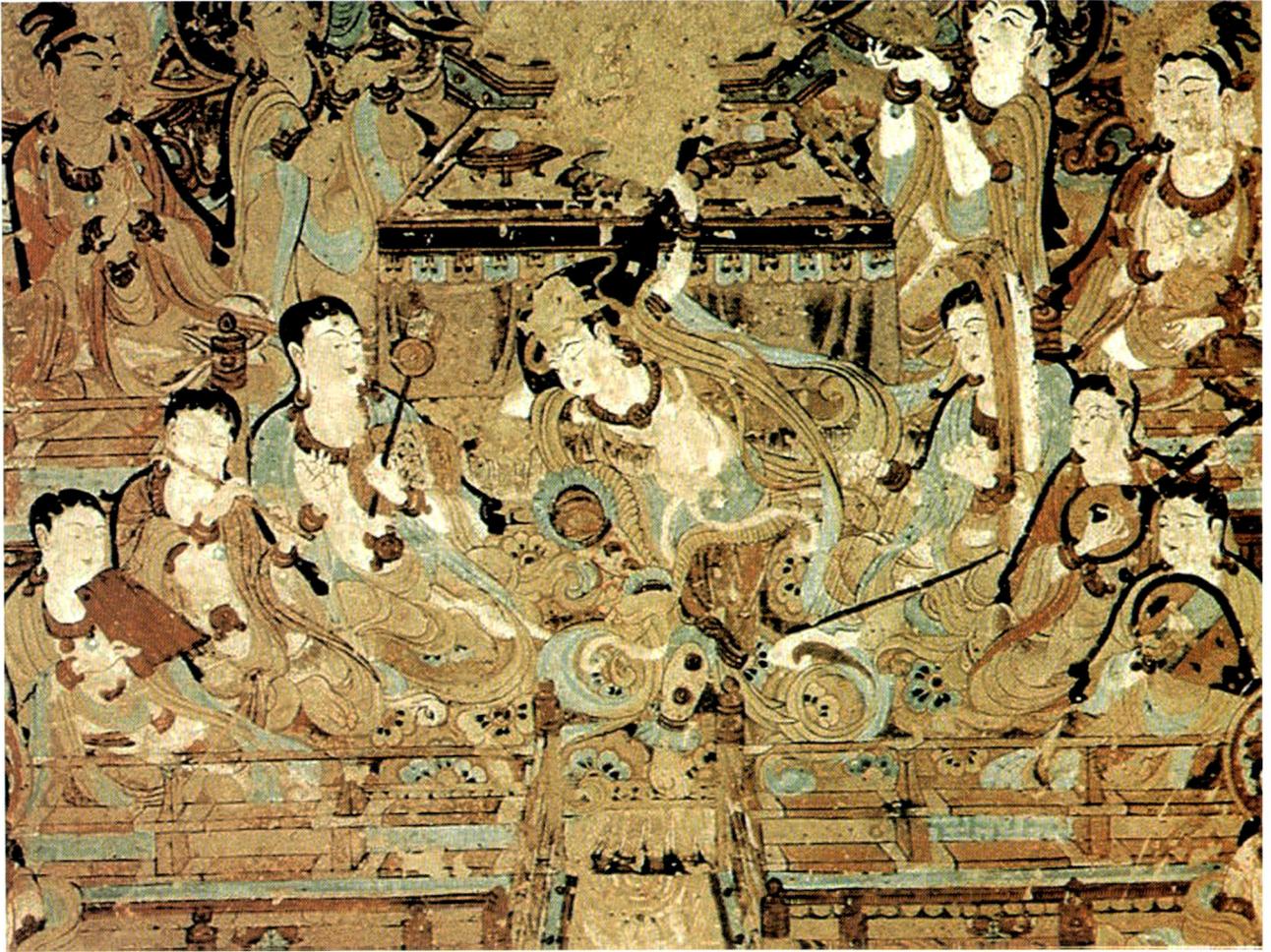

图1-15 敦煌壁画四

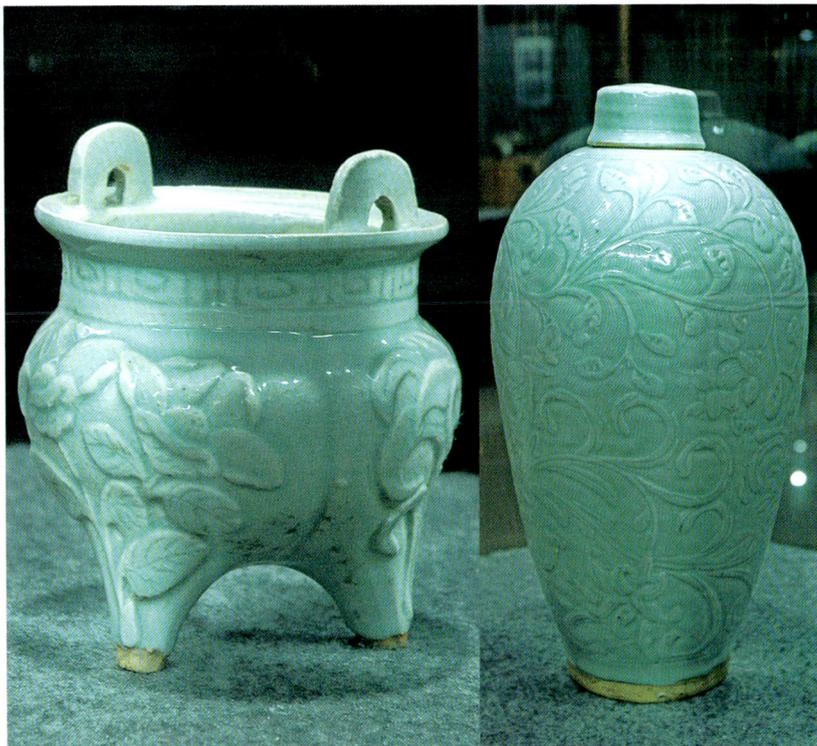

图1-16 宋代瓷器一 　　　　　图1-17 宋代瓷器二

1.3 图案的类别

　　根据表现形式图案有具象和抽象之分。具象图案在图案设计中占有显著地位，它是人们从具象的自然形态中美化、创造出来的。具象图案的设计要摆脱纯自然的束缚，用归纳手法来获取自然形态，使其具有图案美。具象图案根据表现对象的不同，大致可以分为装饰植物、装饰动物、装饰人物、装饰风景、装饰器具等

五大类（图1-18、图1-19、图1-20、图1-21、图1-22、图
1-23、图1-24、图1-25）。抽象类图案包括点、线、面、
体，或有机的、无机的、偶然的、变体的等。抽象图案
在电脑设计上有着惊人的表现力，特别是以色彩或线条
所表现的幻觉效果或光线艺术。

　　我们设计图案必须要选择适合内容的表达方式。抽象
图案就适用于音乐、美术、哲学、宗教、信息等不具有具
体外形的内容（图1-26、图1-27、图1-28）。

图1-20 装饰花卉

图1-18 装饰植物一

图1-21 装饰动物

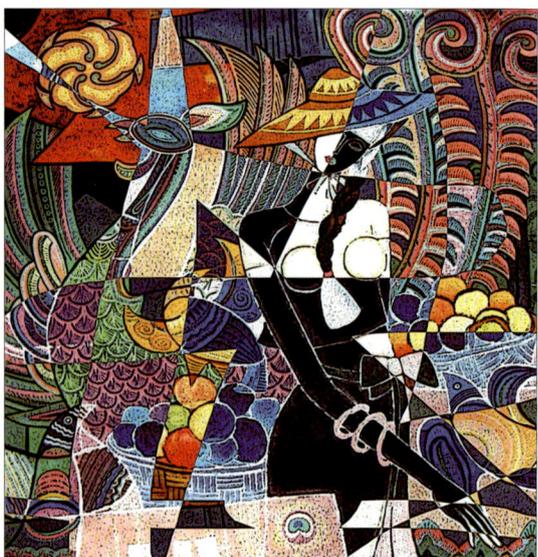
图1-19 装饰人物一

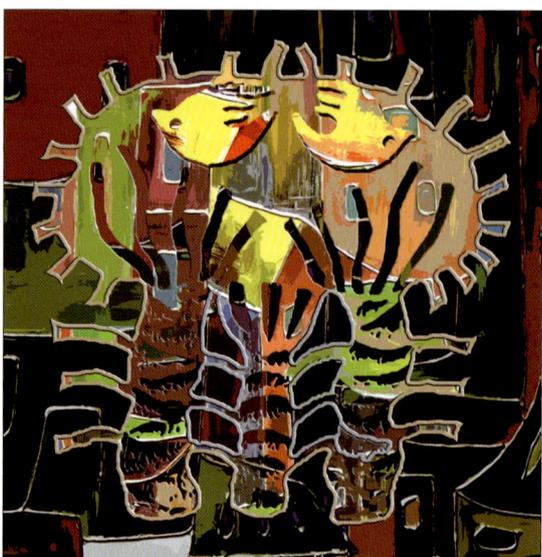
图1-22 装饰植物二

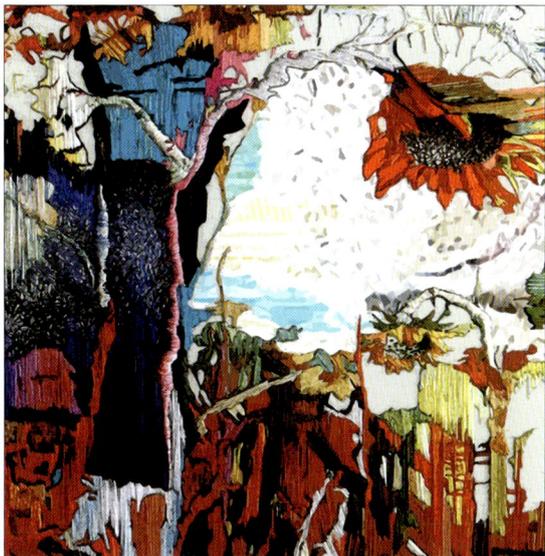

图1-23 装饰植物三

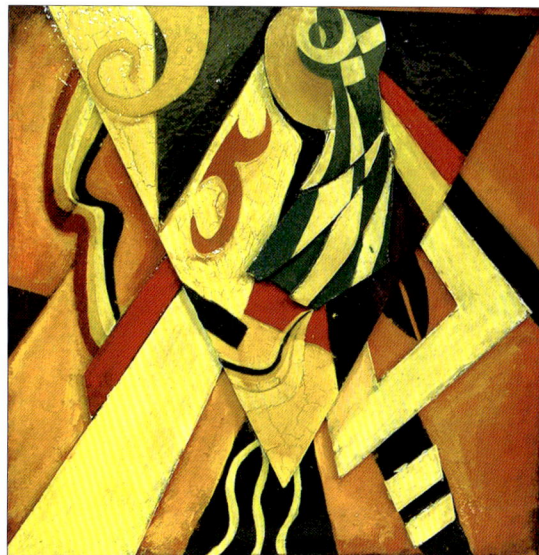

图1-26 抽象图案一

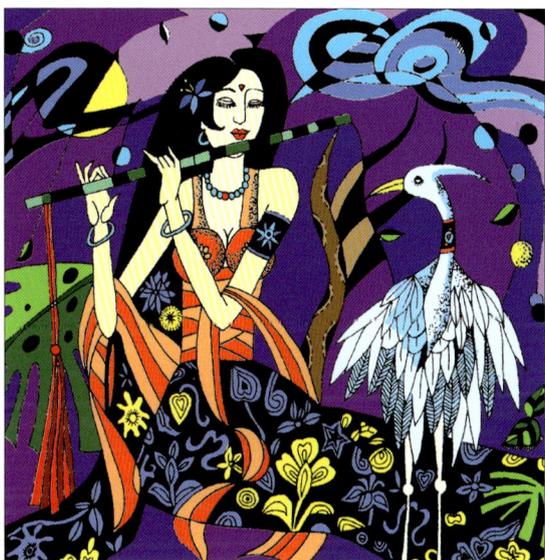

图1-24 装饰人物二

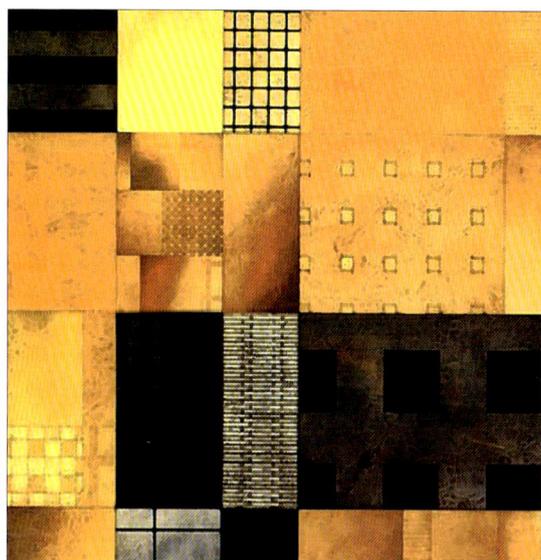

图1-27 抽象图案二

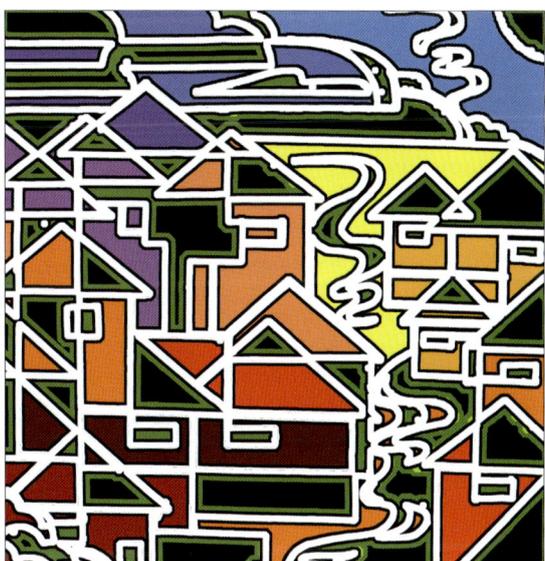

图1-25 装饰风景

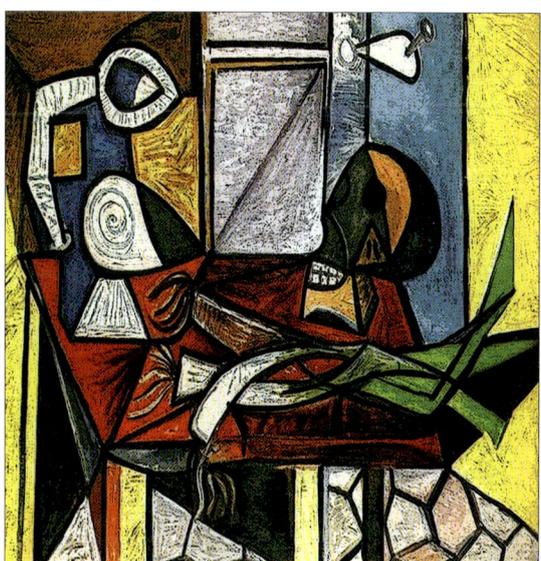

图1-28 抽象图案三

第2章　图案的形式美法则

图案艺术有着极强的装饰性和规律性，这种规律性是人类从客观存在的美的形象中总结、归纳、提炼而成的，我们称之为形式美法则。它是我们表现不同图案内容，取得完美装饰效果的共同原则。

2.1　变化与统一

宇宙与自然是丰富多彩、千变万化的，在所有的变化中均存在着统一的形式和内在的联系。比如人类具有区别于其他物种的固有特征，而每一种族又有各自的体形、相貌和肤色特点；虽然每个人面目各异，但有着统一的形态结构。宇宙中不同种类的物体都有其共同的特征与个体变化。变化与统一的形式法则存在于自然界的一切物种中。变化与统一的形式法则是一切事物存在的规律，也是图案构成法则中最基本的原则。

变化是指图案各种构成因素的差异，如：大小、方圆、长短、粗细、冷暖、明暗、动静、疏密等。统一是指图案的各个组成因素之间的合理秩序和恰当关系。

图案不论大小都存在着各种矛盾关系，如：构图的虚与实、内容的主与次、形体的大与小、色彩的冷与暖、线条的长与短等。这些矛盾关系使图案生动而富于变化，但如果处理不好，会显得杂乱无序。我们应该用统一的手法，把这些矛盾关系有机地组织起来，从统一中求变化，在变化中求统一，使图案的各个组成部分既有区别又有内在联系，形成既有规律又有丰富变化的统一体（图2-1、图2-2、图2-3、图2-4、图2-5）。

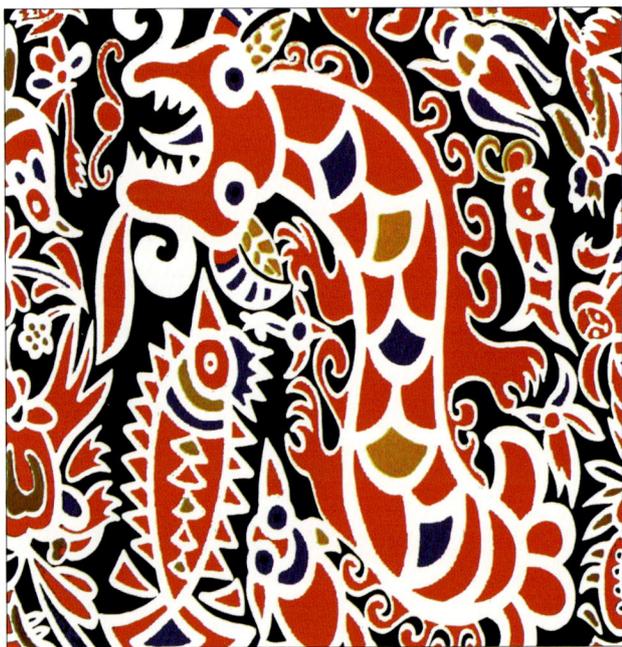

图2-1 贵州苗族图案，主题形象"龙"的造型非常有特色。画面中点、线、面、颜色等元素有机地组合成一个整体。变化是寻找各部分之间的差异、区别；统一是寻求它们之间的内在联系、共同点或共有特征

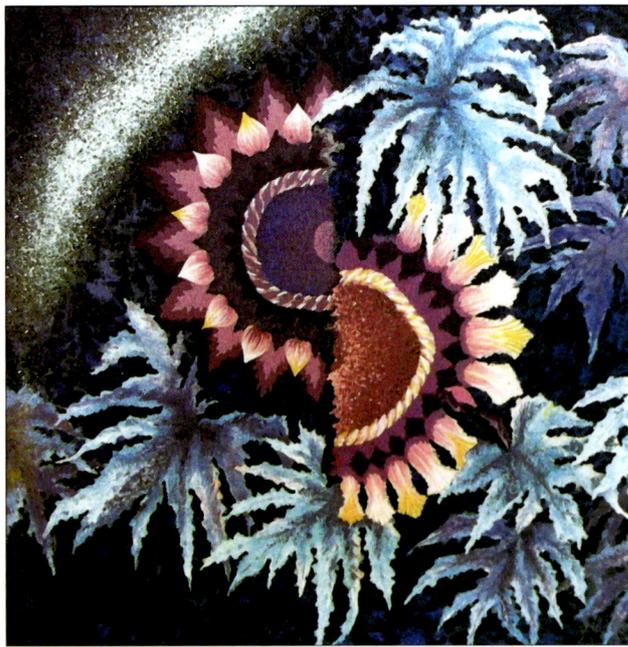

图2-2 线条简洁有力，造型生动流畅。用重复的构成手段协调了画面的冲突，强烈的色彩在大面积黑白的衬托下，显得统一而有张力

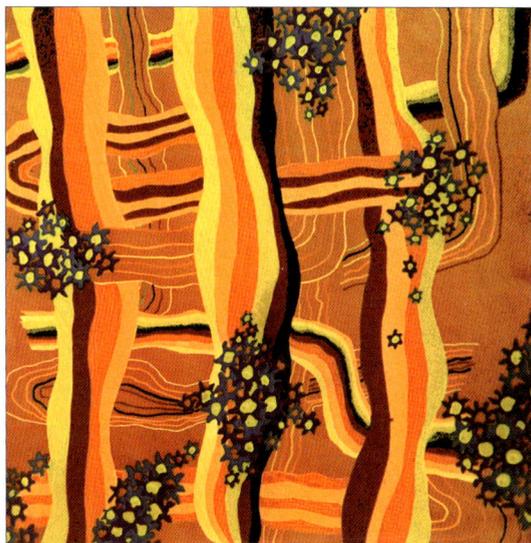

图2-3 有效地利用线条和花卉的前后遮挡，在二维的平面内营造出三维的空间效果。在图案中，没有变化则单调乏味和缺少生命力；没有统一则会显得杂乱无章，缺乏和谐与秩序

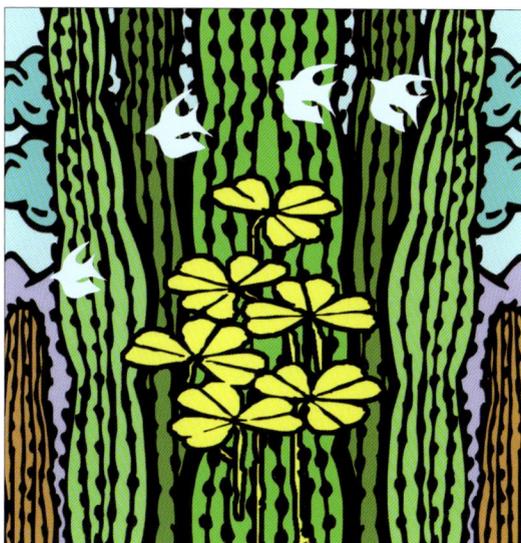

图2-4 组成植物的线条凸显了图案的秩序美感，而花和鸟则打破了这种秩序，体现出灵动和轻盈的效果

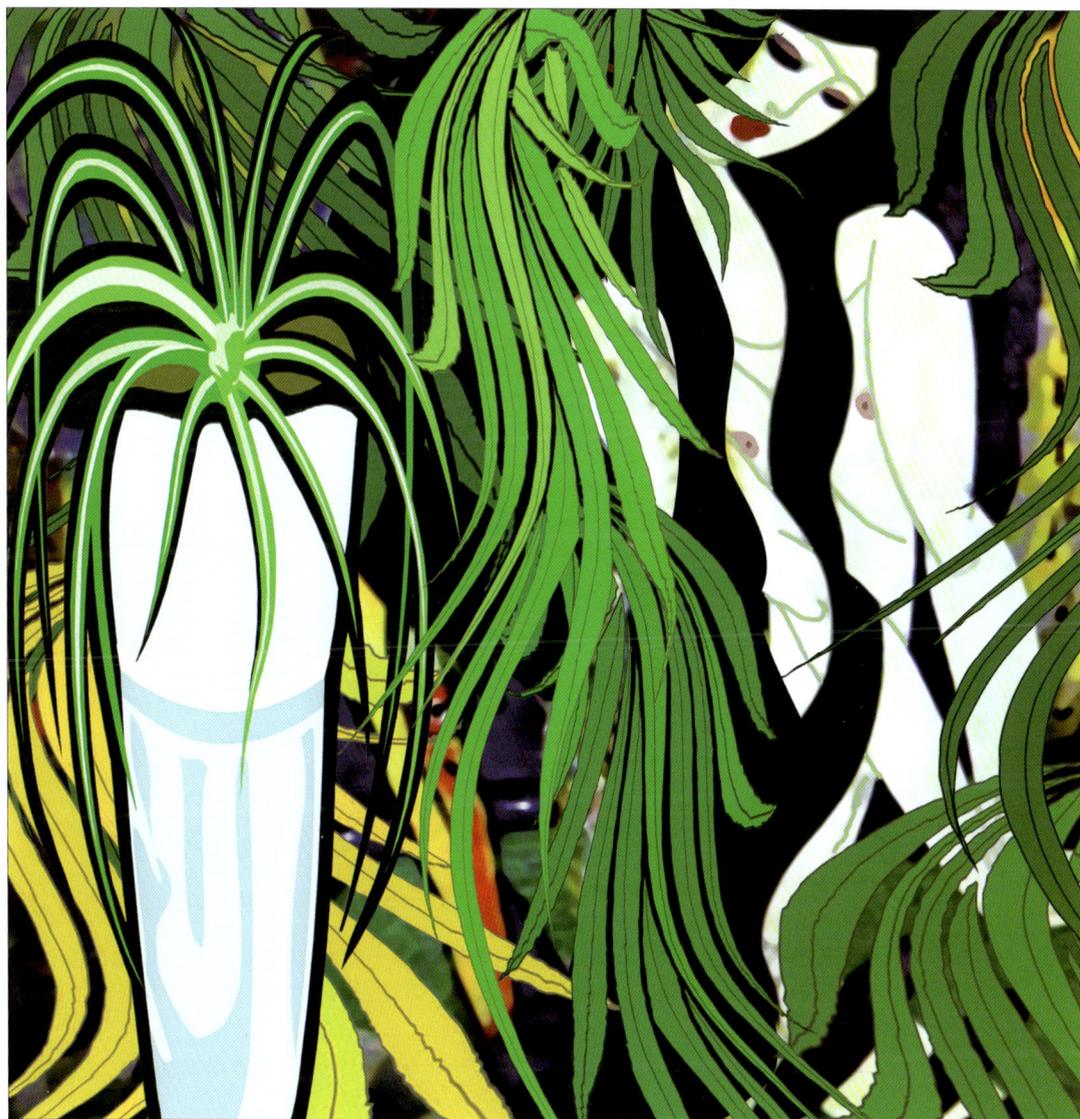

图2-5 花瓶、植物和人物按前后次序组合，强调了空间感和层次感。色彩以黄、绿色为主，简洁流畅、生动自然

2.2 对称与均衡

对称是以假设的中心点或中心线为依据，在其上下、左右配置相同形状和色彩的纹样，使图形产生整齐、庄重、平稳的效果。

我们在自然形象中，随处都可以发现对称的形式，如：花叶、动物、人物等。人类创造了无数具有对称形式的物体，如：房屋、器皿、家具及交通工具等。从心理学的角度来分析，对称体现了人们在生理和心理上对于平衡的要求。对称是原始艺术和一切装饰艺术普遍采用的表现形式，对称形式构成的图案具有重心稳定和静止庄重、整齐的美感（图2-6、图2-7、图2-8、图2-9）。

均衡也称平衡，是以假想的重心为支点，在视觉上保持重心周围纹样量的均等，即分量相同，但纹样和色彩不同，是以中轴线或中心点保持力的平衡。它体现了自然界中生物的动态形式。植物的生长、动物与人物的运动及各类物种的生态共存，均表现为一种均衡状态。在图案设计中，这种构图生动活泼，富于动感和变化（图2-10、图2-11、图2-12、图2-13、图2-14）。

对称与均衡是图案最基本的两种组织、构成形式。对称体现了静感与稳定性，具有端庄、安定的美。均衡则表现了动感和变化性，具有生动、活泼的美。

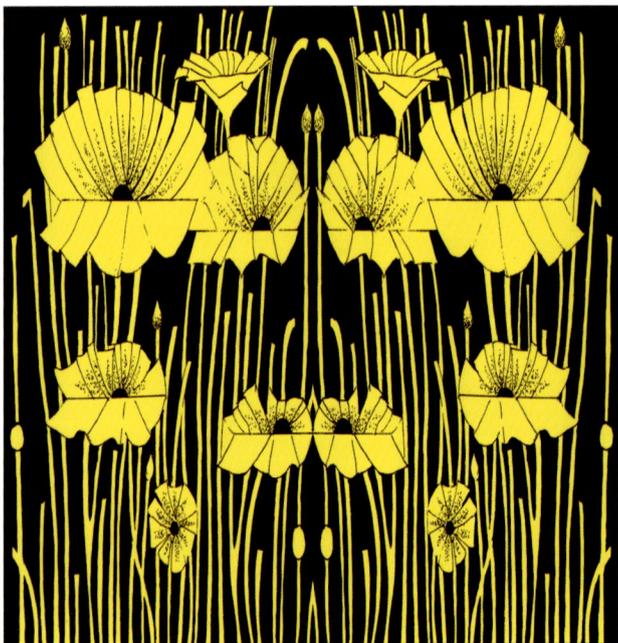

图2-7 我们将画面看作是一个"力场"，中心是一个支点，相同的景物分布在画面的左右两侧，相互对应，在视觉重量的分布上是相等的

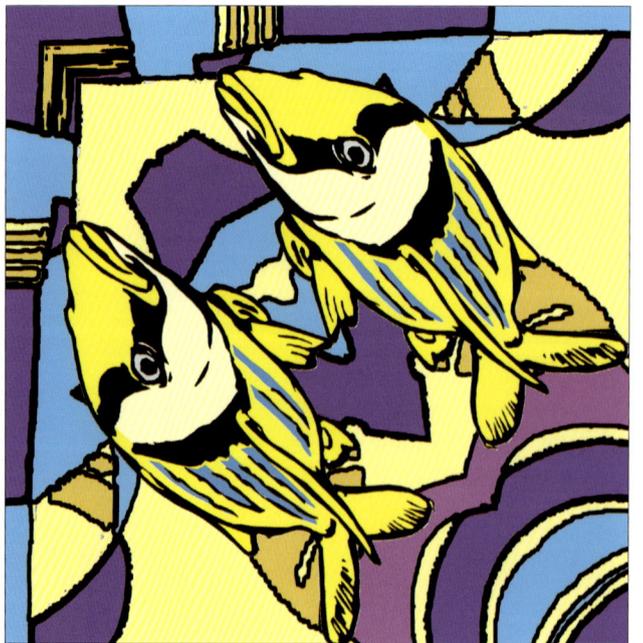

图2-6 沿画面中心轴两侧有等质、等量的相同景物形态，两侧保持着绝对均衡的关系，它在人们心理上感觉偏于理性，有一种庄重感

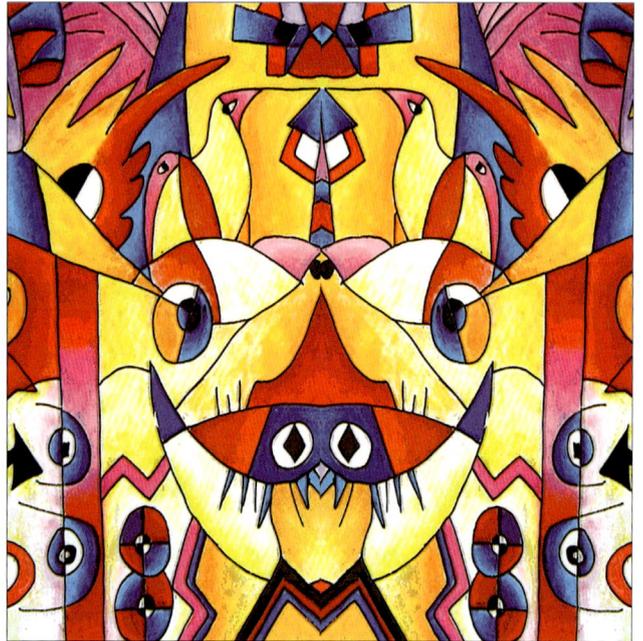

图2-8 对称的构图在图案中多运用正面角度，表现物体的正面形象，使画面工整，能显示出端庄、肃穆、安定的感觉。运用不当时，也往往使人感到呆板、单调、乏味

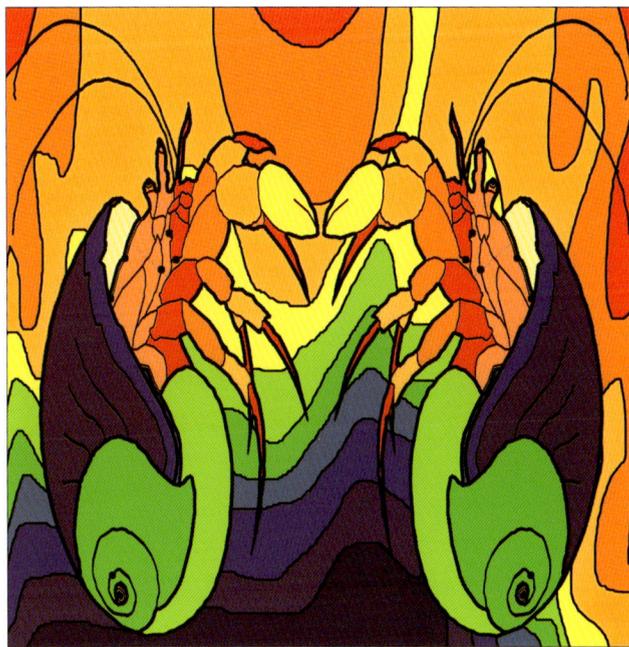

图2-9 两个同一形的并列与均齐，实际上就是最简单的对称形式。对称是同等同量的平衡。对称的形式有以中轴线为轴心的左右对称；以水平线为基准的上下对称和以对称点为源的放射对称；还有以对称面出发的反转形式

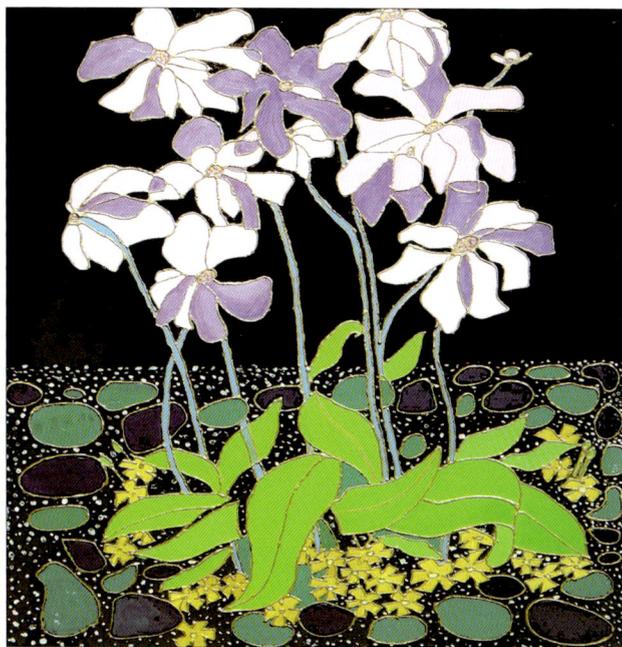

图2-11 均衡图例一

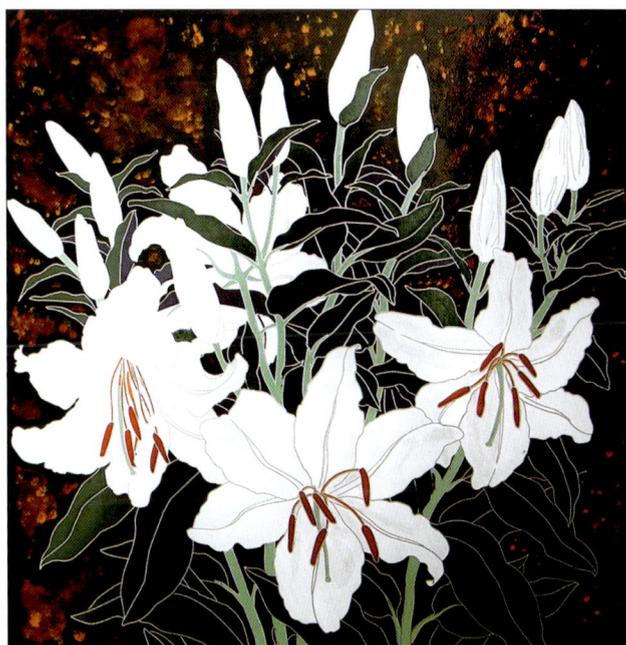

图2-10 在图案中影响均衡的要素有物体的大小、运动方向、空间位置，以及色彩、明暗，影像的虚实、疏密、繁简的布局等

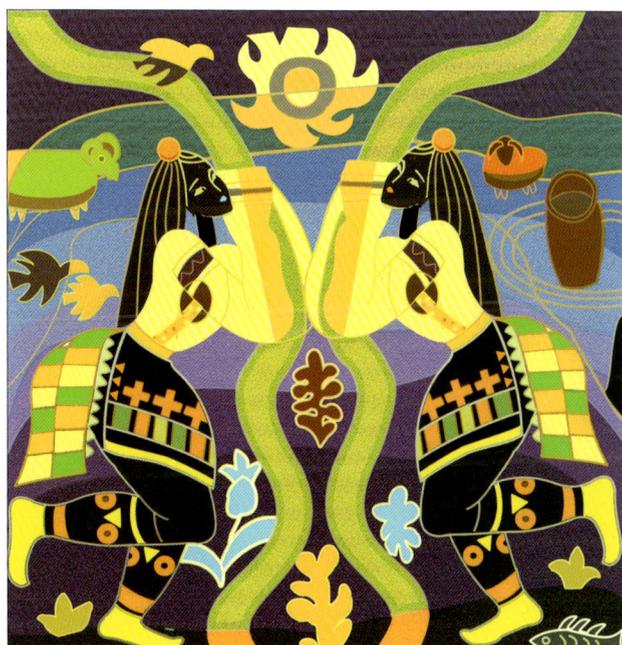

图2-12 均衡图例二

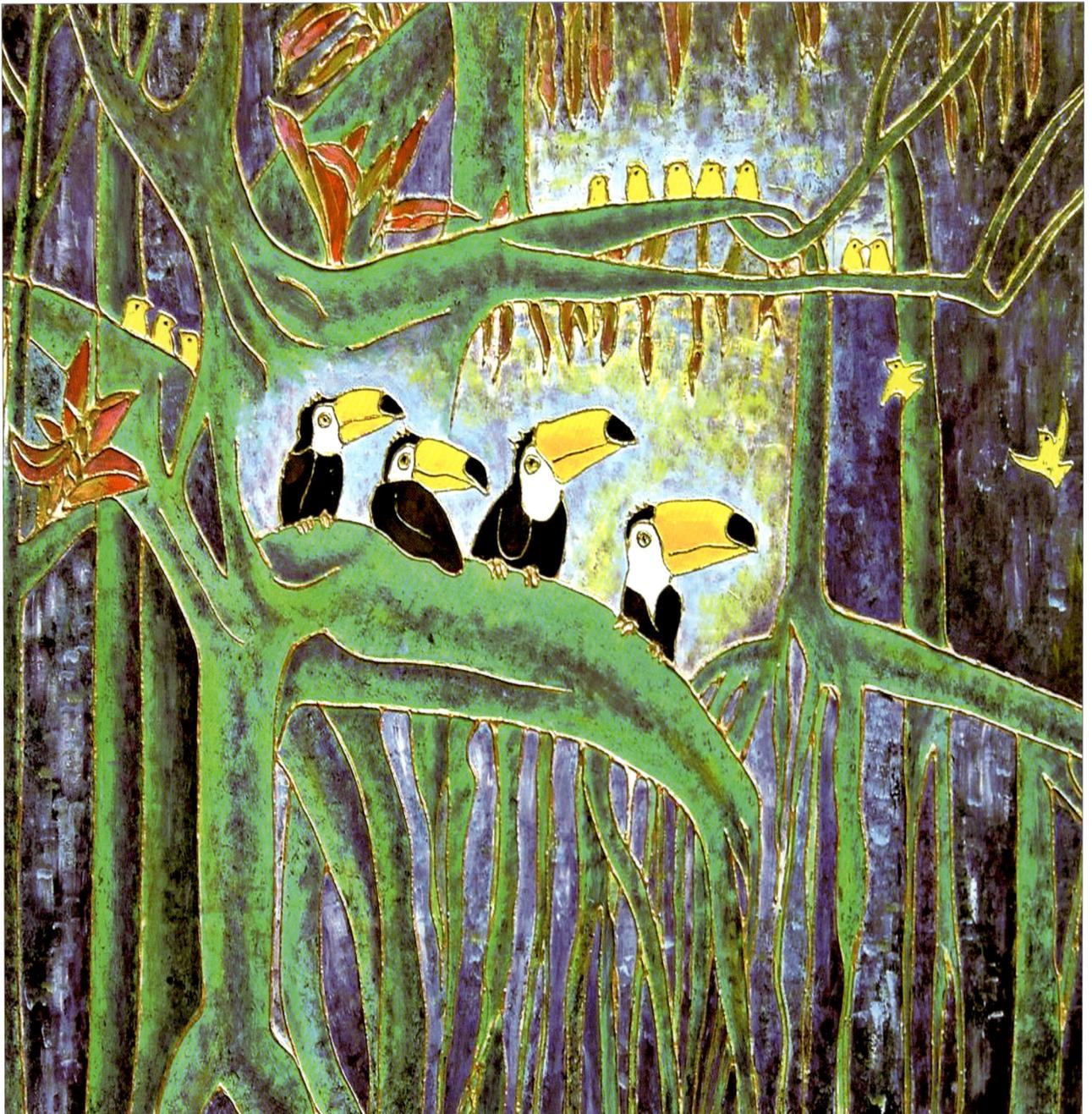

图2-13 均衡也称作动态平衡，是一种有形式变化的平衡，它较之对称的平衡显得生动、有活力

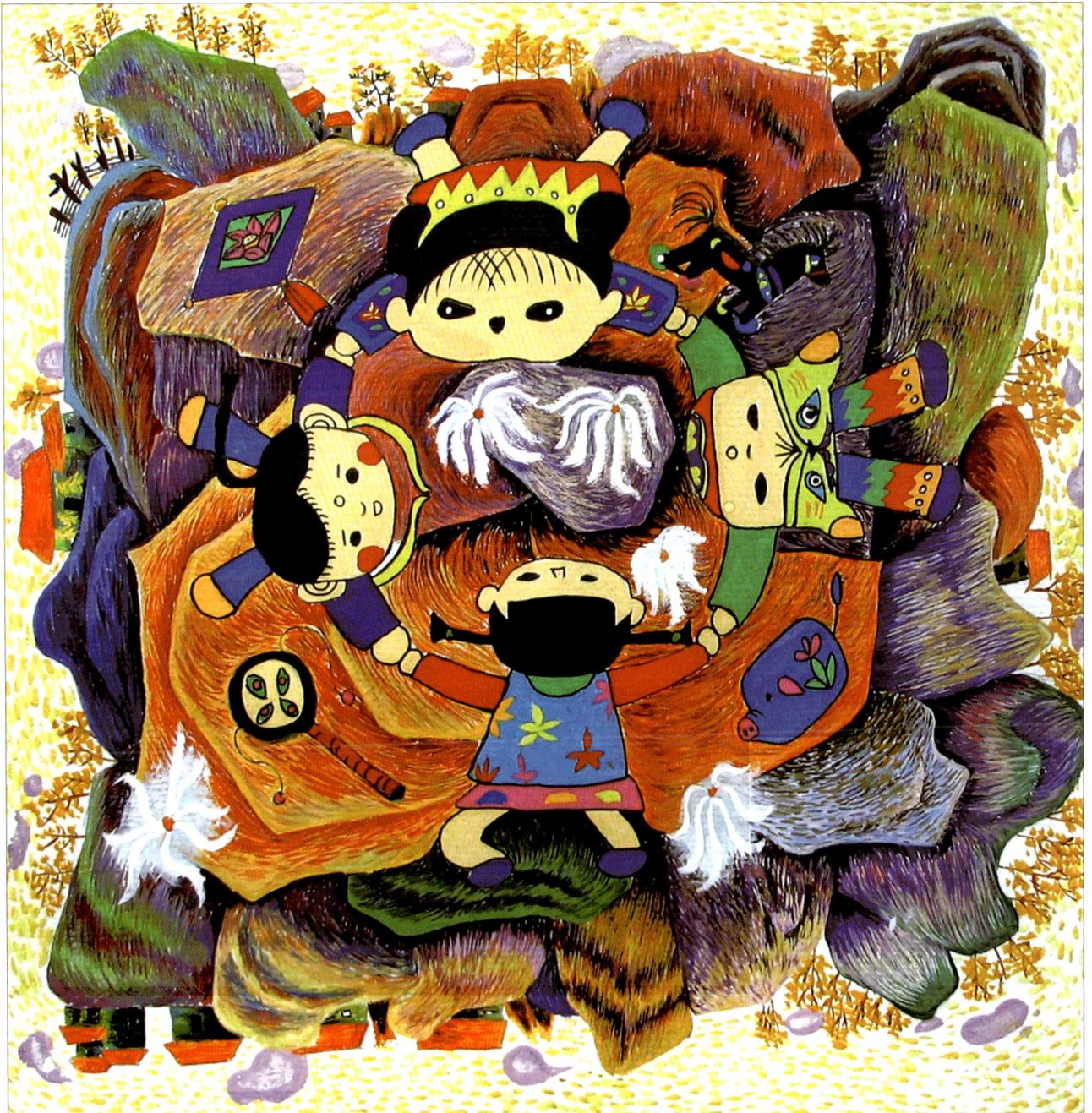

图2-14 均衡图例三

2.3 条理与反复

条理与反复即有规律的重复。自然中的万物看似繁杂纷乱，实则井然有序，如植物花卉的枝叶生长规律，花形生长的结构，飞禽羽毛、鱼类鳞片的生长排列，以及田园的分布、山峰的脉络等，都呈现出条理与反复这一规律。只要细细观察，随处可发现它们所具有的规律性、秩序化和循环反复的美。自然界的物象都是在运动和发展的，这种运动和发展是在条理与反复的规律中进行的。

条理与反复既是万物生长固有的形式，也是图案组织的重要原则。条理是对事物有规律、有秩序的组织和安排，是使物象单纯化、统一化的重要手段。反复是将相同的形象或单位纹样以某种形式规律往返重复排列，形成整齐、单纯、富于节奏的美感。图案中的连续性构图最能说明这一特点。连续性的构图是装饰图案中的一种组织形式，它是将一个基本单位纹样作上下左右连续，或向四方重复地连续排列而成的连续纹样，将图案纹样有规律地排列，有条理地重叠交叉组合，使其具有淳厚质朴的感觉。图案的许多构成形式均具有条理与反复的性质，如对称、发射、转换、旋转、二方连续、四方连续等，不仅达到了变化和统一的效果，而且也便于工艺制作。条理与反复是图案特有的一种组织形式，在图案构成中它们往往是相互涵盖、不可分割的（图2-15、图2-16、图2-17、图2-18、图2-19）。

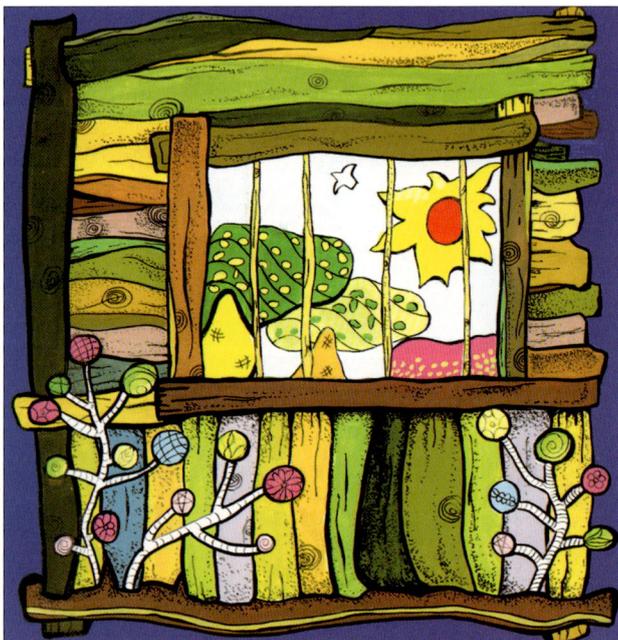

图2-16 条理就是构成图案纹样的规律性，反复是图案的一种条理形式，就是以一个纹样为单位，反复接续排列，比如图中房屋和飞鸟的造型排列

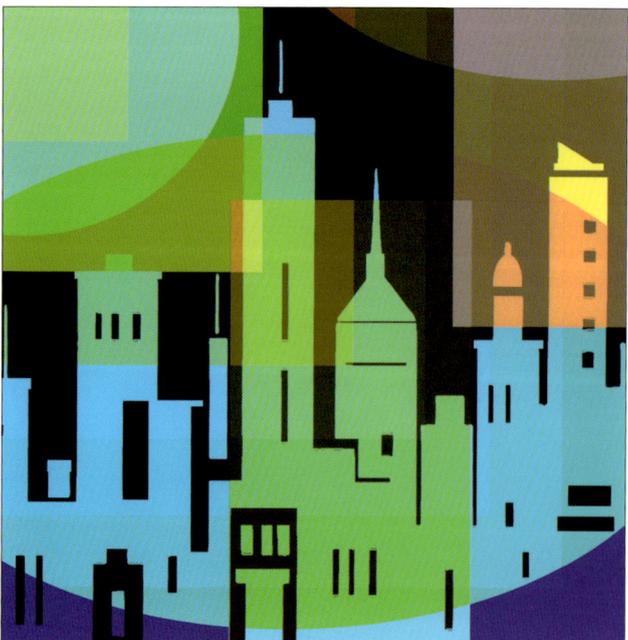

图2-15 条理与反复构成了图案美的组织原则，经条理和反复原则的组织，可使不统一、不协调的形、色得到浑然一体的良好效果

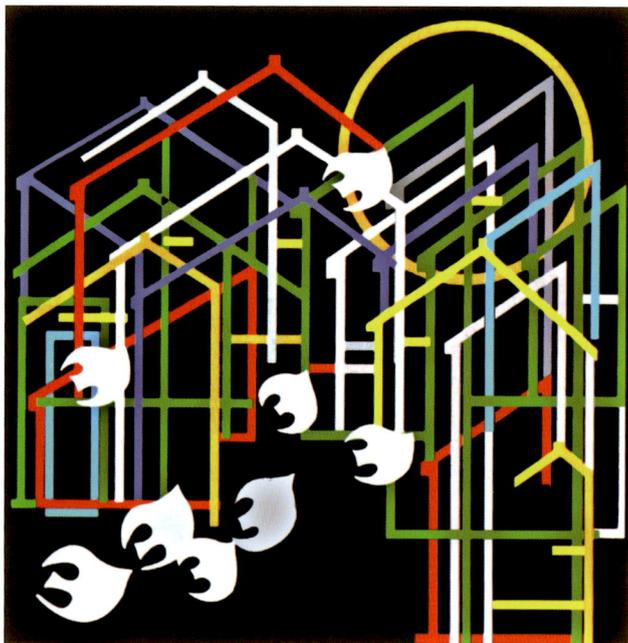

图2-17 条理与反复构成了图案的节奏和韵律，也形成了图案的装饰美

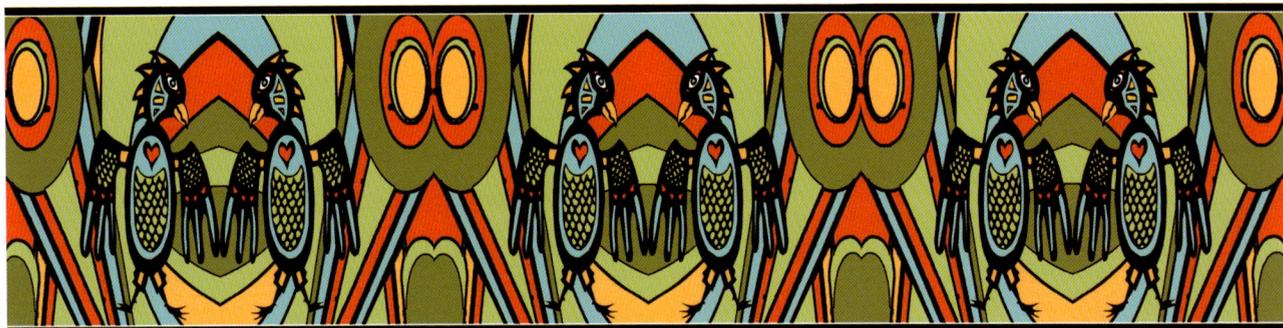

图2-18 二方连续的构成组织形式很好地体现了条理与反复的作用

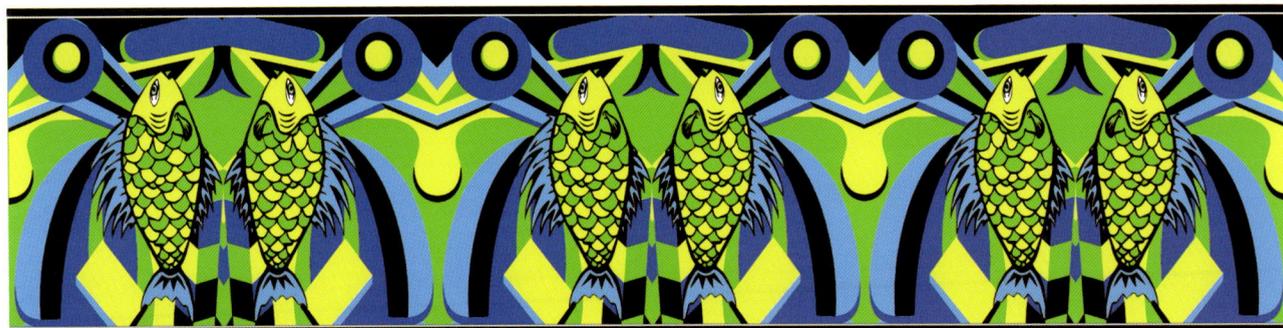

图2-19 二方连续图例

2.4 对比与调和

在图案中，对比是指两种或两种以上性质差异较大的形象要素的配合，如：黑与白、方与圆、直与曲、软与硬、红与绿、浓与淡、疏与密等。对比强调差异，在图案中常采用的对比方法是形色对比、质量对比、静动对比。对比使画面产生鲜明、生动、丰富的艺术效果。调和就是构成对象之间被赋予了统一和谐的状态。调和强调统一，图案中常将性质相同或类似的形象要素进行配合，以减弱形、线、色等图案要素间的差距，缓解差异和矛盾。如同类色和邻近色、曲线与折线、圆与椭圆等配合在一起，具有和谐安静的艺术效果，给人以协调感。

对比与调和在图案中缺一不可，没有调和就没有对比，它们是不可分割的矛盾统一体，是图案设计的重要手段。对比使事物双方充分展示个性特点，增强视觉刺激感，可使画面活泼而富于变化，避免单调与平淡。调和使对比适度、恰当，避免零乱和生硬，有协调矛盾，使个性化的图案趋于统一的效果。对比与调和是变化与统一原则的重要体现（图2-20、图2-21、图2-22、图2-23、图2-24）。

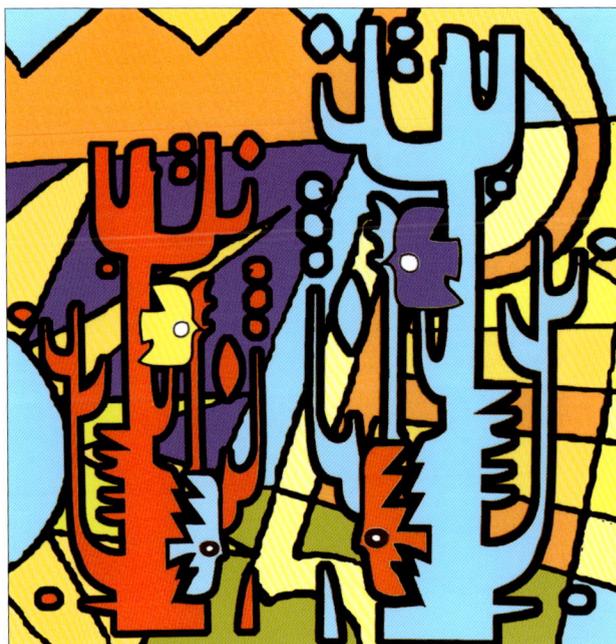

图2-20 调和就是用图案中元素组合的相关方式，使元素形态产生统一关系的方法和手段

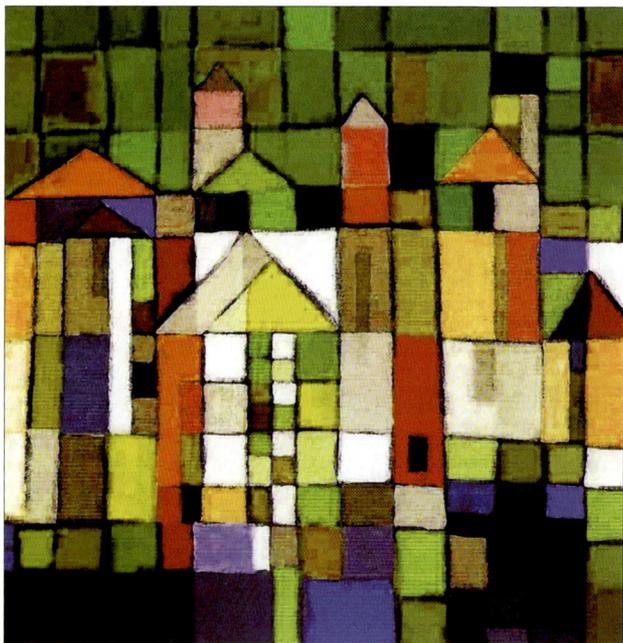

图2-21 对比手法的运用无处不在，可以涉及图案的各种特性，有明暗对比、色彩冷暖对比、材料肌理对比、传统与现代的形式对比等。图中采用的明暗对比和冷暖对比使画面跳跃而绚丽

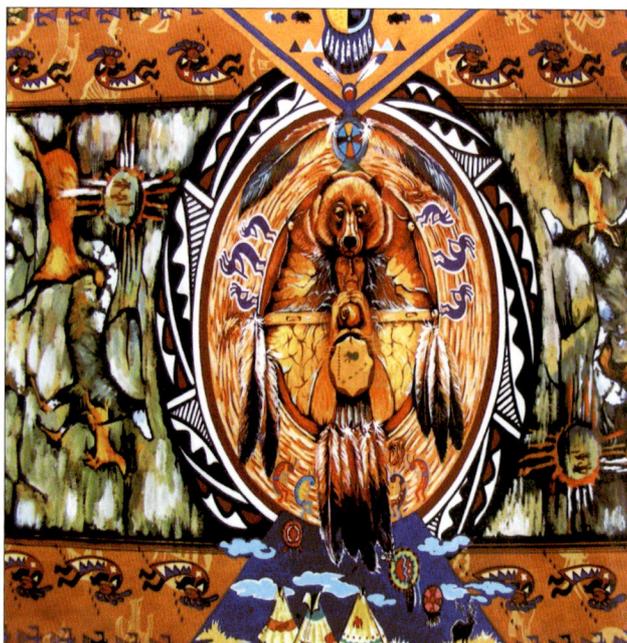

图2-23 对比使图案具有更多样式的变化，从而演绎出各种不同节奏的表现方式和技巧

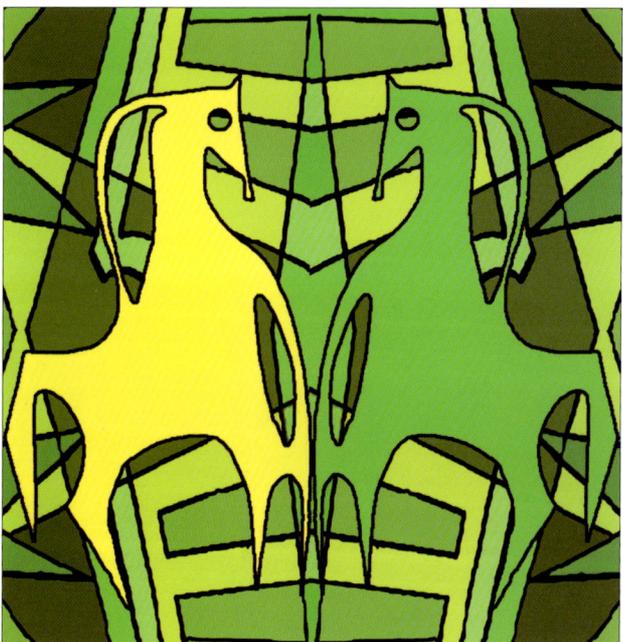

图2-22 调和是将对比双方进行缓冲与融合的一种有效手段，使图形之间层次更加统一

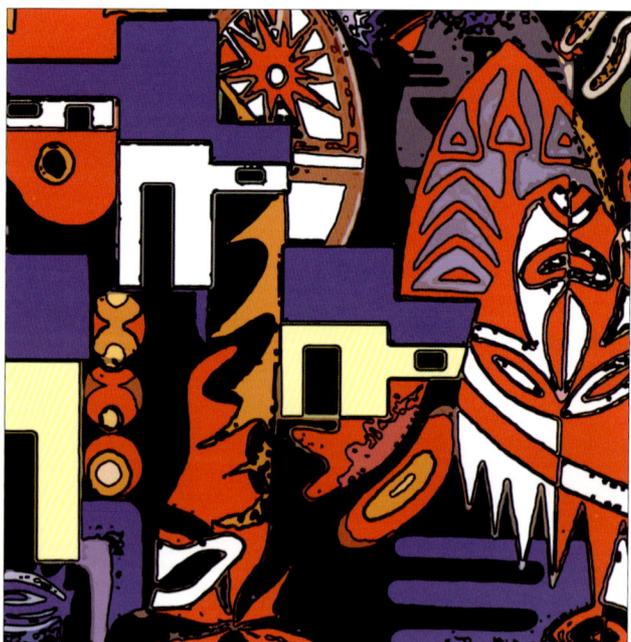

图2-24 黑色与红、白色在视觉上的强烈反差对比，体现了粗犷的抽象风格，同时也增加了空间的趣味性

2.5 节奏与韵律

　　节奏与韵律是借助于音乐术语，将听觉要素转化为视觉要素。建筑、绘画、舞蹈等各类艺术形式中都有节奏与

韵律的体现，而这种节奏与韵律也是源于大自然中万物的生长与运动的规律，如动物的心跳、海潮的涨落等都充满了节奏和韵律感。

　　节奏是规律性的重复。在音乐中节奏被定义为"互

相连接的音，所经时间的秩序"，在造型艺术中则被认为是反复的形态和构造。在图案中，节奏表现为形、色、主次与组织等有规律的布局和变化，如连续变化的点、线、面等。

韵律是节奏的变化形式，节奏如同音乐中的节拍，韵律好比音乐中的调子，韵律赋予节奏美的形式并在节奏变化中产生无穷的情趣（图2-25、图2-26、图2-27、图2-28、图2-29）。

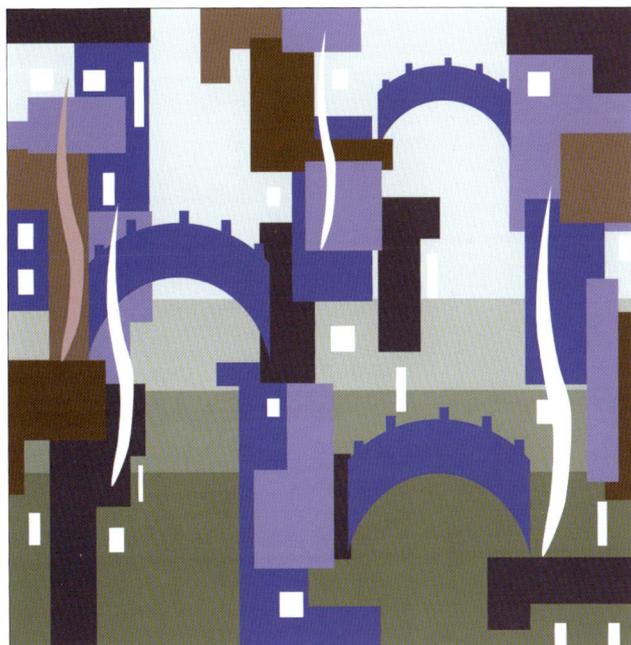

图2-25 节奏与韵律是通过体量大小的区分、虚实的交替、排列的疏密、长短的变化、曲柔刚直的穿插等等变化来实现的，具体手法有：连续式、渐变式、起伏式、交错式等

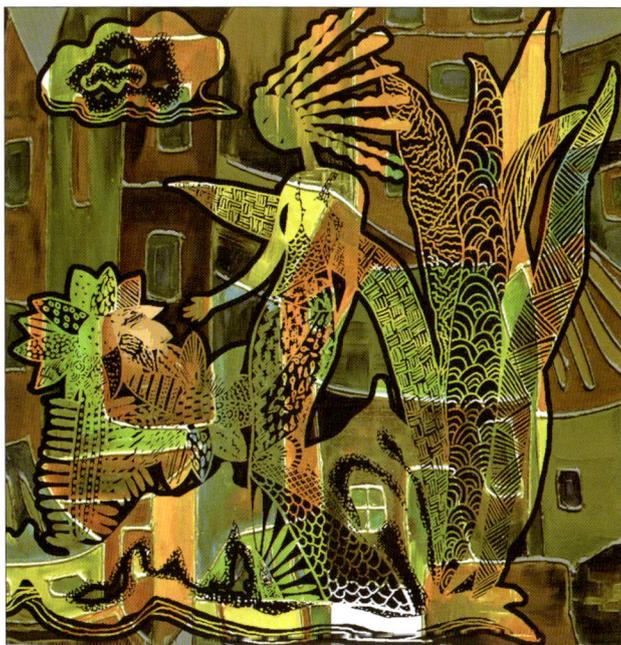

图2-27 树叶的组织用了最单纯的节奏——重复，有机械的美。房屋的韵律是构成要素连续反复所造成的抑扬调子，具有感情的因素，满足了人的精神享受，体现了节奏与韵律法则运用中的相辅相成

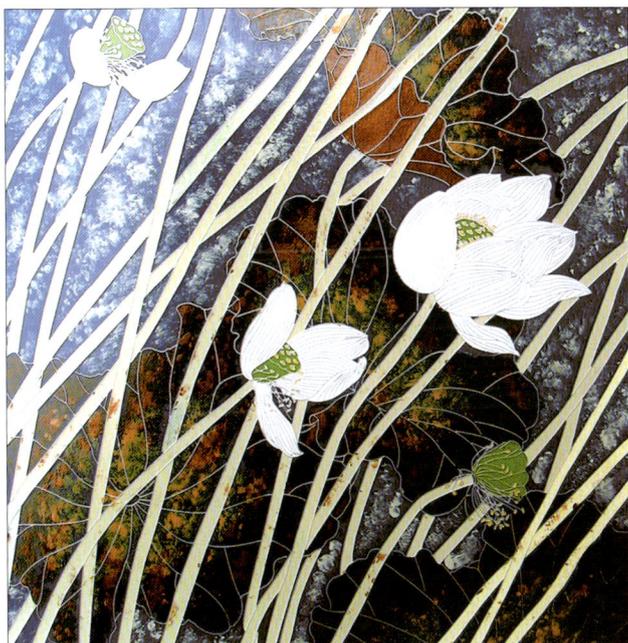

图2-26 以明确动人的节奏和韵律，将无声的花枝形象变为生动的音乐般的视觉语言，加强了图案的感染力

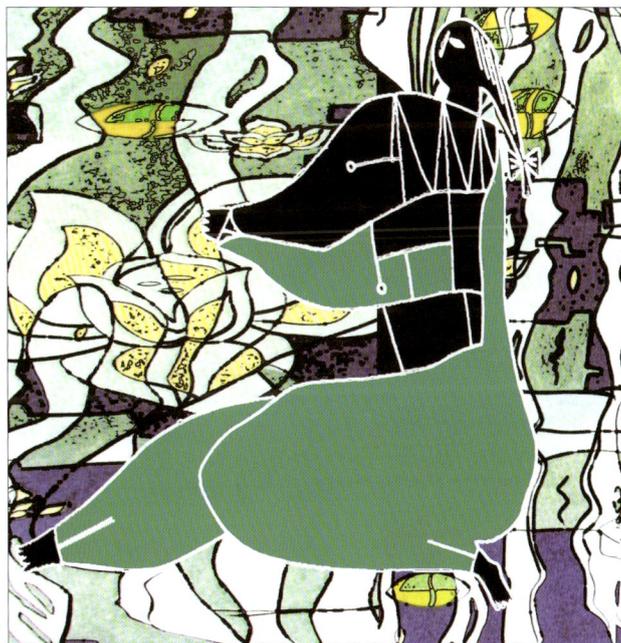

图2-28 韵律使图案产生情趣，具有抒情意味，能增强我们设计作品的感情因素和感染力，引起共鸣、产生美感、开阔艺术的表现力

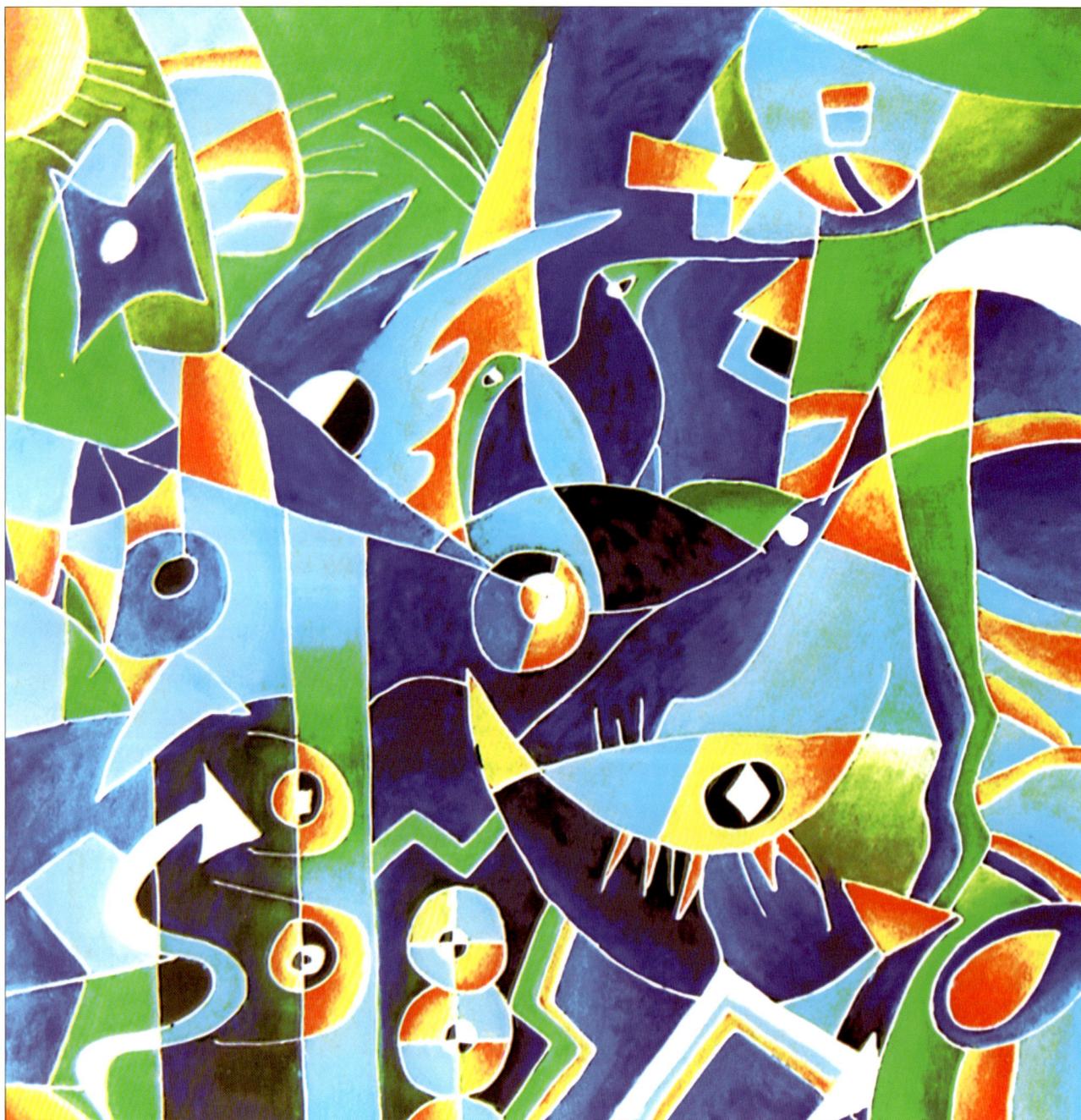

图2-29 通过起伏的曲线将各元素组织在一起，体量的穿插和点的应用像一首动听的乐曲，给人美的享受

2.6 比例

比例是指形象与空间、形象整体与局部、局部与局部之间量的关系。图案中的比例可有多方面的对照标准。

2.6.1 参照自然的比例尺度

大自然中万物的形态结构为适应不同的生存需求形成了不同的比例特征，大多是美而和谐的，可以直接用于图案的表现之中。

2.6.2 参照画面构成的比例需要

根据画面构成形式的需要来设计图案造型的比例关系，可完全打破自然的比例尺度，自由地夸张变形。这种方式在图案中运用较为普遍，也更富于装饰美感，有较强的艺术感染力。

2.6.3 参照人体比例尺度

有些图案造型比例还应对照人体的结构比例来设定，特别是一些立体图案，如：器皿、包装、家具的造型比例等，均要考虑人体各部分的结构尺度关系，像杯子与手的比例，椅子与人腿的比例等。

2.6.4 黄金比例

人们在生产、生活实践中还发现总结了一些最佳的比例方案，为图案设计提供了数理性的依据。众所周知的黄金矩形比例，也称"黄金分割"，它的长与宽之比是1:0.618或1.618:1。黄金比例被广泛用于纸张、书本、画框等许多方面。

图案的比例包括造型与空间、形象之间以及色彩之间多方面的关系，在设计中要根据实用与审美的需求来对照设定不同的比例尺度，恰当地安排画面的比例关系，从而达到整体的协调与统一（图2-30、图2-31、图2-32）。

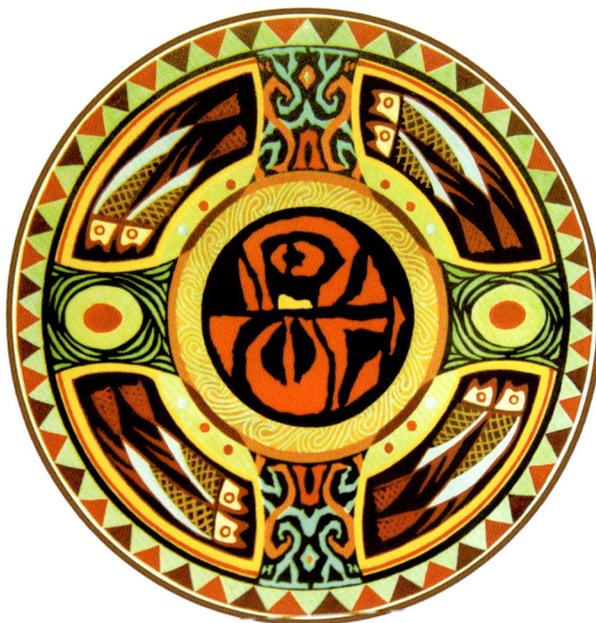

图2-31 比例系统或能直接显示于视觉，但更多状况下，其主要功能是安排各元素位置及大小，使其合理地变化

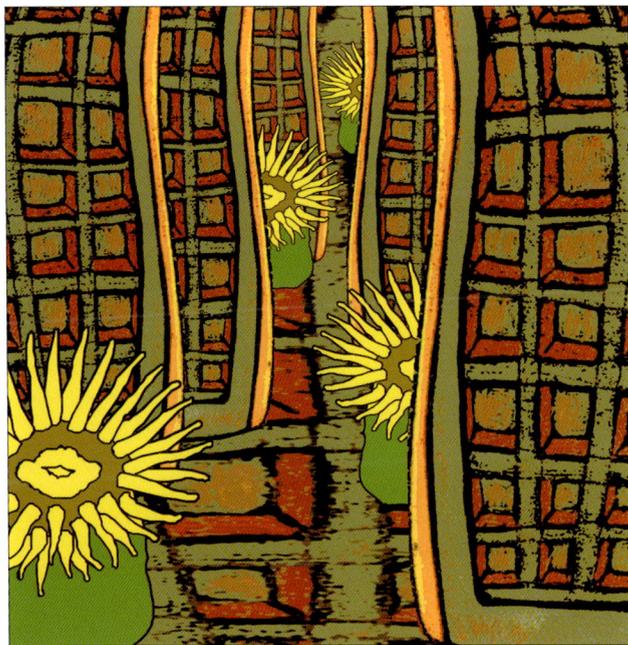

图2-30 古罗马神学家圣·奥古斯丁说："美是各部分的适当比例，再加一种悦目的颜色。"单独考虑各部分比例不具任何意义，重点是局部与整体的比例关系，以及各元素之相似性的调和关系

图2-32 尺度是各个元素之间相比，不需涉及具体尺寸，完全凭感觉上的印象来把握。比例是理性的、具体的，尺度是感性的、抽象的

2.7　正形与负形

正形和负形是图与底的关系，是不可分割的。两者之间安排得是否合理，决定了作品艺术水准的高低，有时正形和负形各作为独立的视觉元素同时存在于画面之中，而且形成相互转换的关系，这种情况被称为"图底反转"。因此不能只重视正形的处理而忽略了负形的大小、疏密等问题的处理（图2-33、图2-34、图2-35、图2-36）。

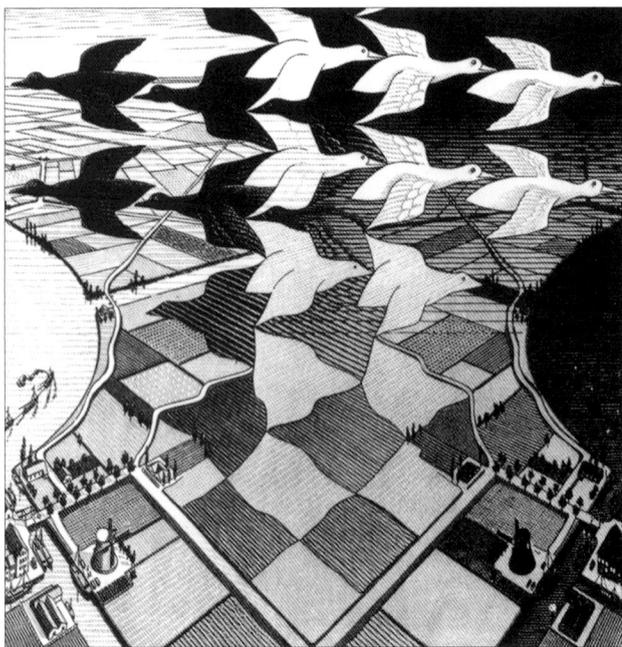

图2-33　埃舍尔的作品

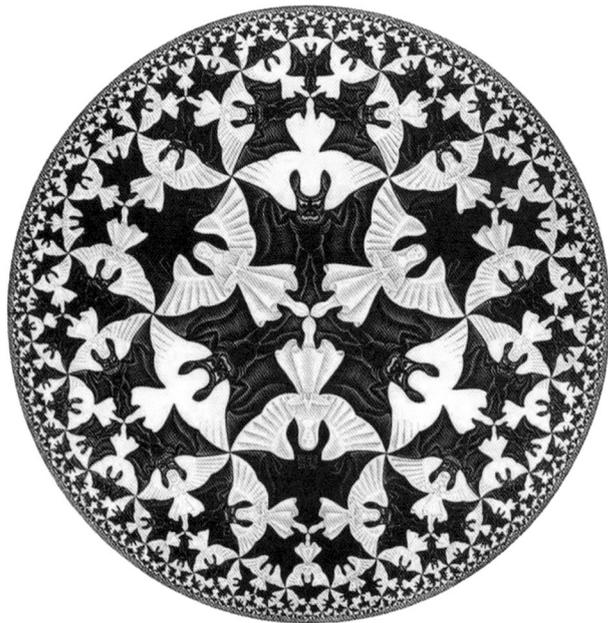

图2-35　荷兰艺术家埃舍尔的作品，在图中正形与负形得以巧妙地共生

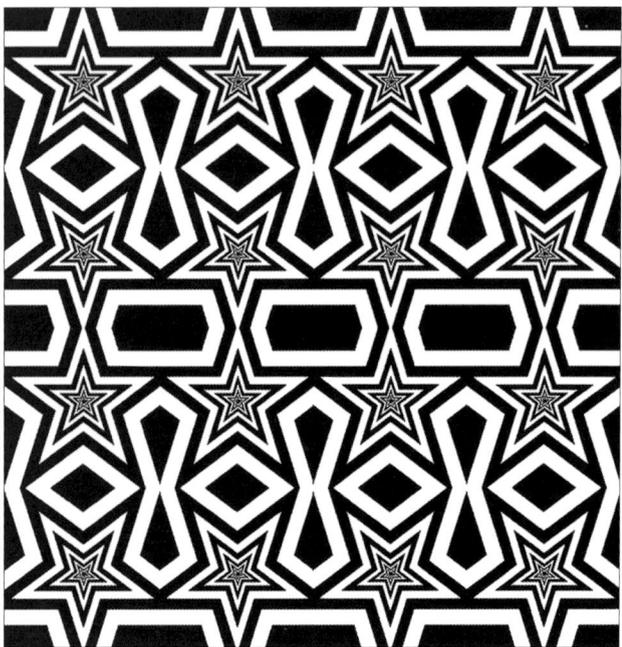

图2-34　埃舍尔的作品

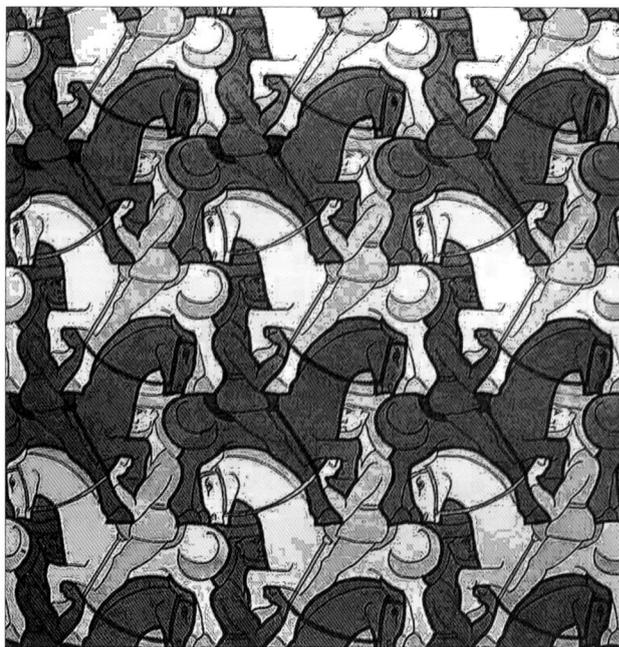

图2-36　正形和负形同时存在于画面之中，要注意它们的比例关系

第3章 图案变化的基本方法

在图案的创作过程中，应遵循图案变化的基本原理，在表现形式上应符合图案变化的基本原则。变化不是最终目的，变化是为了寻求不同的形在同一画面里的共性。变化使得客观素材与主题更好地和谐与呼应，最后达成统一的表现形式。变化的手法有以下几类：

3.1 归纳与取舍

归纳与取舍是抓住对象美的本质，进行提炼和概括，使之更具典型性，将物象的特征更突出地表现出来。经过思考而将其外化了的图案已非自然物象的简单复制，它应成为

图3-1 对长颈鹿的形态作了大胆的归纳，突出了长颈鹿的表情意向。对其形体的局部细节取舍有度，概括地表现了形体特征

与人交流并能引起共鸣的具有特别艺术感染力的一种艺术语言。要达到这一点，必须注意以下三个方面的问题：

1．在形式结构上应能传达普遍的认知概念，例如一般人对树木、房屋、动物、花草的视感知所形成的形象概念。

2．对色彩的一般感觉概念，如不同的色彩对人所产生的不同的心理与生理反应。

3．对空间的感知和感觉概念，如对画面的空间关系处理所引起的视觉上对纵深感、舒展感、压抑感、沉重感、距离感等的一般感知规律。这是作为形态归纳与想象造型进行发挥的基本依据（图3-1、图3-2）。

图3-2 在植物树叶的表现上，舍弃了繁琐的细节，简化的形态给人以强烈的感染力

3.2 夸张与变形

夸张与变形是将最具代表性的特征加以夸张，使其更醒目、更具代表性，使人一目了然。人们能够接受这些形象的原因是由于它们更接近人的"心灵的意象"。单就视觉而言，这些似乎远离现实的形象却更符合人们的审美需求，能给人以更多的想象空间（图3-3、图3-4）。

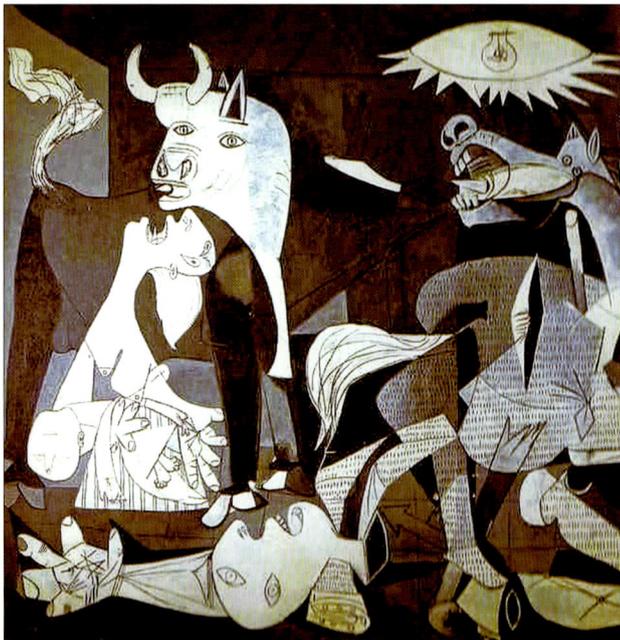

图3-3 西班牙绘画大师毕加索的作品《格尔尼卡》局部。毕加索的极端变形和夸张的艺术手法，在表现畸形的社会和扭曲了的人性之间的关系方面，有独特的力量

图3-4 一个艺术家无论如何虔诚地看待自然和模拟自然，也无论他怎样如实地去描绘形体，终因每个人对"真"与"实"的看法不同而产生种种的差异。这些差异是客观存在的，它既决定了任何作品只能相对的"如实"，也给夸张、变形的产生与运用以广泛的机会。它的产生、它的存在、它的运用，不仅自然而且合理

3.3 提炼与重复

　　提炼与重复是先对自然形进行概括提炼，在确定基本形后，再对其进行反复排列组合。通过这种重复，形成井然有序、疏密有致、虚实相间的装饰图形（图3-5、图3-6）。

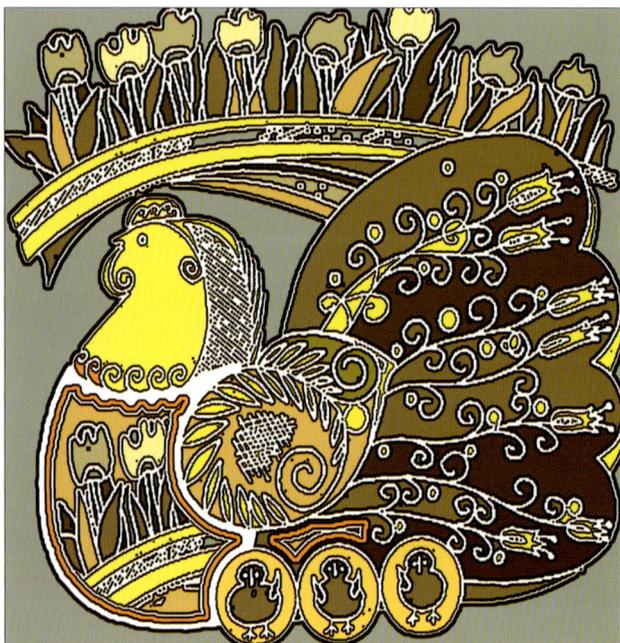

图3-5 将自然物象以抽象的的语言加以提炼，经过重复的排列组合，得到了丰富的效果，给人以想象的空间

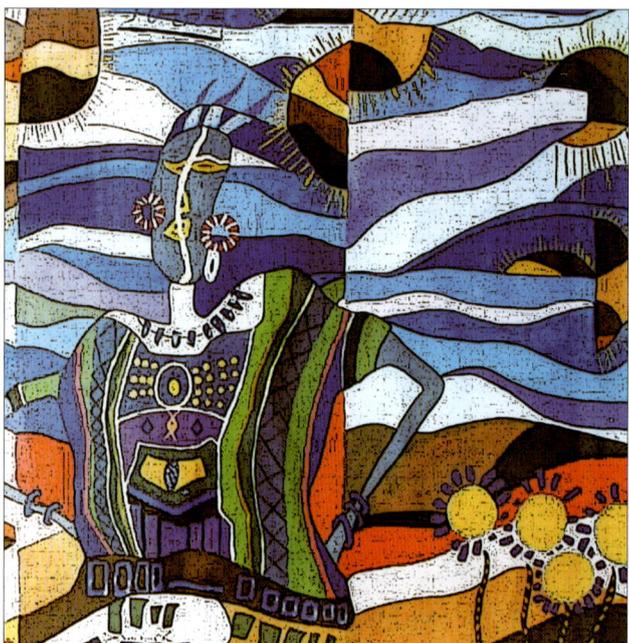

图3-6 人物形态经过高度提炼变得淳朴有力，前后重复的次序增加了画面的层次感

3.4 想象与添加

想象与添加是在某一图形的中间或周围适当加入一些装饰造型，使原有的图形更加丰富完善，以活跃画面的气氛，增加艺术效果和艺术想象力（图3-7、图3-8、图3-9）。

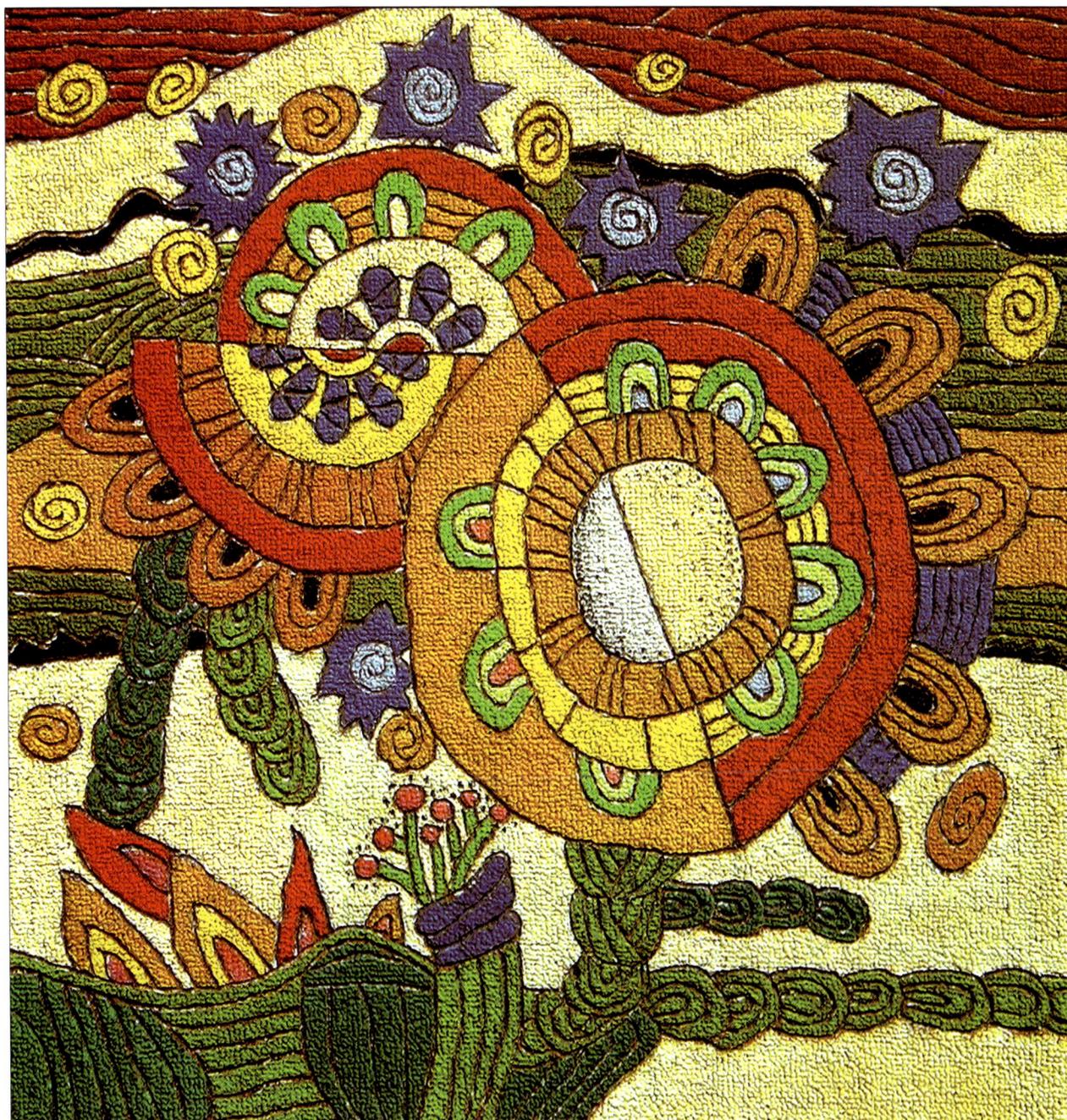

图3-7 想象是人类的天性，是图形变化中取之不尽的源泉，而添加是一种变化手段，它可以丰富表现内容，避免单调的描绘

图3-8 想象与添加图例一

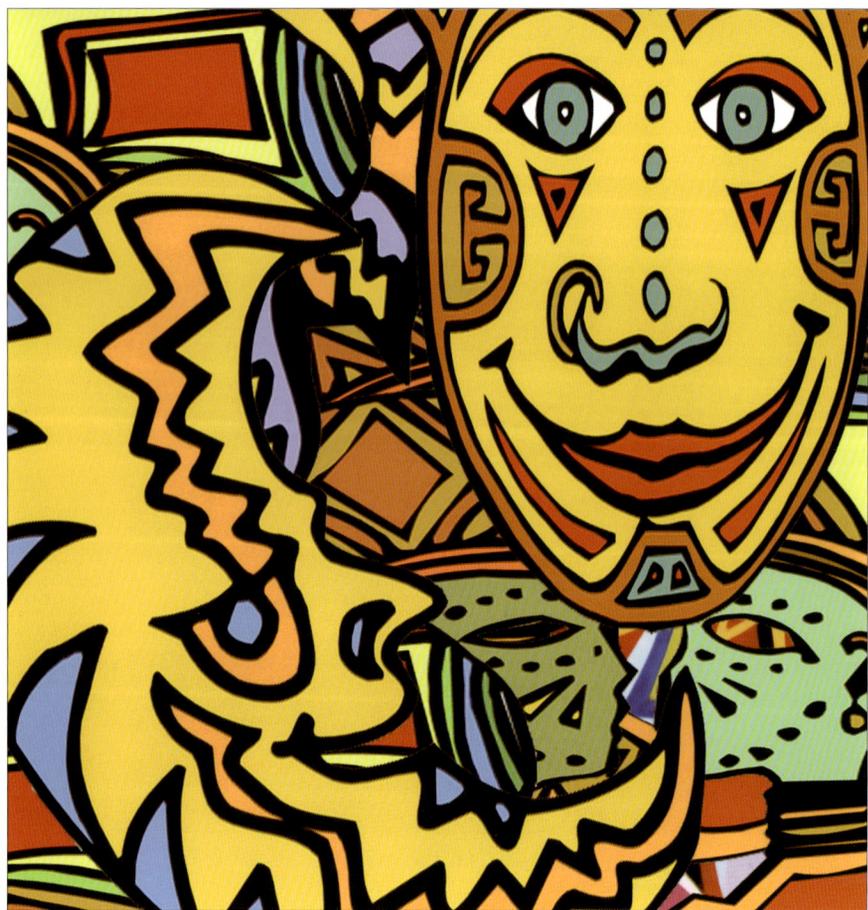

图3-9 想象与添加图例二

3.5 巧合与共用形

巧合与共用形是运用巧妙的艺术构思，利用形与形之间的穿插与重叠，产生共用形。可以共用某一局部，也可以共用一个整体形（图3-10、图3-11、图3-12）。

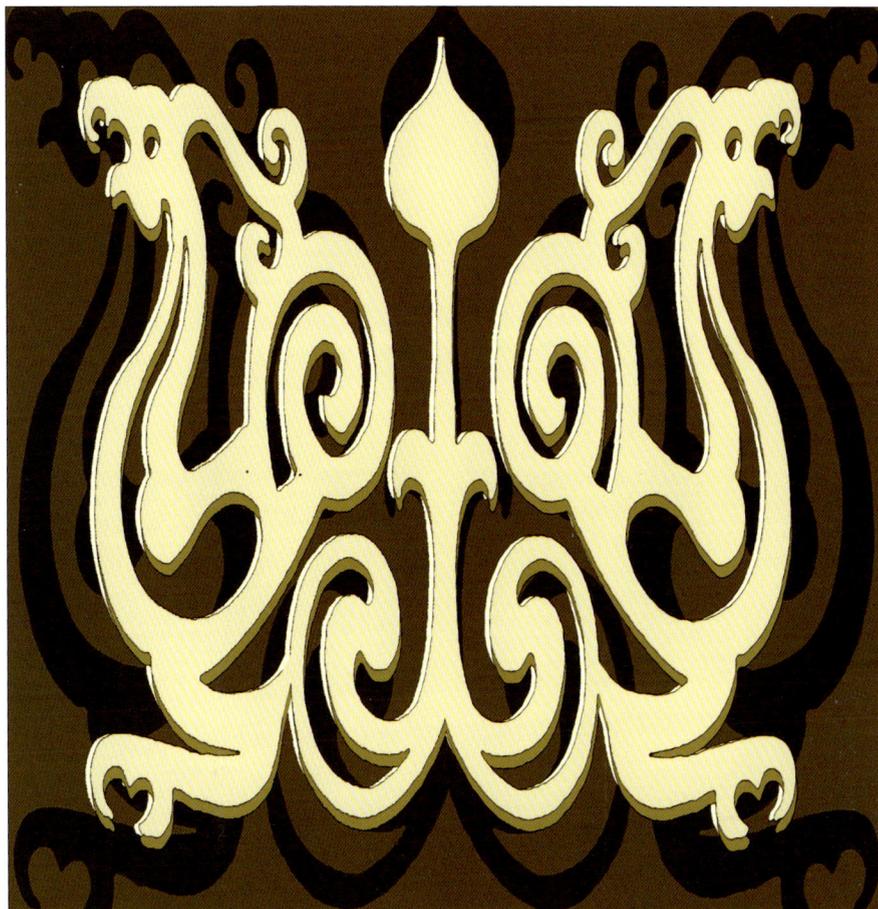

图3-10 巧合与共用形图例一

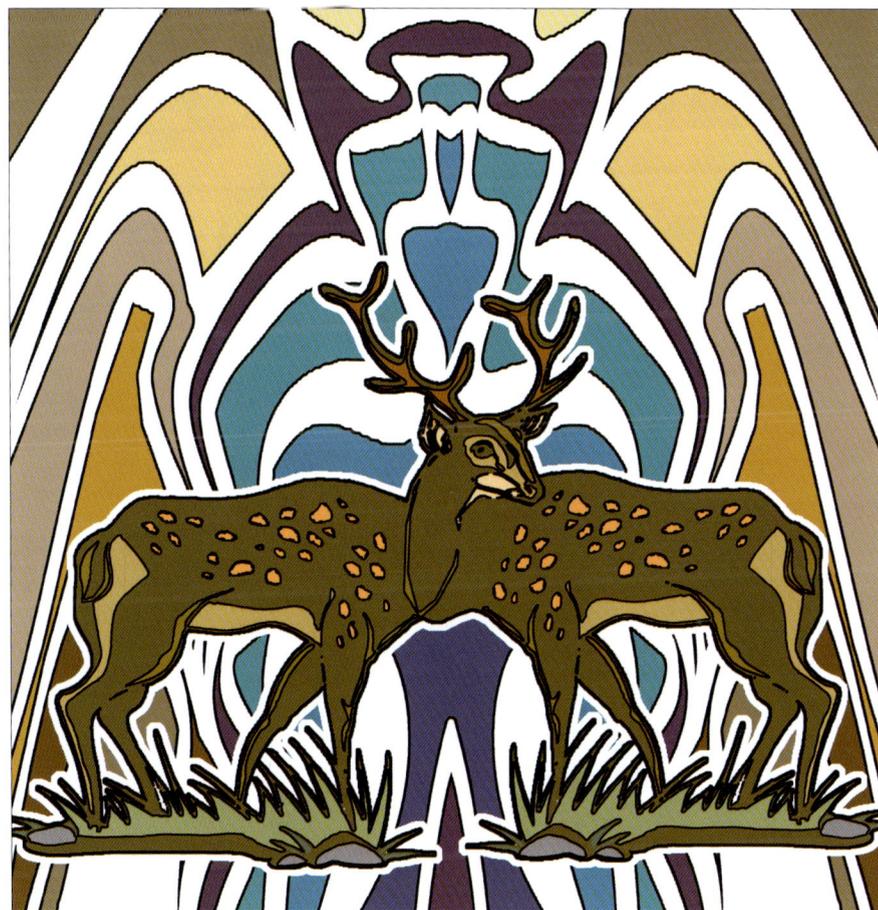

图3-11 巧合与共用形图例二

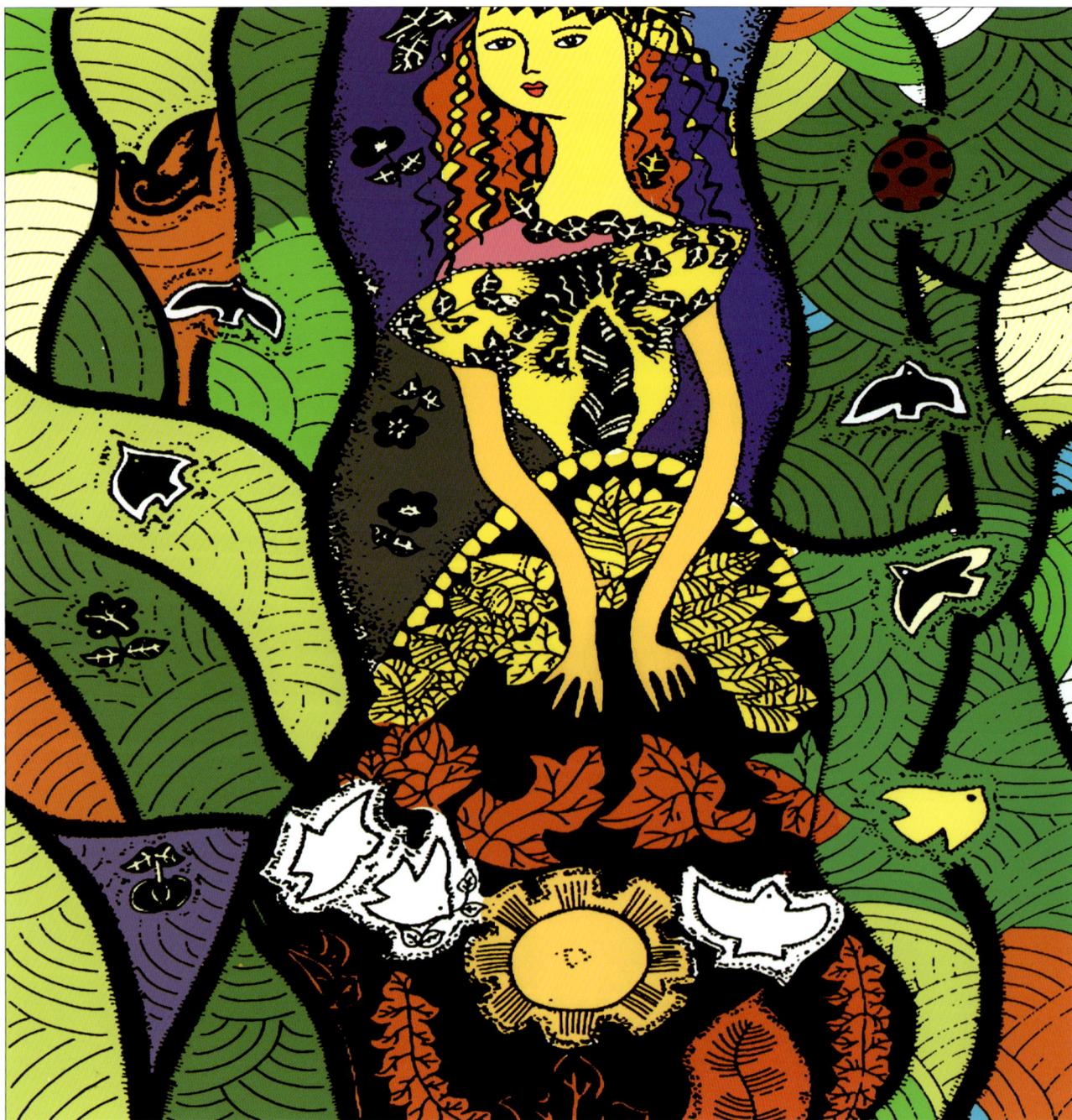

图3-12 巧合与共用形图例三

3.6 超自然与同构

　　超自然与同构是指打破客观世界时间与空间的界限，通过创造性的构思，把不同时空发生的现象同时组合在一起（图3-13、图3-14、图3-15、图3-16）。

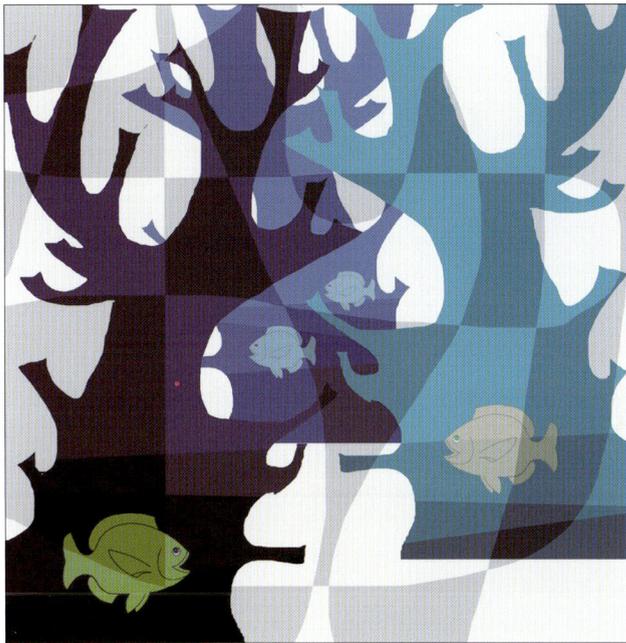

图3-13 树和鱼各自脱离了自己的生存环境，以透叠的手法组织在一起，使人仿佛置若梦境

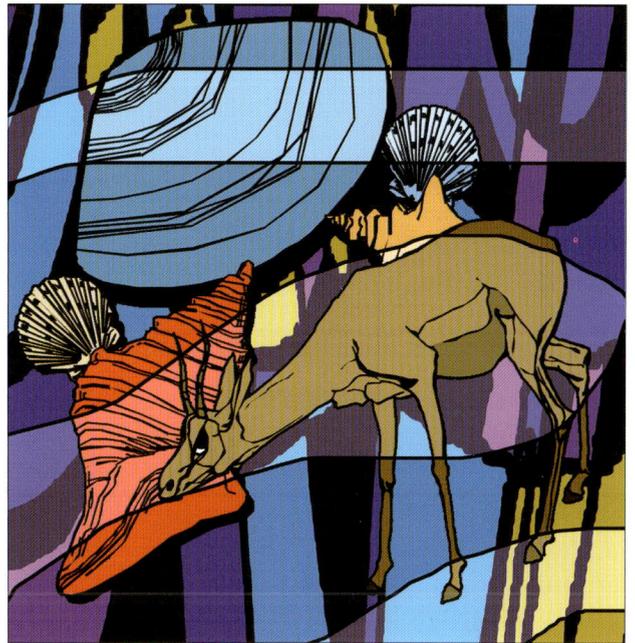

图3-14 超自然与同构图例一

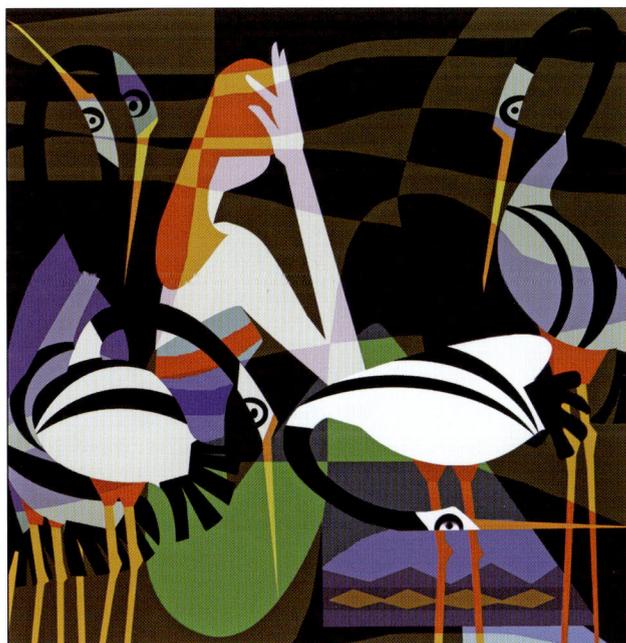

图3-15 超自然与同构图例二

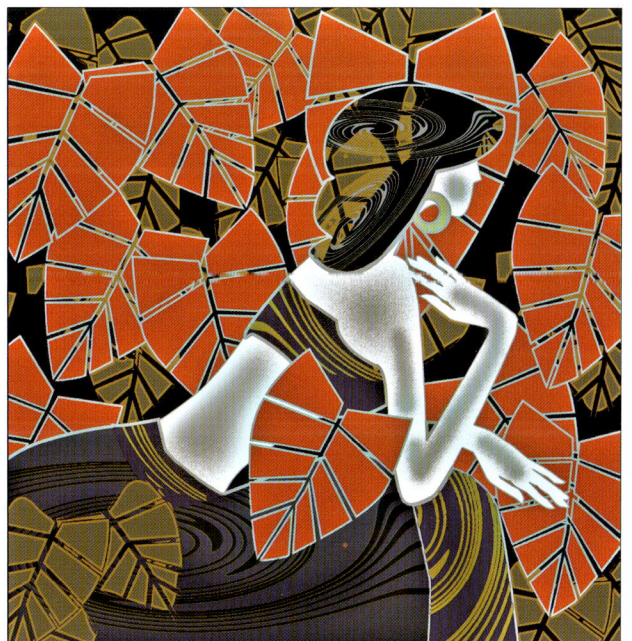

图3-16 超自然与同构图例三

3.7 改写与重组

改写与重组是指将原有的作品加以重组和改写，赋予其新的表现语言，使画面体现装饰的特点（图3-17、图3-18）。

3.8 打散与分割

先将完整的对象进行分割和打散，再重新组织这些不完整的形象，使其既包含原始对象的特点又体现新的形式感受（图3-19、图3-20）。

图3-17 改写与重组图例

图3-19 打散与分割图例一

图3-18 利用了图3-17的所有造型与色彩元素，按照理想的状态进行重组，给人以似曾相识的感觉

图3-20 打散与分割图例二

3.9 其他艺术作品的借鉴

　　从其他优秀艺术作品，如绘画、摄影中吸取精华，分析比较其中的造型方法、构成形式及表现技法等，为图案变化注入新的活力（图3-21、图3-22）。

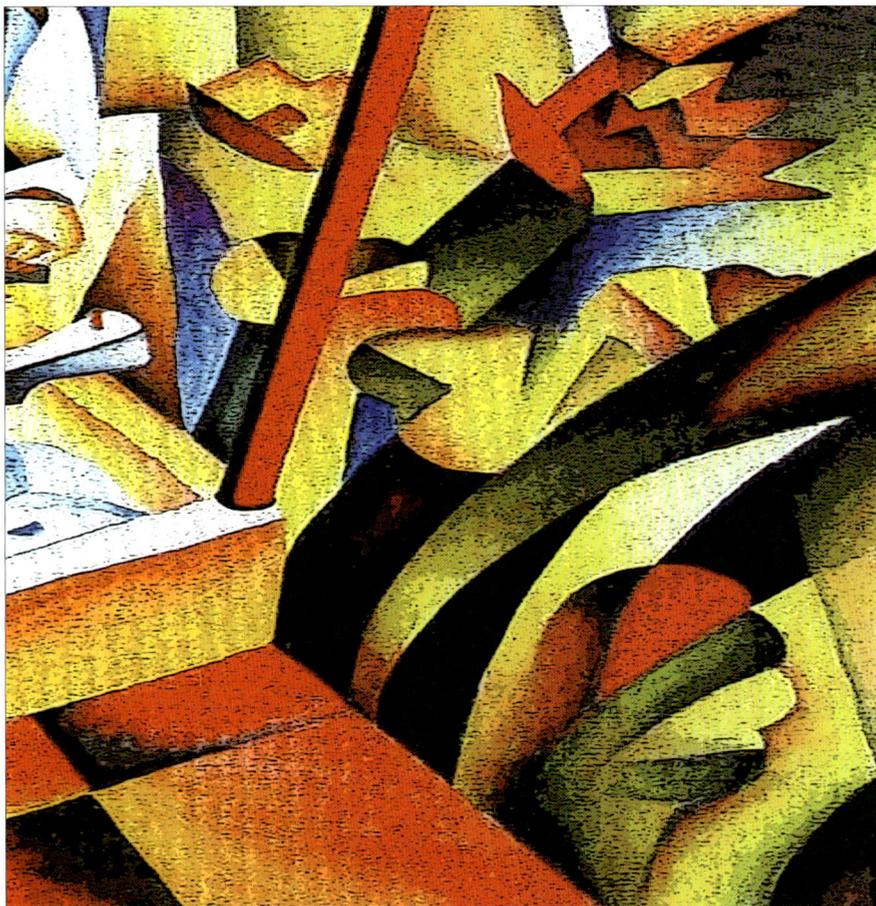

图3-21 借鉴绘画艺术图例一

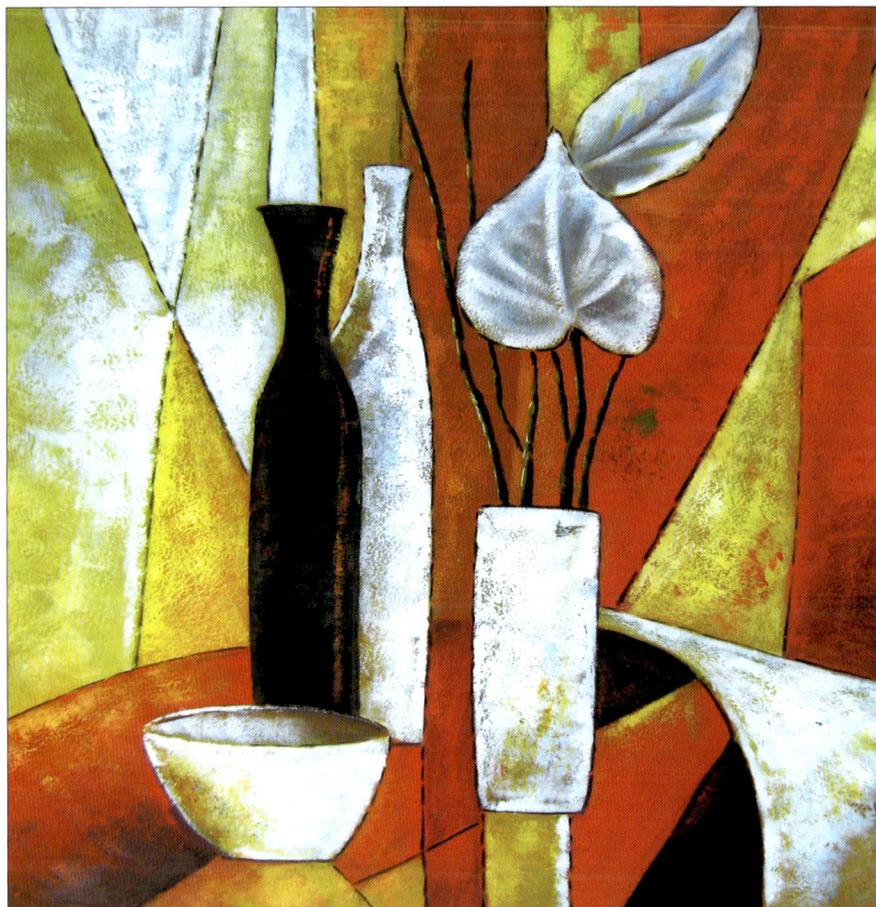

图3-22 借鉴绘画艺术图例二

3.10 电脑技术的应用

　　随着科学技术的迅速发展，新工艺、新材料在不断地出现，尤其是电脑在艺术设计领域中的应用，为装饰图案表现力的拓展提供了更多的可能性，图案变化的表现技法也由于电脑的使用而更加丰富多彩（图3-23、图3-24）。

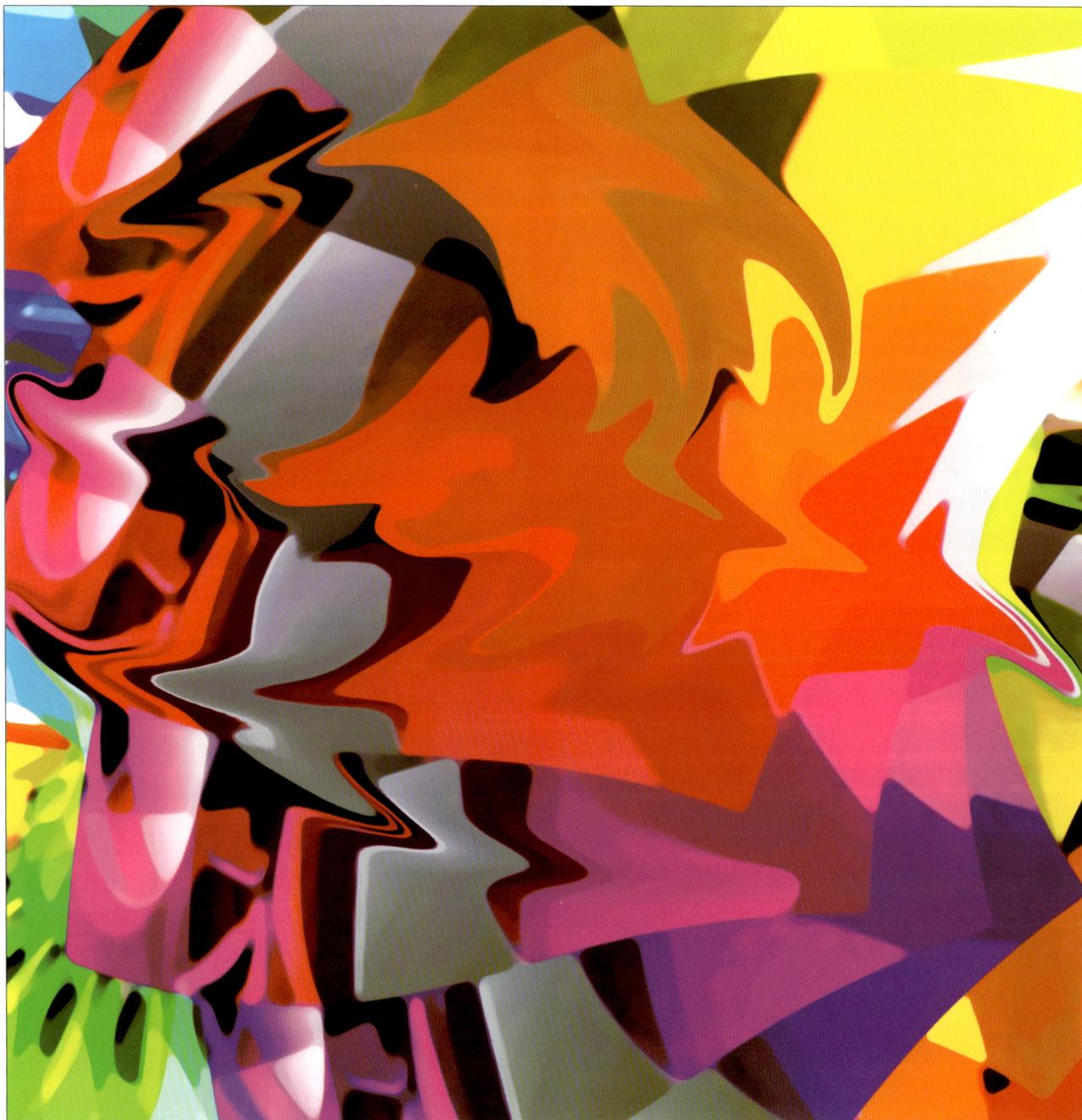

图3-23 电脑绘图软件制作图例一

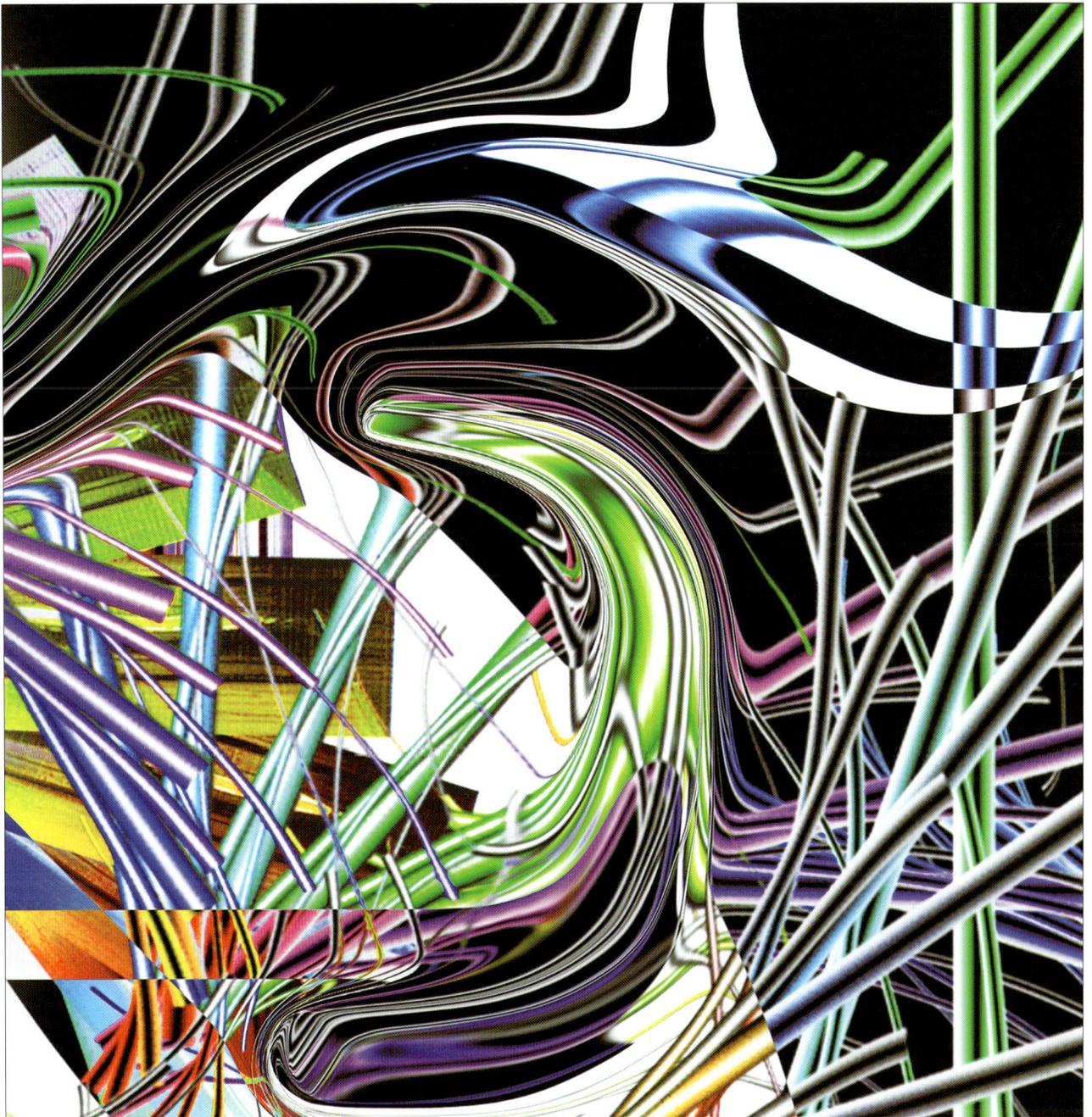

图3-24 电脑绘图软件制作图例二

第4章 图案的构成形式

图案的构成形式除了受作者的主观感受影响外，通常还取决于装饰的对象、目的、材料、制作工艺等因素。从总体上讲，图案的构成形式可分为单独纹样、适合纹样、连续纹样、综合构成四大类。

4.1 单独纹样

单独纹样是指可以单独存在、具有相对独立性的纹样。它不受外轮廓和形状的限制，但要求图案形象完整，从形态到结构不能残缺。这种纹样可以根据构图的需要自由安排。单独纹样的构成方式有对称式和均衡式两种。

4.1.1 对称式

对称式也称均齐式，是以假设的中心轴或中心点为对称依据，图案结构严谨丰满、工整规则。可分为左右对称、上下对称、三面对称、四面对称、多面对称等。再细

分又可分为绝对对称和相对对称两种组织形式。

4.1.1.1 绝对对称

绝对对称是指对称的双方形状和色彩完全相同。按对称角度的不同，一般有左右对称、上下对称、旋转对称三种形式。给人以严肃、稳定的感觉。

4.1.1.2 相对对称

相对对称是指纹样总体外轮廓呈对称状态，但局部存在形或量的不等变化，具有动静结合、稳中求变的新鲜感（图4-1、图4-2）。

4.1.2 均衡式

又称平衡式，均衡式构图形式比较活泼，不受中心轴或中心点的制约，可以自由地进行组织安排。纹样的形象虽不对称，但量感、大小、色调等在布局中保持了平衡感。这种图案风格灵活多变且有较强的运动感（图4-3、图4-4）。

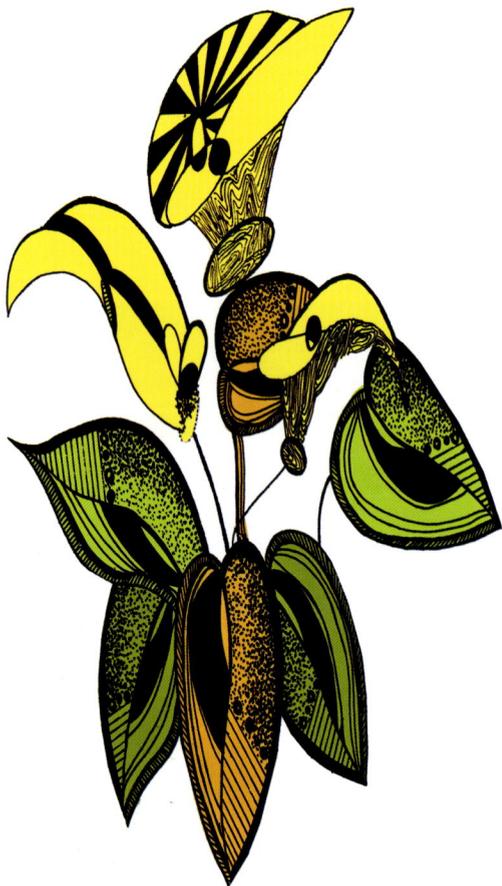

图4-1 相对对称式单独纹样

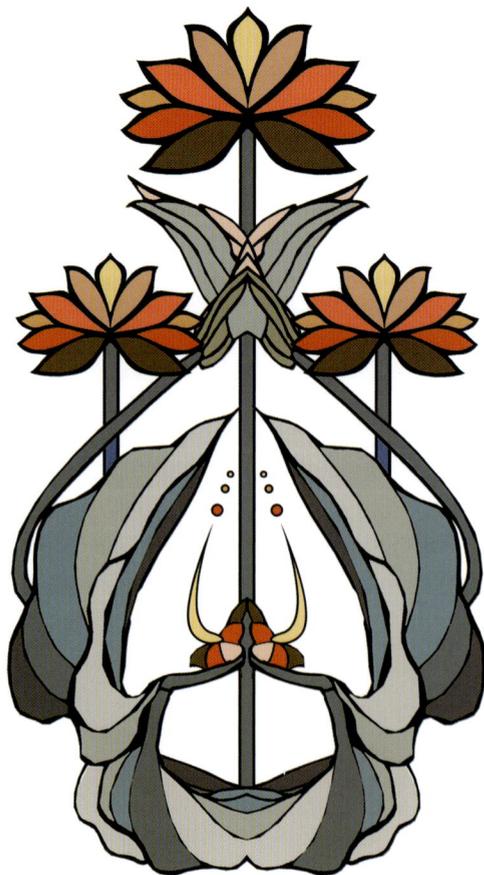

图4-2 绝对对称式单独纹样

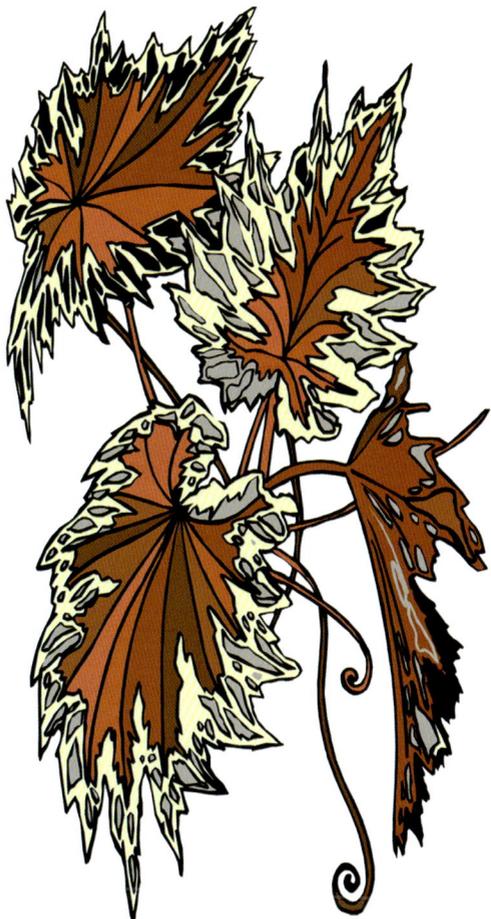

图4-3 均衡式单独纹样一

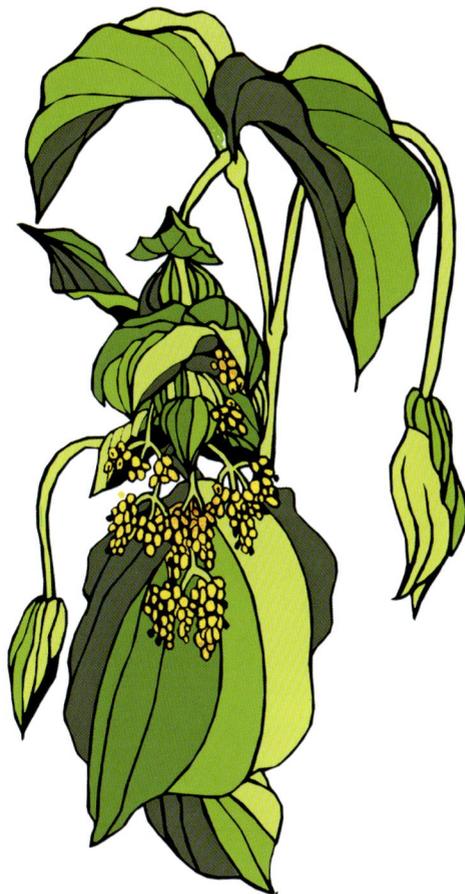

图4-4 均衡式单独纹样二

4.2 适合纹样

适合纹样是与一定的外轮廓相适应的，属于单独纹样的范畴。常独立应用于造型相应的工艺美术装饰上。适合纹样的组织结构与布局要求均齐平衡、主次分明、疏密得当、构图完整，在适合形中求变化。

适合纹样有均齐式、均衡式、边角适合、格律体等几种形式。均齐式一般从中心开始，分几个相等的单元区域。首先完成一个单元纹样，再复制到其他单元使用。适合纹样和单独纹样的均衡式，在构图上都可以自由地进行组织安排，但不同之处在于适合纹样中要适合特定的外形。格律体是以几何骨骼为依据，利用米字格、九宫格的对角线、经纬线，创造出丰富多彩且又格律严谨的图案。

从外形上看，适合纹样可归纳为几何形、自然形和人造形三种形式。常见的几何形有方形、圆形、三角形、多边形等；自然形有梅花形、海棠形、桃形、葫芦形等；人造形有器具形、建筑形、家具形、服装形等（图4-5、图4-6、图4-7、图4-8、图4-9、图4-10、图4-11、图4-12）。

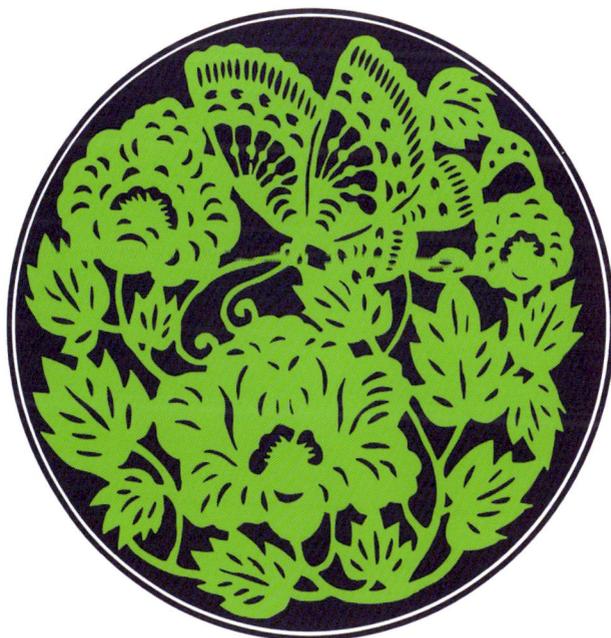

图4-5 均衡式适合纹样的设计制作要注重色彩的配合，要把握好单元与单元之间的统一性、均衡性和整体效果

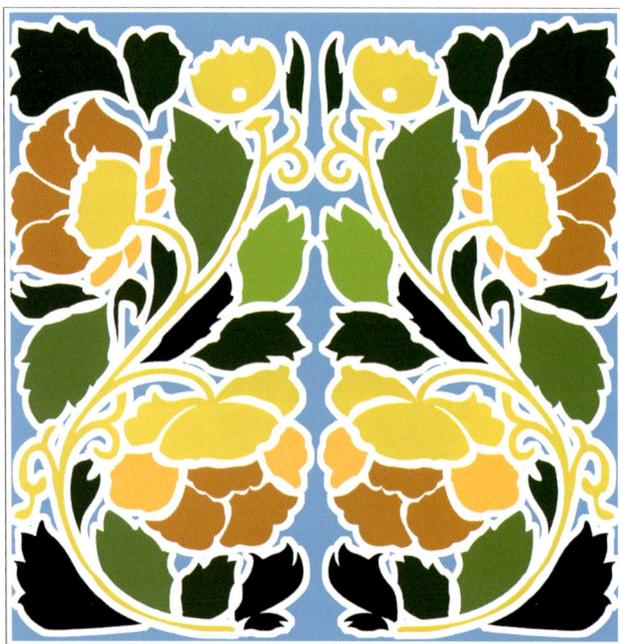

图4-6 对于外形严谨的几何形适合纹样，要注意用一个或数个不同的形象填满一定的外轮廓，其形象自然地随外形而变

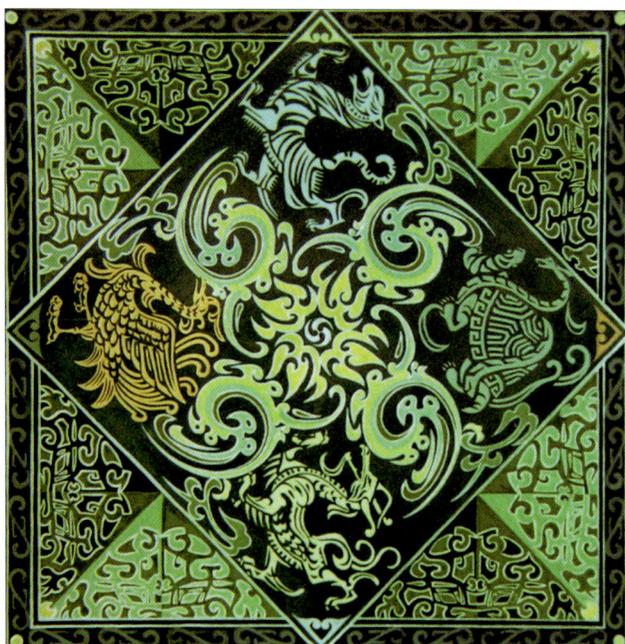

图4-7 适合纹样单纯明确、优美完整，常用于建筑、园艺、陶瓷、服饰、商标、标志等上面。但要注意空间分隔得体及整体的平衡感

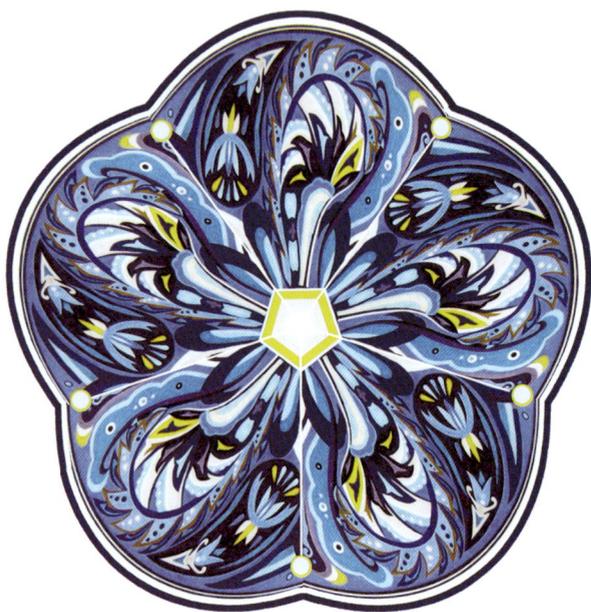

图4-8 梅花形适合纹样

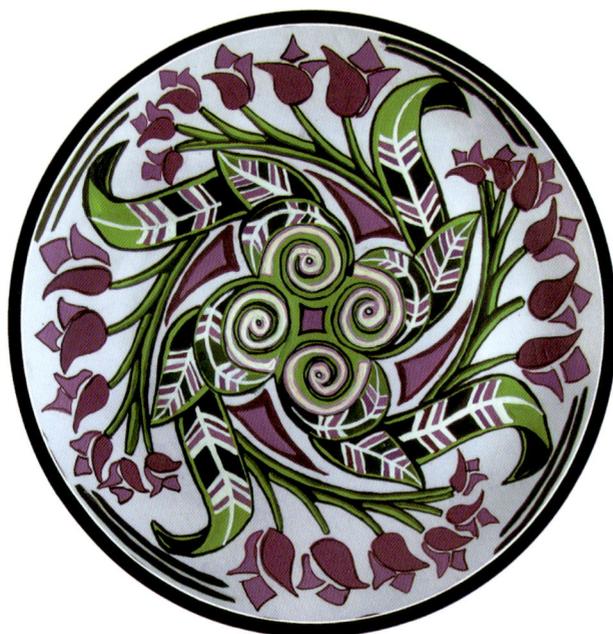

图4-9 圆形适合纹样

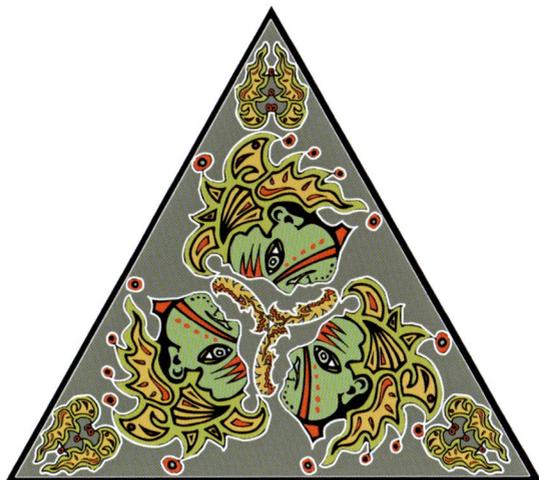

图4-10 角隅形适合纹样是指与角的形状相适合，受到等边或不等边的角形限制的装饰纹样。它可用于一角、对角或多角装饰上。除内部纹样要随角形而变外，角尖端外形亦可作变化

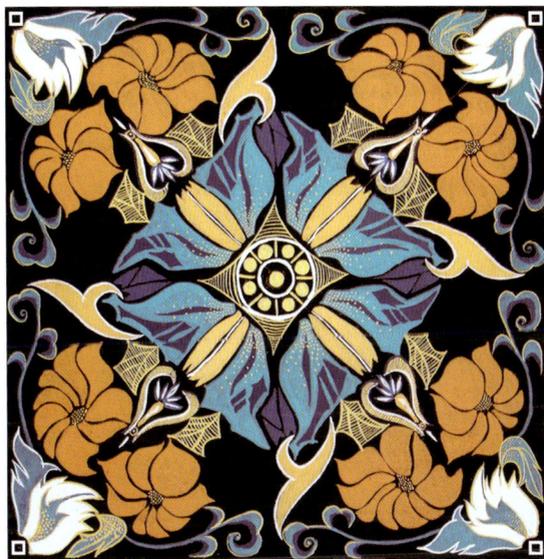

图4-11 方形适合纹样

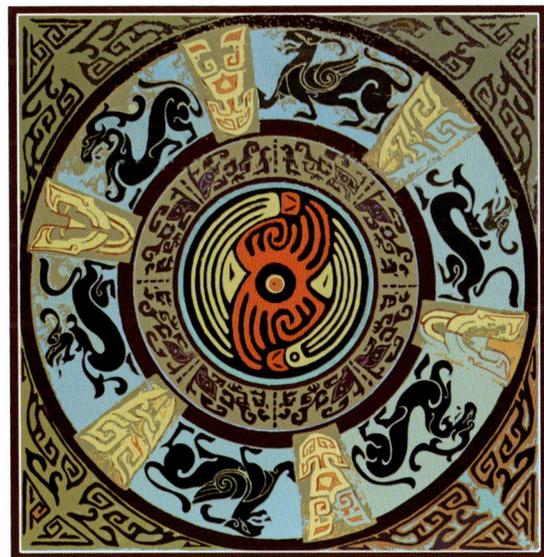

图4-12 圆方结合形适合纹样

4.3 连续纹样

连续纹样分为二方连续和四方连续。

4.3.1 二方连续纹样

二方连续是指一个单元纹样经过上下或者左右的连续排列，可无限延长和伸展的连续性纹样。上下连续为纵式，左右连续为横式。其特点是通过纹样的反复组合产生优美的节奏感和韵律感。设计时要仔细推敲单位纹样中形象的穿插、大小错落、简繁对比、色彩呼应及连接处的处理。二方连续广泛用于建筑、书籍装帧、包装带、服饰边缘、装饰间隔等。二方连续按照基本骨式的变化，分为以下四种组织形式（图4-13、图4-14、图4-15、图4-16）。

4.3.1.1 散点式

采用完整而独立的单独纹样，以散点的形式来分布，纹样之间没有明显的连接形象。有简洁明快的特点，但易显得呆板生硬。

4.3.1.2 波线式

单位纹样之间以波浪状曲线起伏作为连接，形式流畅自由。

4.3.1.3 折线式

具有明显的向前推进的运动效果，连绵不断。单位纹样之间以折线状转折作连接。直线形成的各种折线边角明显，刚劲有力。

4.3.1.4 几何连缀式

单位纹样之间以几何形（圆形、菱形、多边形等）相交接的形式作连接，分割后产生强烈的面的效果。设计时要注意正形、负形面积的大小和色彩的搭配。

4.3.2 四方连续纹样

四方连续是指由一个或几个单位纹样，向上下左右反复排列而形成的连续性图案。在设计时，除了要注意单位纹样本身，更重要的是如何根据连续的方向设计单位纹样的接口，这是产生连续效果的关键。连续得自然与否、紧凑与否、流畅优美与否，都与它息息相关。另外，还要注意单位纹样之间连接后不能出现太大的空隙，以免影响大面积连续延伸的装饰效果。四方连续纹样广泛应用在纺织面料、室内装饰材料、包装纸等上面。四方连续按照基本骨式的变化，分为以下三种组织形式（图4-17、图4-18、图4-19）。

4.3.2.1 散点式

以一个或多个单独纹样，在连续纹样中作均衡分布。特点是主题比较突出，形象鲜明。但在组织上要注意单位纹样的方向和大小的变化，以免过于单调呆板。

图4-13 综合式二方连续

图4-14 波纹式二方连续

图4-15 折线式二方连续

图4-16 散点式二方连续

4.3.2.2 连缀式

一般以线条或块面连接在一起，纹样连绵不断，有着强烈的连续效果。常见的有波线连缀、菱形连缀、阶梯连缀、几何连缀等。

4.3.2.3 重叠式

是两种以上不同的纹样相互重叠应用的一种形式。它们分别称为"浮纹"和"地纹"。"浮纹"为主要表现纹样，"地纹"则用于衬托。应用时要注意以表现浮纹为主，地纹尽量简洁，以避免层次不明、杂乱无章。

4.4 综合构成

综合构成是指按照一定的工艺条件、功能要求和审美需要，把多种构成方法综合运用到一个完整的构图中。综

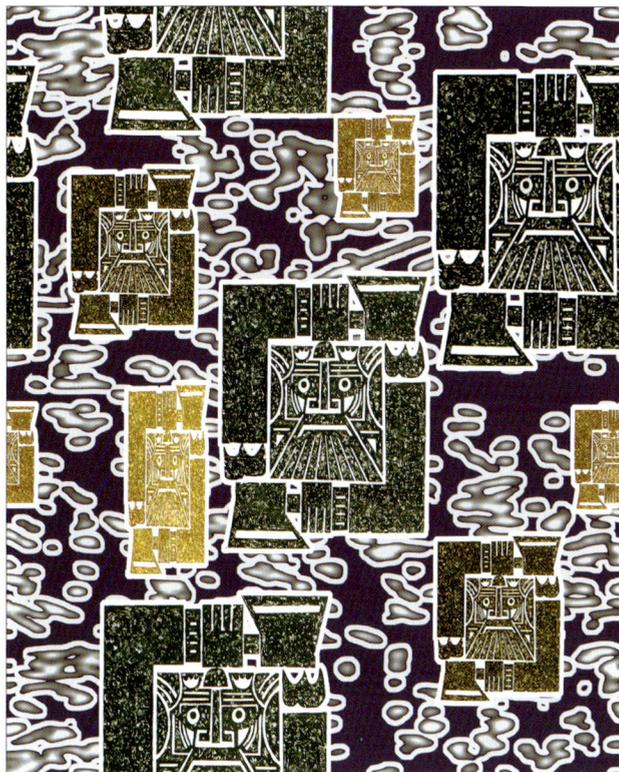

图4-17 散点式四方连续

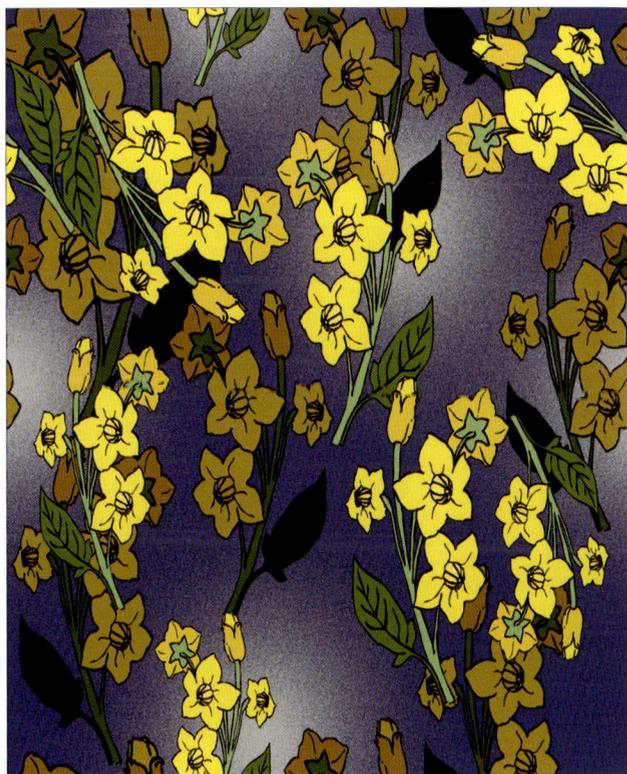

图4-18 纹样分布可以较均匀齐整、有规则，也可自由、不规则。但要注意的是，单位空间内同形纹样的方向可作适当变化，以免过于单调呆板

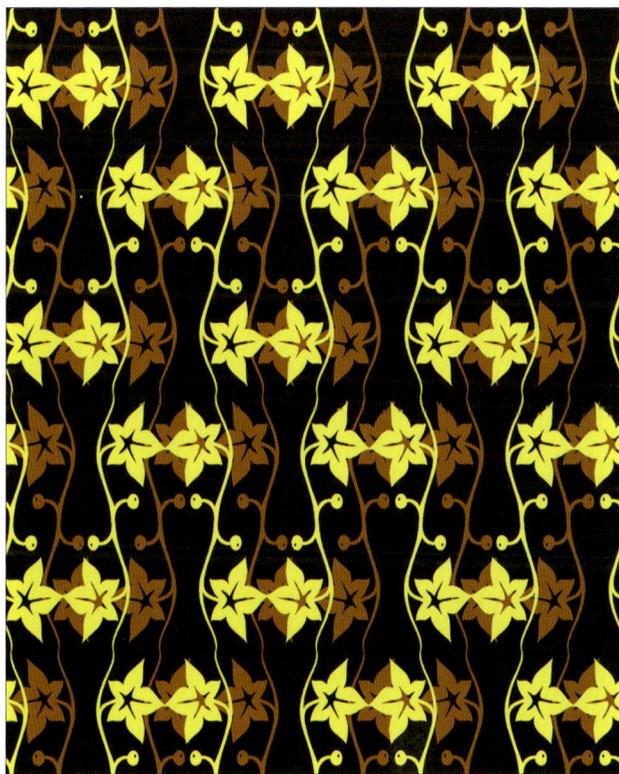

图4-19 连缀式四方连续

合构成形式多样，常见的有格律体、平视体和立视体（图4-20、图4-21、图4-22）。

4.4.1 格律体构图

格律体构图是指以九宫格或米字格作骨式基础的构图，既具有结构严谨、和谐稳定的程式化特征，又具有骨式变化多样、不拘一格的情趣。

4.4.2 平视体构图

平视体构图是指画面不受透视规律限制，形象一般表现侧面，简练单纯，不刻意追求空间的纵深层次，犹如剪纸效果。

4.4.3 立视体构图

立视体构图是指运用中国传统画中散点透视的原理，以"前不挡后""大观小"和"蒙太奇"的手法自由组合的构图。可产生一览无余的立体化画面效果，在传统壁画风景图案中运用较多。

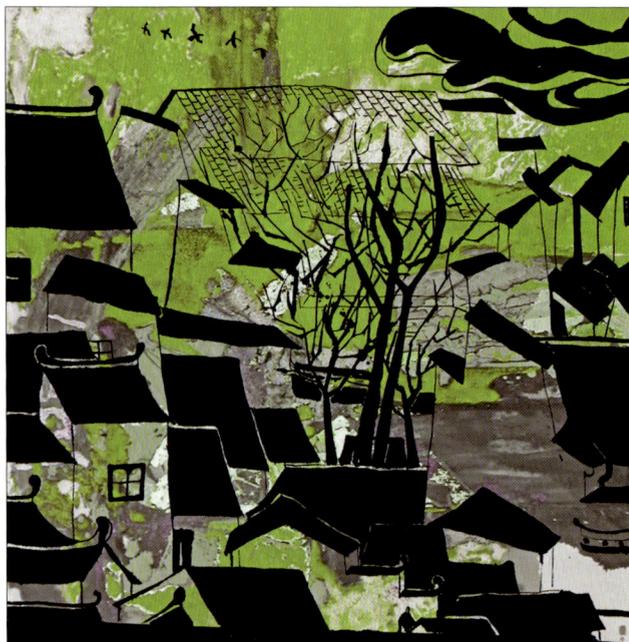

图4-20 平视体构成

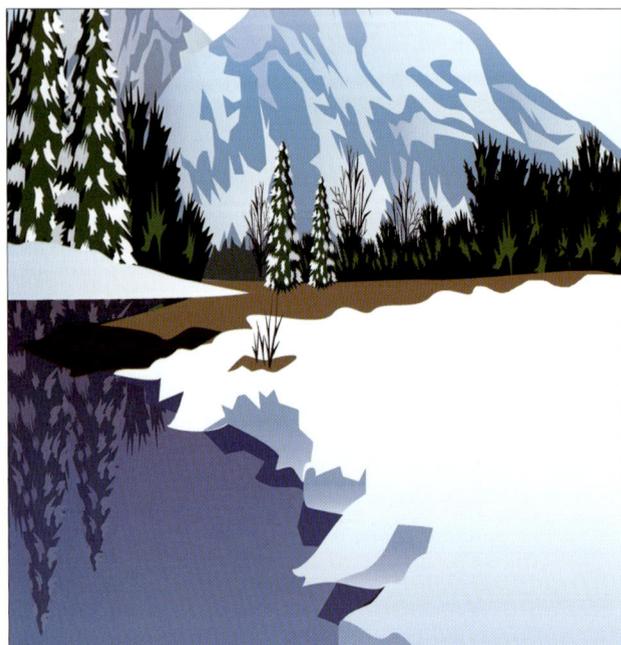

图4-21 立视体构成

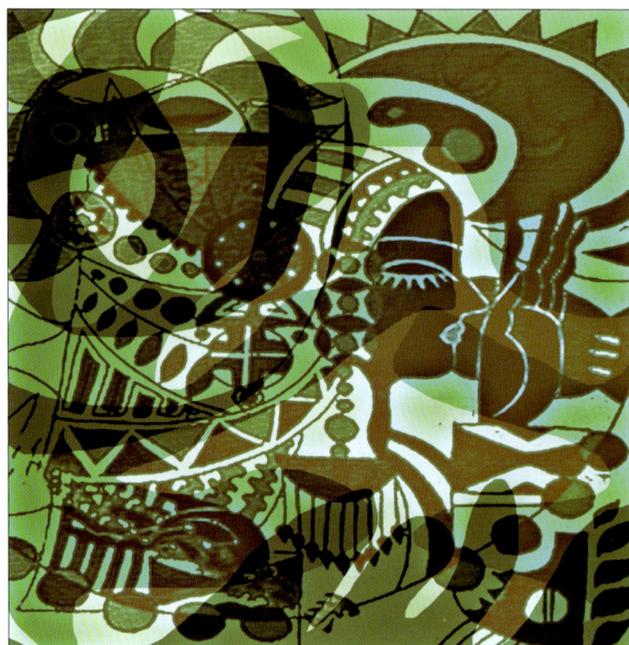

图4-22 格律体构成

第5章 图案中点、线、面的应用与色彩配置

5.1 图案中点、线、面的应用

5.1.1 点

点在图案设计中起着重要作用，点可以构成纹样中的线，也可以组成纹样的面。用点可以再现图案的明暗、深浅和层次，效果细腻、精美。点的形状有规则形、自由形；点的组织有疏密、大小、轻重、虚实的变化。不同的点具有不同的装饰效果（图5-1）。

5.1.2 线

线在图案表现中的使用是颇为广泛的。线有直线和曲线之分；有粗细、轻重、强弱之变化；还有枯笔、润笔、抖笔之效果。线有着丰富表现力，对于不同内容的纹样，可选用不同形式的线来表现。（图5-2）

5.1.3 面

面有形状、大小与虚实变化，有正形与负形之分。用点、线组成的面，丰富而有变化，用块面表现的面，充实而有力。

5.1.4 点、线、面综合应用

图案的变化是丰富多样的，表现手法也不只限于点、线、面的独立运用，往往是将三种形式结合在一起综合运用，以表现层次、对比等各种变化，形成丰富生动的画面效果（图5-3、图5-4）。

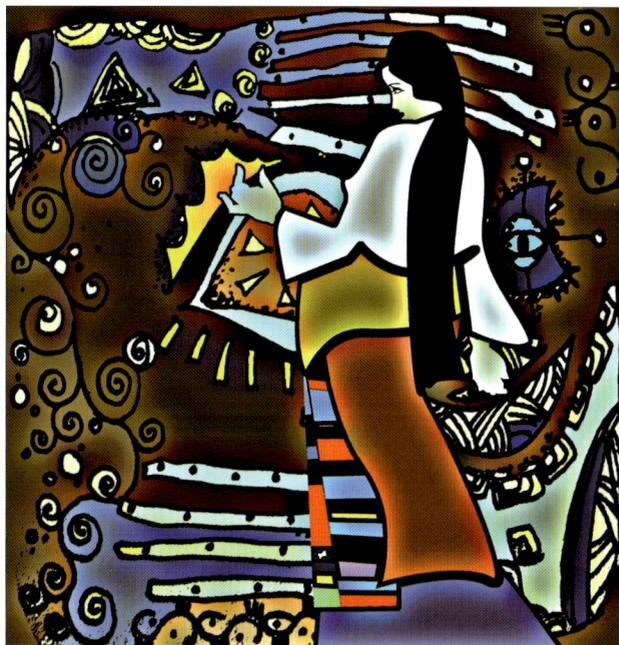

图5-1 用长短不一的线组成大小不同的面，通过叠加、重复、对比的构成形式有机的组织在一起

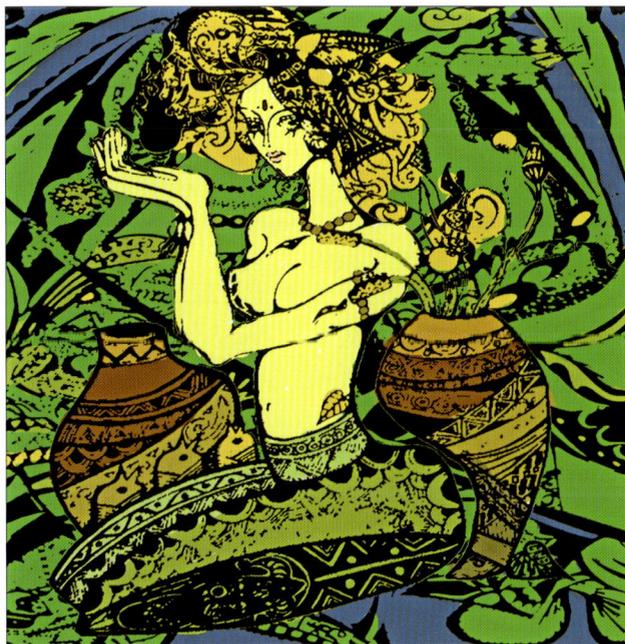

图5-2 形象是物体的外部特征，是可见的。形象包括视觉元素的各部分，所有的概念元素如点、线、面在见于画面时，也具有各自的形象

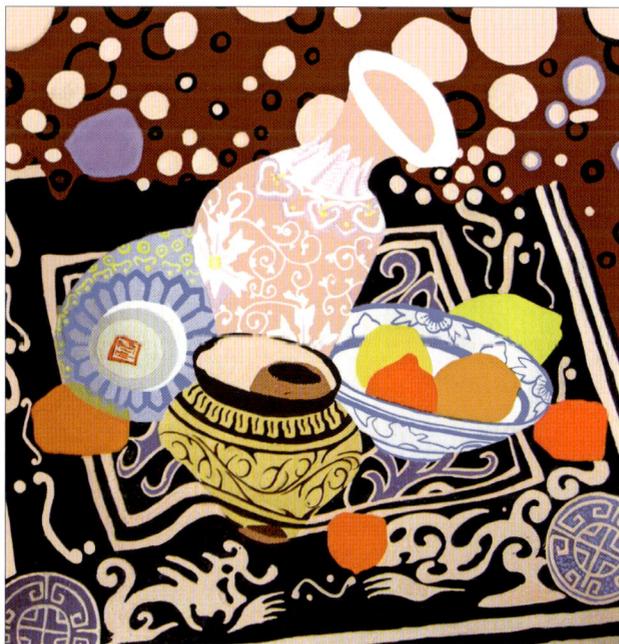

图5-3 利用各种点的特性，大点形成面，小点连成线。层次分明、主题突出

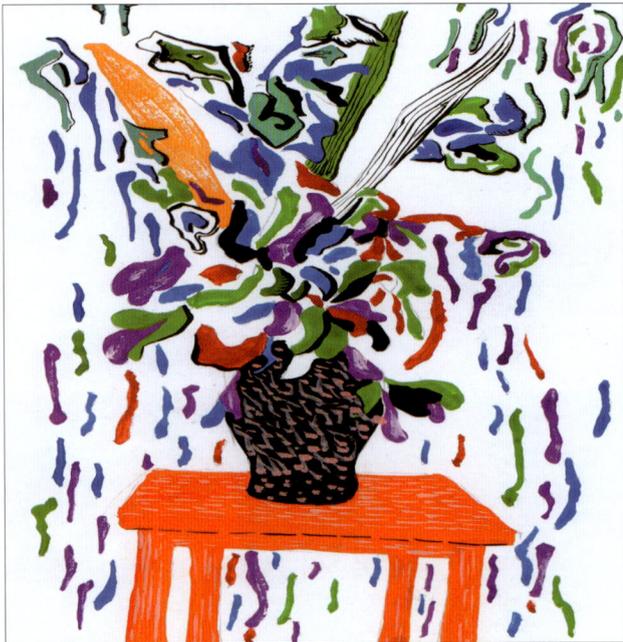

图5-4 点、线、面综合在一起，表现力更强、层次也更加丰富

5.2 图案的色彩配置

　　运用适当的、不同的色彩来制作图案，可以使图案的效果更加丰富，形式美感更强。色彩是图案语言的重要组成部分，总结起来有以下两个特点：第一，用色有一定的限量。这是因为装饰本身需要高度的概括与提炼，要用有限的色彩表现丰富的物象。另外，考虑到图案的应用目的，图案设计有时要与不同的生产工艺相结合，用色过多会导致成本过高和增加工艺难度。第二，图案的色彩可以根据装饰需要任意设定，不必考虑真实的自然色彩，红花绿叶可以画成黄花蓝叶，碧水青山可以绘成玄水橙山。夸张的色彩和色调处理，是图案色彩的魅力所在。

　　图案的色彩强调归纳性、统一性和夸张性，尤其注重对整体色调的设定。我们可以从以下几方面掌握其配置方法：

5.2.1 确定图案基本色调

　　图案的色调是指一幅画面总的色彩倾向。色调可以是纯色调或灰色调、亮色调或暗色调，也可以是冷色调或暖色调，或是有单色倾向的色调（如：红色调、绿色调、黄色调等）。在调配一幅图案的颜色之前，首先要对图案的色调有一个总体的构想，确定大的色彩基调，具体的颜色搭配都应与基调的构想相符与呼应。颜色的面积比例关系对色调起着至关重要的影响。色调是具有很强表现力的视觉化语言，是最易通过人的视觉去感染情绪的。对比强烈

　　的色彩和其明暗关系会起到刺激和兴奋的作用；柔和的暖色调会适合大多数人的视觉心理需求，因它更能传达出温和、慈爱的信息；偏冷的色调宛如清风拂面般给人以宁静感，更易营造神秘的气氛。遵循色彩与视知觉的一般规律才能更准确地运用色调语言（图5-5、图5-6）。

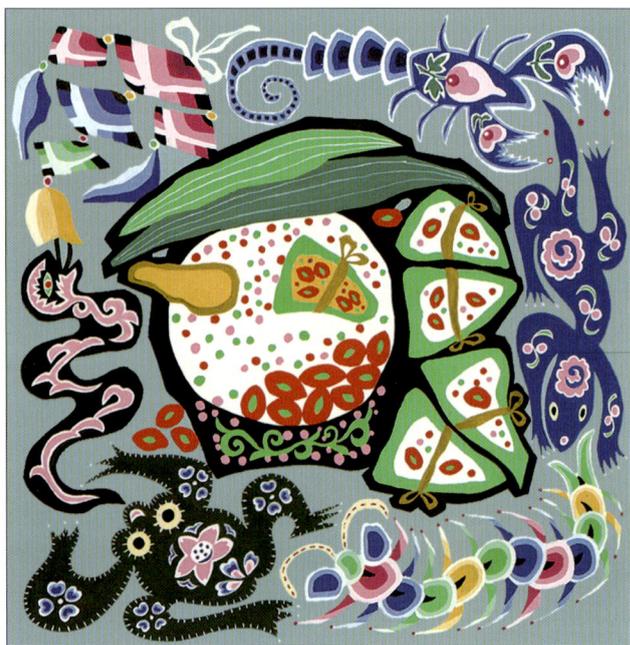

图5-5 冷色调图例

图5-6 暖色调图例

5.2.2 调和色的配置

调和色包括同类色和邻近色，这类色彩的色相差别小，对比弱。比较容易达到和谐的效果（图5-7、图5-8、图5-9、图5-10）。

5.2.2.1 同类色

指有单一色相系列的颜色，如：黄色系或绿色系等。

使用同类色的图案，效果协调柔和，但也容易使画面显得平淡和单调。同类色在运用时可加大色彩明度和纯度的对比，使画面丰富起来。

5.2.2.2 邻近色

指色相环上相邻（夹角小于90°）的颜色，如：黄色与绿色，蓝色与紫色等。邻近色容易达到调和，与同类色相比，色彩的变化更为丰富。

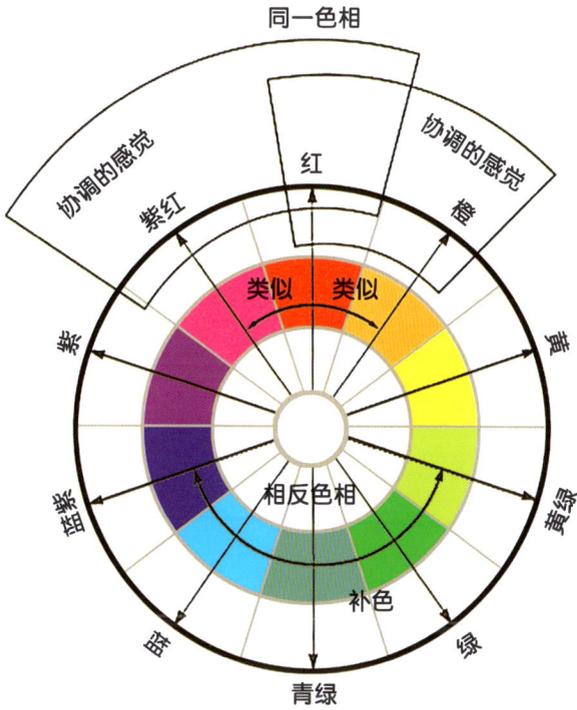

图5-7 色相环

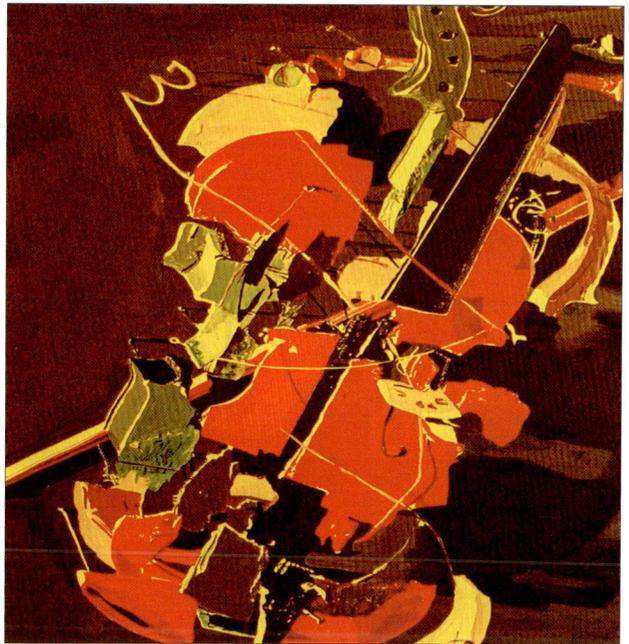

图5-8 邻近色配置

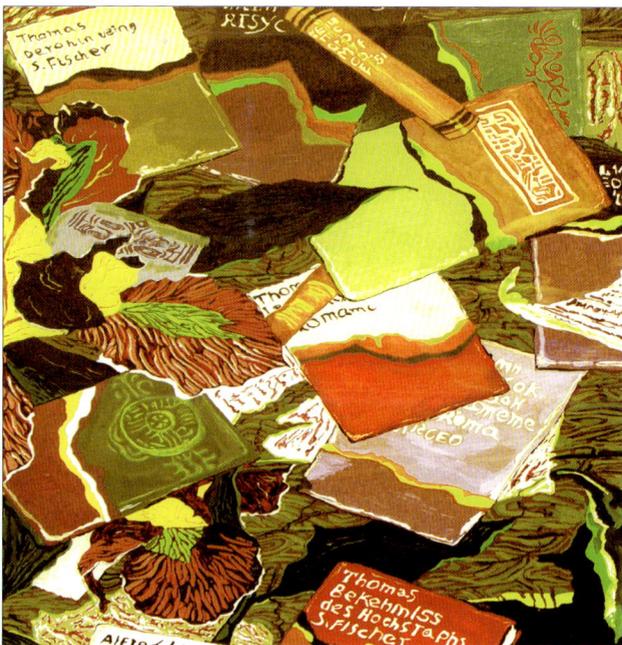

图5-9 同类色配置

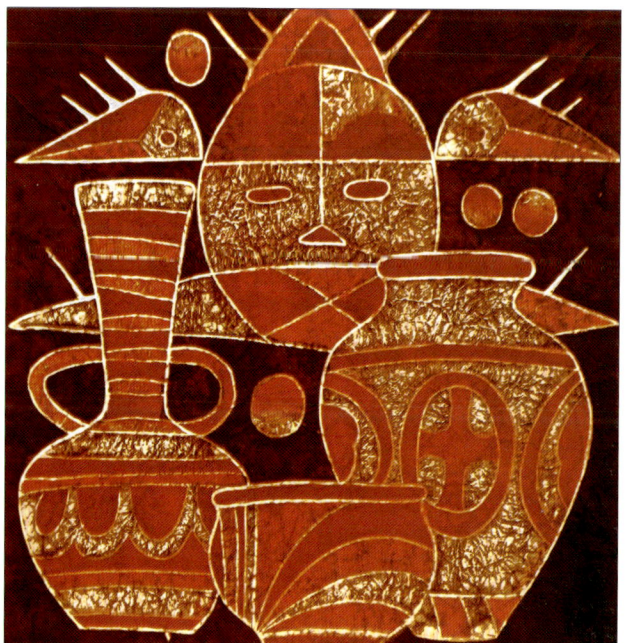

图5-10 同类色配置

5.2.3 对比色的配置

　　对比色是指色相环上的120°以外的颜色。其中处于180°相对应的两色叫补色，对比最为强烈。对比色效果活泼、变化丰富，但在应用时要注意色彩的调和与统一。可以采用以下的手法协调画面（图5-11、图5-12、图5-13、图5-14）。

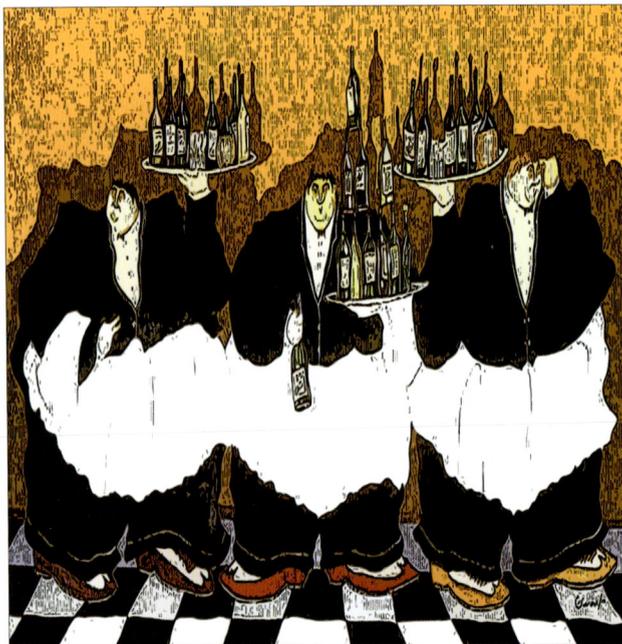

图5-11 黄、褐色作为主色，大面积使用，其他对比色蓝、紫为辅色，少面积点缀，使对比减弱，达到画面调子的统一

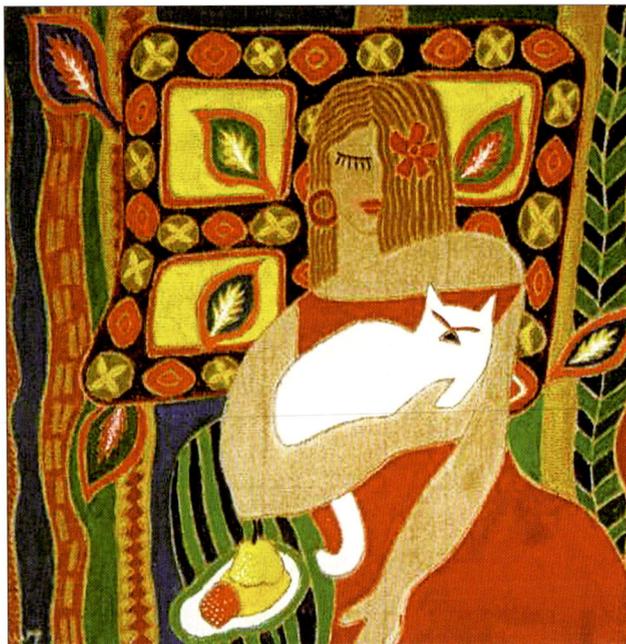

图5-12 降低了绿色系的纯度，使色彩变得含蓄温和，达到了既变化丰富又和谐统一的效果

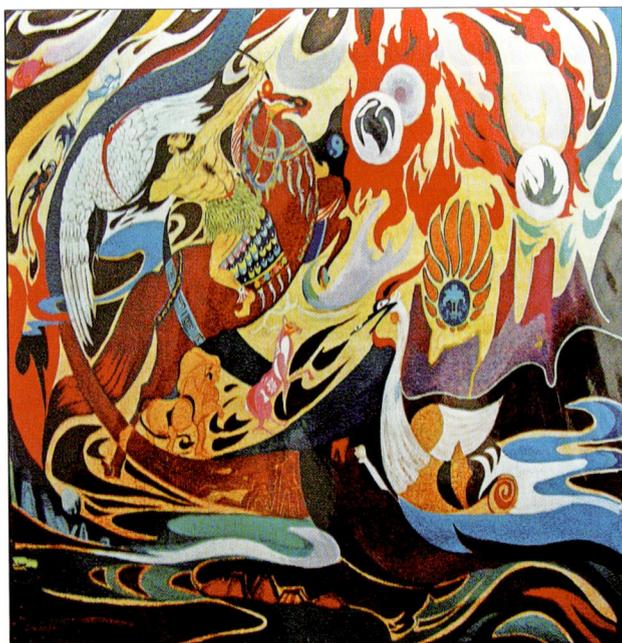

图5-13 运用黑、白两色将对比间隔开，既达到协调统一，又不失对比关系

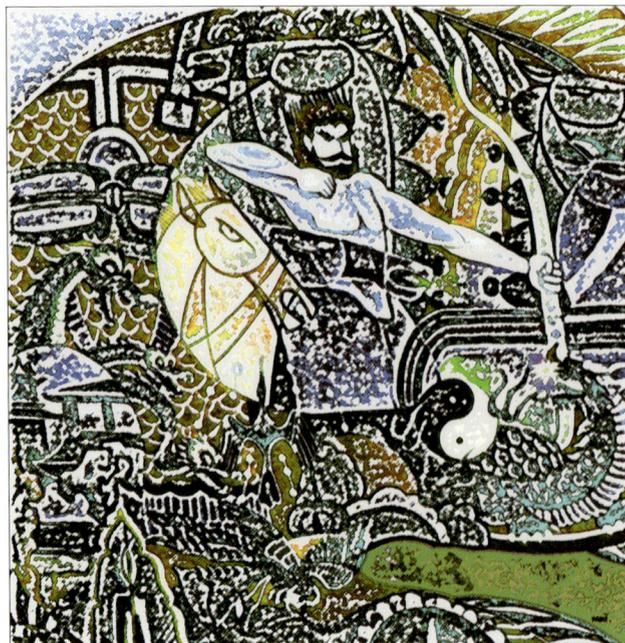

图5-14 将对比色分成小面积并置使用，类似空间混合的手法，使色彩远看能混合成一体，从而达到统一

5.2.3.1 降低纯度

对比色在颜色纯度较高时对比较为强烈，如果将对比色一方或几方纯度降低，比如加人灰色或将对比色彼此少量互调，可使色彩变得含蓄温和，达到既变化丰富又和谐统一的效果。

5.2.3.2 面积的调整

对比色在面积较大而均等时往往对比最为强烈，如果将一种对比色作为主色，大面积使用，其他对比色为辅色，少面积点缀，可以使对比减弱，达到统一。另外，也可以将对比色分成小面积并置使用，类似空间混合的手法，使色彩远看能混合成一体，从而达到统一。

5.2.3.3 无彩色的调和

在对比色配置中运用黑、白、灰、金、银等，将对比色间隔开，是使对比色达到协调统一的极有效的手法。

5.2.3.4 色彩渐变

选择两个对比色之间的系列色相与对比色同时使用，如在使用橙色与蓝色的同时，使用黄橙、黄、黄绿、绿、蓝绿等色，并将它们秩序化排列，使对比色产生渐变的效果，达到和谐统一。

5.2.4 借鉴艺术作品的色彩配置

图案的色彩也可以借鉴其他类型艺术作品的颜色搭配，有些艺术作品本身已具有非常理想的色彩效果，如：绘画、摄影、民间美术、工艺美术品等，特别是现代风格的绘画作品及民间工艺品，其色彩有很高的概括性和装饰性。

对于摄影及写实绘画作品色彩的借鉴，要特别注意归纳和提炼。因为这类作品往往颜色变化过于细腻与微妙，不太符合图案的色彩要求。另外，还要注意图案中局部与整体的色调比例关系，仔细推敲颜色的穿插及位置的安排，方能恰到好处（图5-15、图5-16、图5-17、图5-18）。

5.2.5 从自然中提取色彩

大自然中美妙的颜色配置为图案的色彩设计提供了很直观的参照。许多自然物的颜色配置可以直接提取使用，其本身就有很好的色彩搭配，有的甚至是我们主观无法设想出来的，如：石头草木、花卉昆虫、飞禽走兽及海洋生物等。在运用自然物象的色彩时，要特别注意各颜色的面积比例关系和位置关系，以保持自然色彩原有的整体感。如果忽视这一因素，将某种颜色面积使用过大或过小，或将某种特有的颜色位置关系打乱，就会改变色彩原有的色调，无法达到我们所期望的色彩效果（图5-19、图5-20、图5-21、图5-22）。

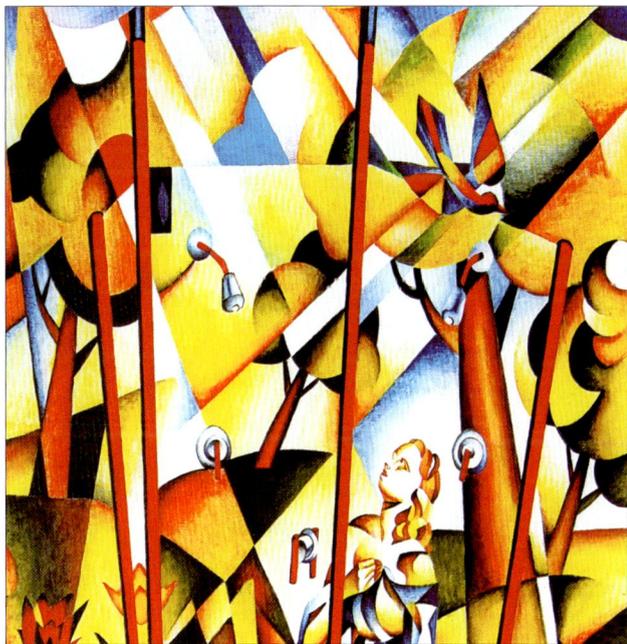

图5-15 借鉴绘画艺术配色一

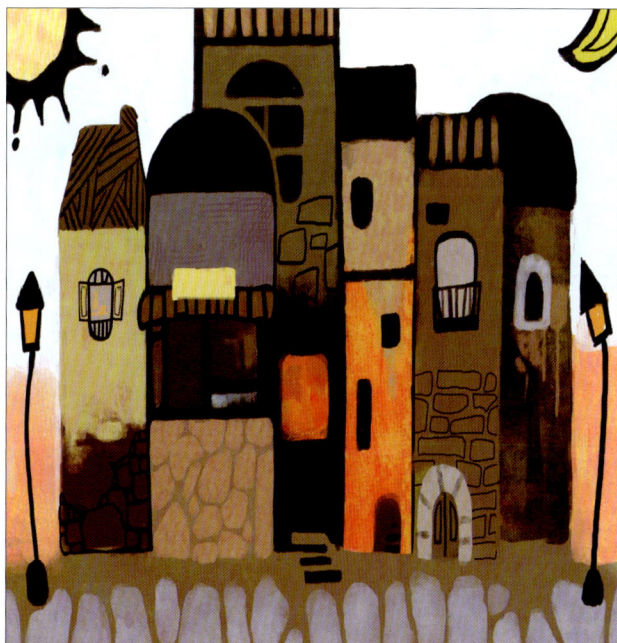

图5-16 借鉴摄影艺术配色二

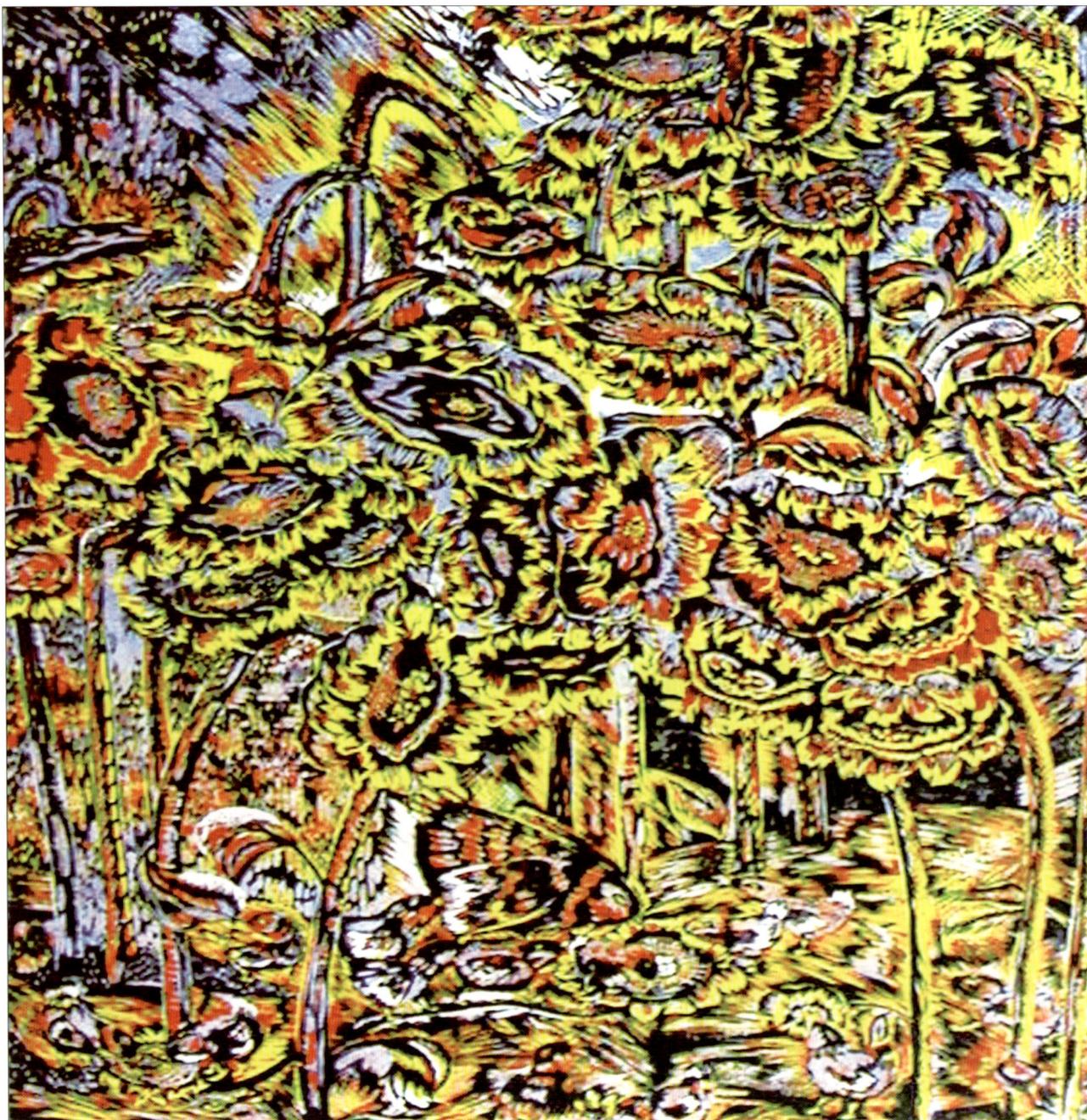

图5-17 借鉴绘画艺术配色三

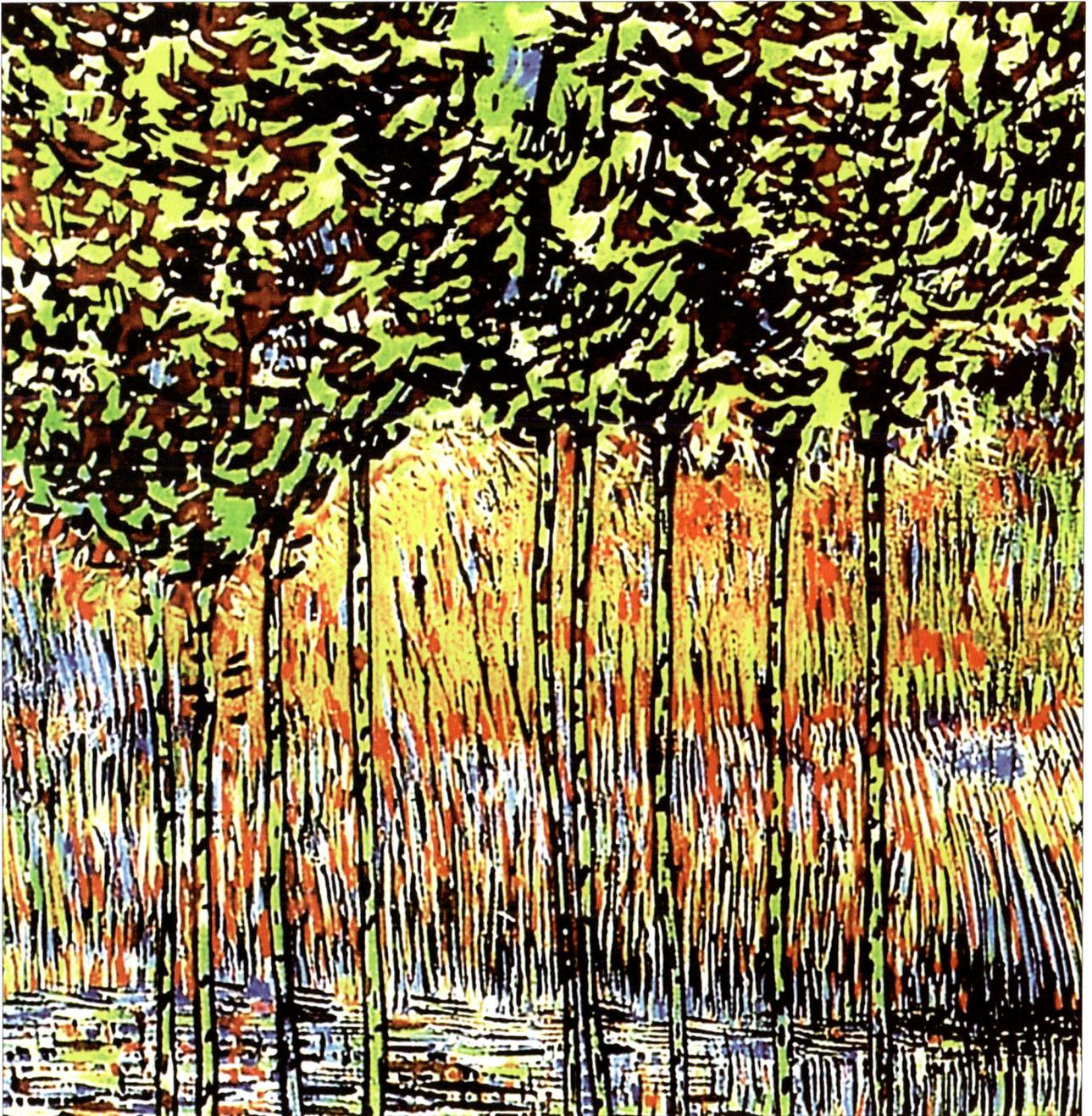

图5-18　借鉴绘画艺术配色四

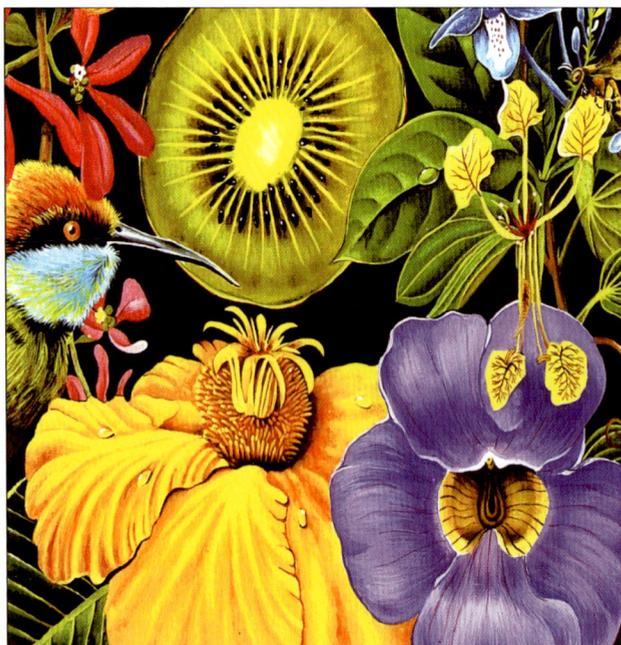

图5-19 参照自然色彩配置一

图5-20 参照自然色彩配置二

图5-21 参照自然色彩配置三

图5-22 参照自然色彩配置四

第6章 图案的表现技法

有效运用图案的表现技法，可以使图案更具魅力，并展示出与众不同的个性。图案的表现技法大致有以下几类。

6.1 套色表现技法

这是图案较传统也是最常用的一类技法。一般是先铺一个底色，然后将图案纹样转印到底色上，再用事先调好的套色一层层描绘上去，要求颜色涂染均匀、干净、平整。描绘时可采用以下的方法（图6-1、图6-2、图6-3、图6-4）。

6.1.1 平涂

运用大小不同的色块来填充纹样，主要靠色彩的面积对比和层次变化来达到画面的和谐统一。

6.1.2 平涂勾线

在平涂的基础上，用线条勾勒出纹样的轮廓结构，可以使画面更加协调，纹样更加清晰和精致。线条可以有各种形式的变化。

6.1.3 平涂点绘

在平涂的基础上，用色点绘制细部结构的变化。

6.1.4 色彩退晕

把图案纹样分成等比的单元，将渐变的系列颜色按顺序填入纹样，形成色阶变化。

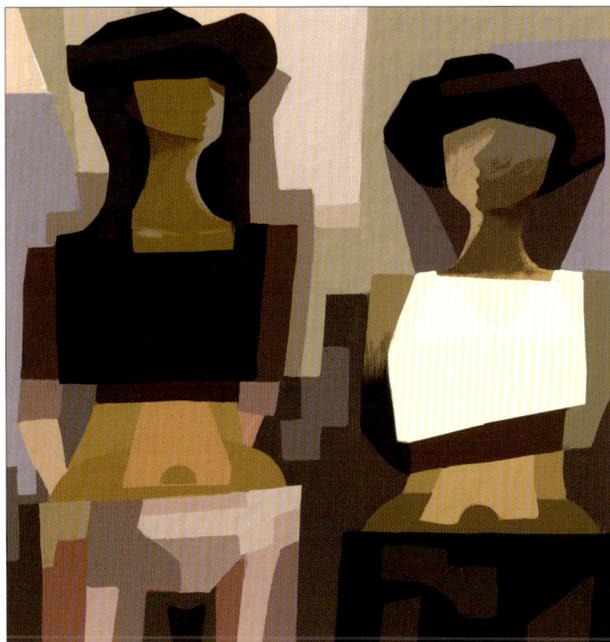

图6-2 平涂技法

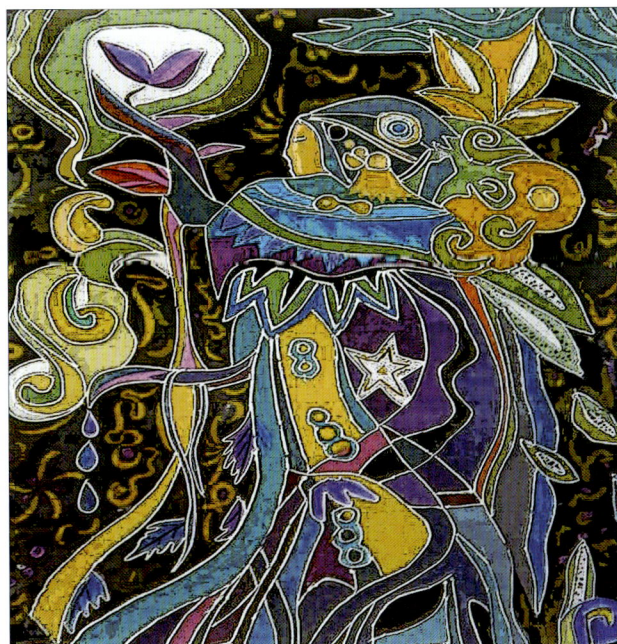

图6-1 平涂晕染加勾线

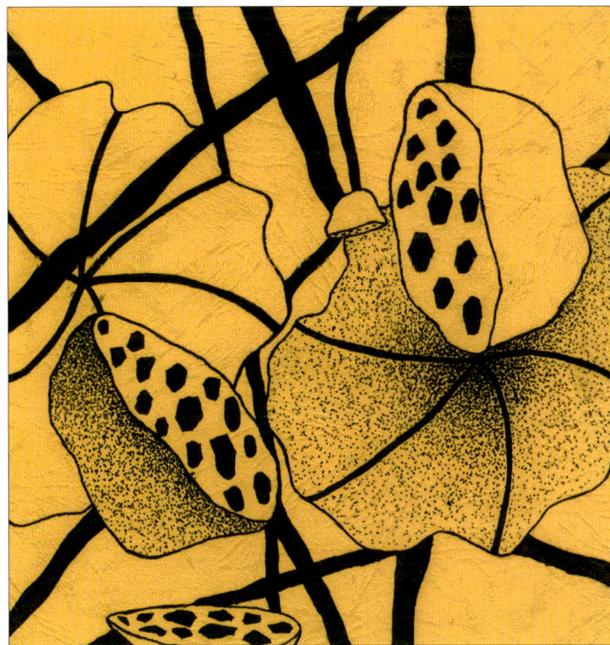

图6-3 平涂点绘

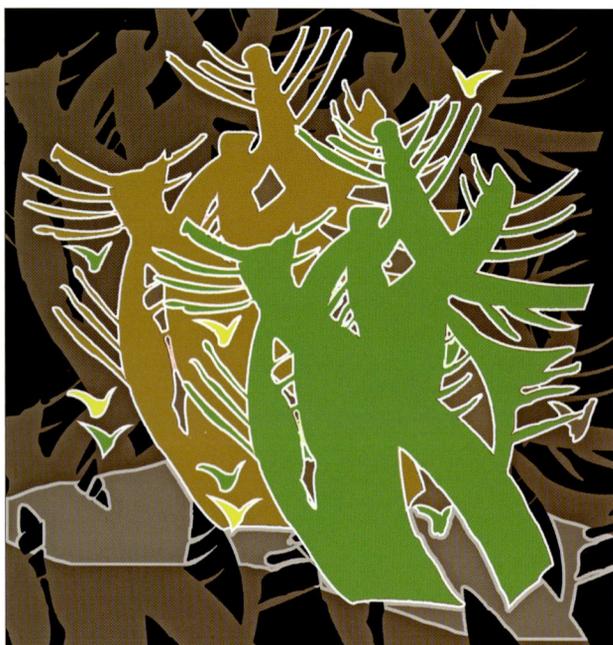

图6-4 平涂勾线

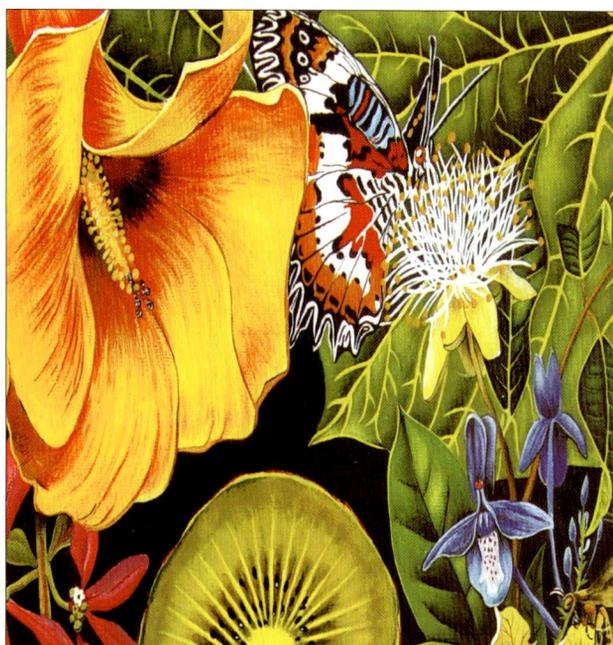

图6-5 皴染法使色彩丰富，还能产生一种肌理变化

6.2 混色表现技法

对画面的颜色有意识地进行不均匀的处理，使图案的色彩效果更加奇妙、丰富。颜色干湿、薄厚的运用是这类技法的主要特点。混色法有以下两种手段（图6-5、图6-6）。

6.2.1 皴染法

皴染法类似中国山水画中的干皴法，一般多与色块平涂结合使用。在底纸或底色上，用干毛笔蘸色蹭到画面上，不仅可以使色彩丰富，还能产生一种肌理变化。

6.2.2 渲染法

在颜色未干时，用湿毛笔将颜色慢慢染开或与其他色衔接，形成从一种颜色向另一种颜色的逐渐过渡。绘制的图案效果含蓄，变化微妙，颜色衔接较自然。

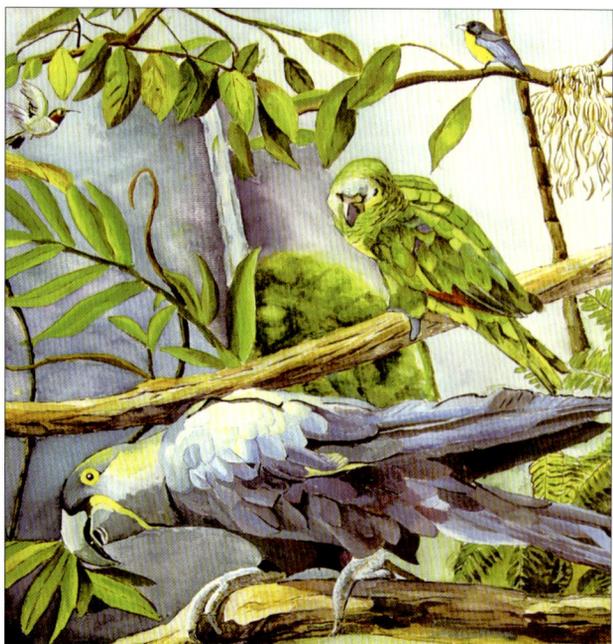

图6-6 渲染法绘制的图案效果含蓄，变化微妙，颜色衔接较自然

6.3 特殊表现技法

在图案设计表现中，使用不同的材料、工具，会产生不同的特殊效果。在这里介绍几种常用的工具、材料及技法（图6-7、图6-8、图6-9、图6-10、图6-11、图6-12、图6-13、图6-14）。

6.3.1 彩色铅笔

彩色铅笔可与水粉或水彩色同时使用，有普通型和水溶型两种。彩色铅笔配色丰富，适合深入细致的刻画，对表现立体感有独到之处，并伴有笔触的纹理效果，变化灵活微妙。彩色铅笔在描绘时不易修改，因此颜色要从轻到重，从浅到深，层层叠加。此外，彩色铅笔不适用于大面积的着色。

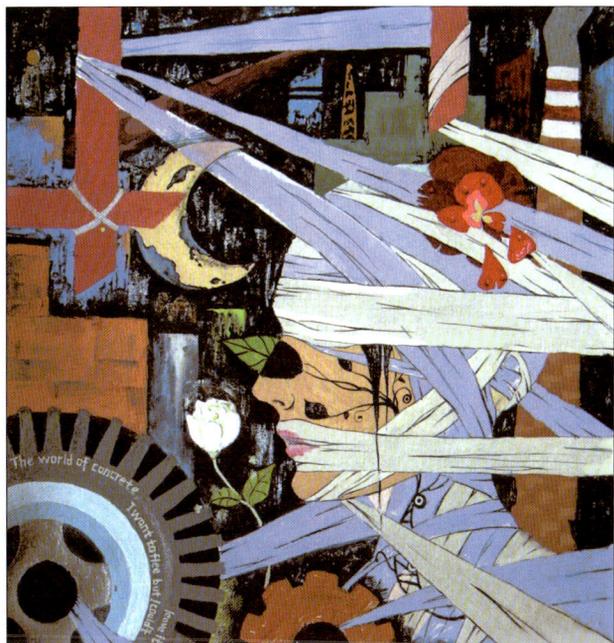

图6-7 宣纸画法

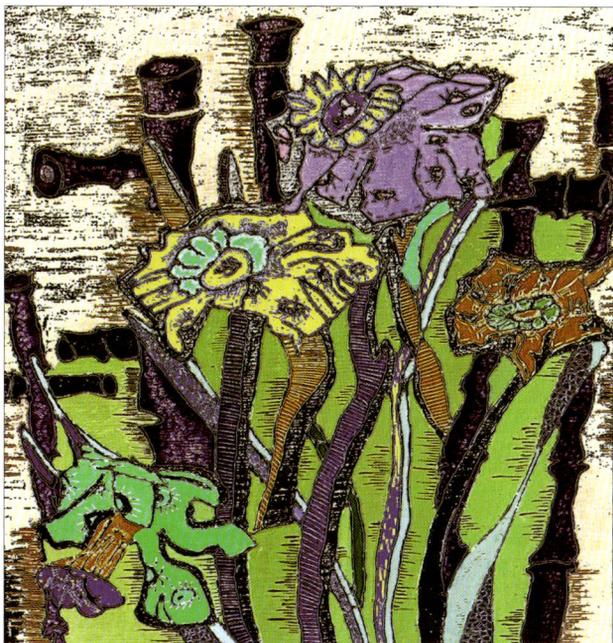

图6-8 画面中的白色先用普通胶水涂盖，再用丙烯画出其他部分，后用水冲洗掉胶水，形成斑驳的效果

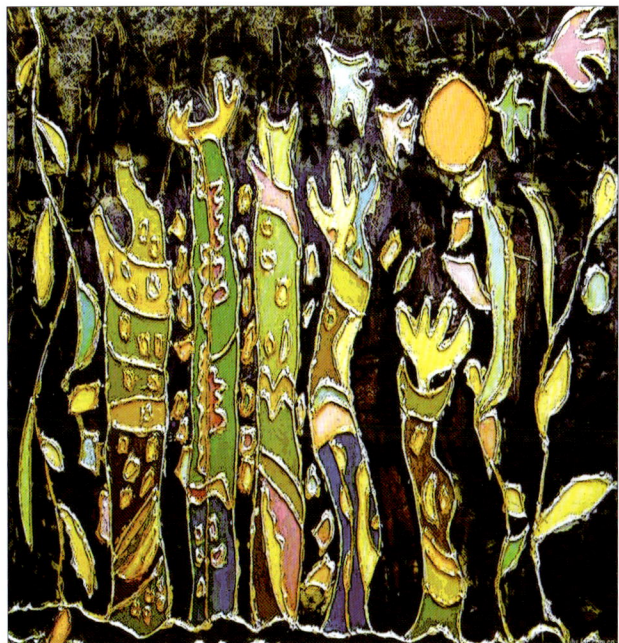

图6-9 图形边缘用立粉（立德粉加白乳胶）装饰，加强了图案的立体感和层次感

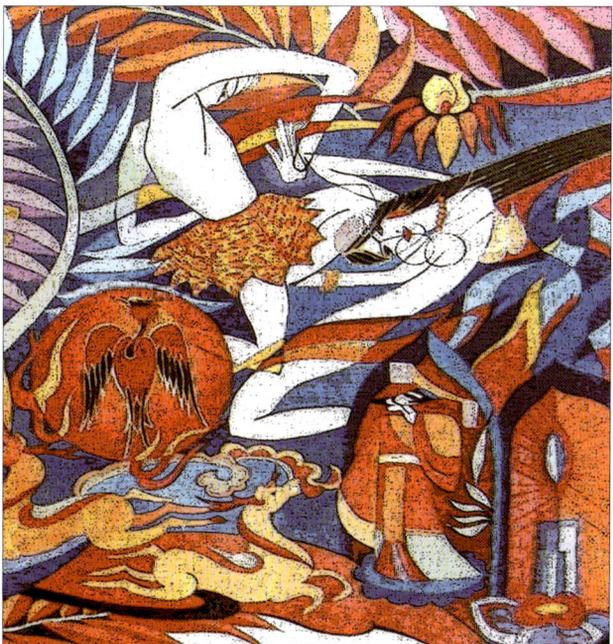

图6-10 宣纸画法制作出虚幻、朦胧的肌理效果

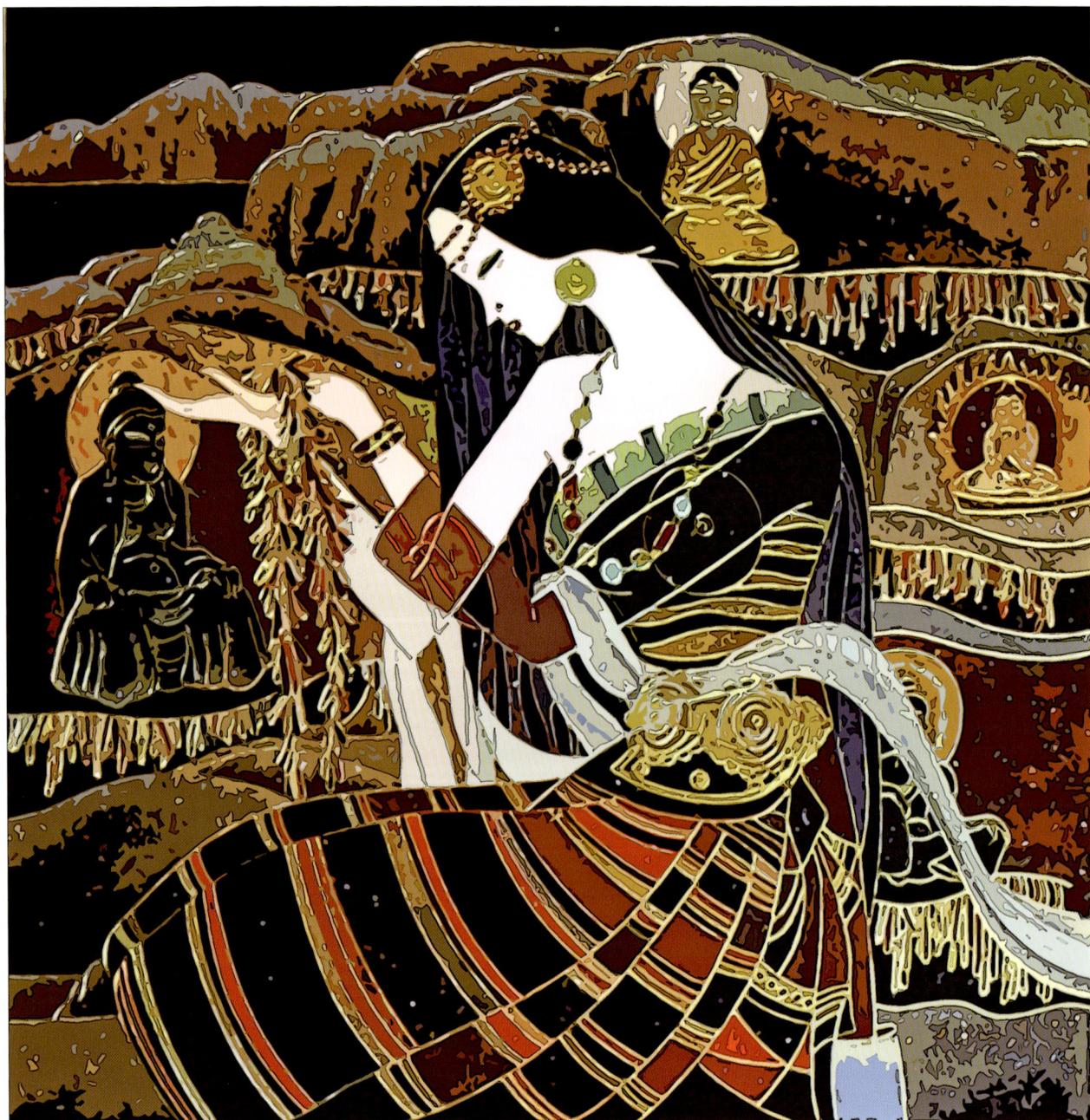

图6-11 仿造版画效果，使画面具有特殊的形式美和统一感

图6-12 电脑制作的图案，拓展了人们的想象空间，具有绚烂的机械美感。我们有必要熟悉掌握一些图形编辑和设计软件如：photoshop、coreldraw等，扩展图案表现的技术领域

6.3.2 喷绘

喷绘图案效果细腻柔和，变化微妙。可以用专业喷笔，也可使用牙刷等有弹性的刷子（将颜料蘸到刷子上，再用手指弹拨，将颜色弹到画面上，通过手指的力度控制喷点的精细度和密度，可产生一种喷洒的肌理效果）。在喷绘时，要用硬卡纸制作模板，将不喷色的部分遮挡起来。

6.3.3 沾染法

沾染法是用海绵、粗纹布、皱纹纸等材料，蘸上颜料后再印到画面上，依靠用力的轻重控制颜色的浓淡层次，可产生出画笔无法绘制的纹理效果。

6.3.4 宣纸画法

宣纸画法主要选用生、熟宣纸或高丽纸等材料，这类纸张柔韧性好、吸色力强，画出的色彩层次丰富、含蓄古朴、衔接自如，可以制作出各种虚幻、朦胧的肌理效果，尤其适合绘制大幅的装饰图案。

6.3.5 电脑处理

电脑在现代设计领域中已被广泛运用，它具有高效、规范、技巧丰富、变化快捷、着色均匀、效果整洁等诸多优势。电脑制作出的许多效果是手绘无法达到的，学会使用电脑技术来处理制作图案，是现代社会发展的需要。因此，我们有必要熟悉、掌握一些图形编辑和设计软件，发挥它们的诸多功能来制作图案，扩展图案表现的技术领域。

图案的表现技法是人们在长期实践中探索发现的，我们可以在自己的实践训练中去发掘、尝试更多的表现手段。比如还有刮色法、蜡染法和油画棒、彩色水笔、马克笔等许多手法均可用于表现图案。但无论技法如何变换，始终是为表现主题服务的，我们应重视艺术素质的培养，避免走入为技法而技法的歧途。

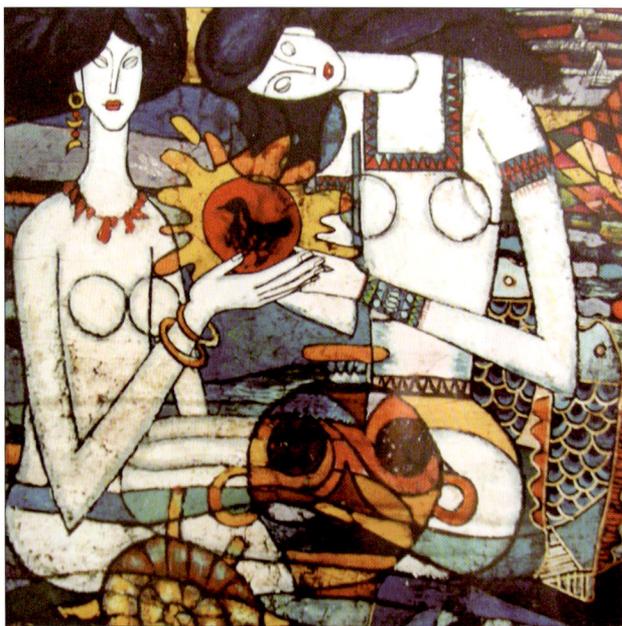

图6-13 高丽纸柔韧性好、吸色力强，画出的色彩层次丰富，含蓄古朴，衔接自如。如果在纸背面托色，可以使色彩更加饱满、厚重

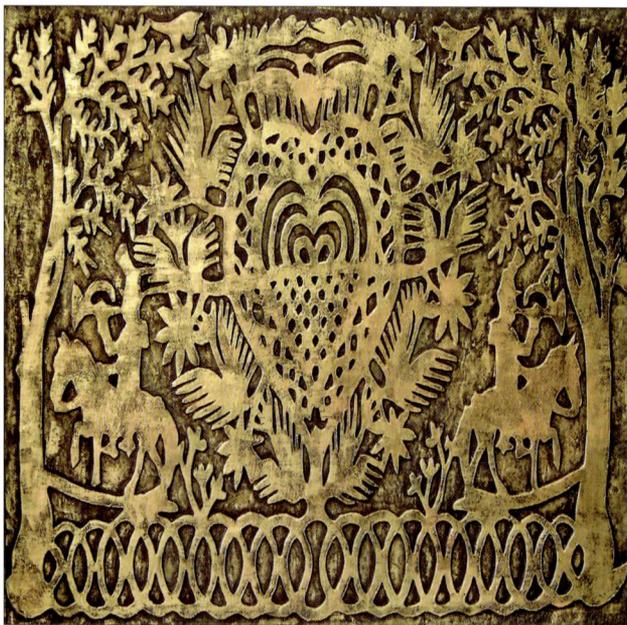

图6-14 利用浮雕形式表现出强烈的立体感

第7章　图案的造型题材及表现

7.1 植物

当我们置身于大自然中，面对各种纷繁杂乱的植物，不可能像照相机一样，把眼前的一切全部记录下来，而必须把庞杂的客观形象进行筛选和净化。我们在表现植物图案时应注意：

7.1.1 要抓住对象的外形特点

外形和轮廓不仅能有效地表现物象的特征，而且与图形的组织有密切关系。就植物而言，有的形态丰润饱满，有的形态奔放流畅，有的小巧精致，有的硕壮厚重。抓住这些外形特点，有利于图案造型的归纳与变化（图7-1、图7-2、图7-3、图7-4、图7-5）。

7.1.2 注意结构和表面纹理

植物的结构和纹理，都可能成为很好的装饰素材。果实与枝叶的连接、树皮与树叶的纹理组织、植物根部与枝干的肌理对比，以及藤蔓翻卷的优美动势，都可以是图案表现的内容（图7 6、图7-7、图7-8、图7-9、图7-10）。

7.1.3 写生与变化

写生是培养观察力和表现力的基本方法。在写生时，

图7-2 植物外形特点图例二

把复杂的脉络纹理规整得有条理，将形态较完美的枝叶组织在一起，为图案变化提供良好的素材。写生可以用铅笔、钢笔、毛笔等工具，通过线的变化来表现不同的形态、特征、组织结构及构图形式。也可以画出对象的光影和明暗效果，表现出对象的立体感和空间感。又可使用彩色颜料(水彩、水粉、丙烯、油画颜料等)进行写生，描绘对象色彩的明暗、冷暖变化等关系。另外，还可使用剪影的形式来表现物象轮廓和投影形状，此种方法加强了平面装饰感和整体感，非常利于植物图案的归纳装饰（图7-11、图7-12、图7-13、图7-14、图7-15）。

变化是一个艺术的再创造过程。在这个过程中要对写生素材进行主观的、有意识的处理。大自然是美好的，但用图案设计的眼光去看，有的过于繁杂，必须对其进行提炼和概括，使其更明确、更简练。简化和归纳是图案变化的基本方法，中国传统图案中的汉代图像和民间美术中的剪纸、皮影等均是此种方法。然后，再对自然形象最具代表性的特征加以强化、渲染。夸张强调特点，使形象更醒目，更有代表性。

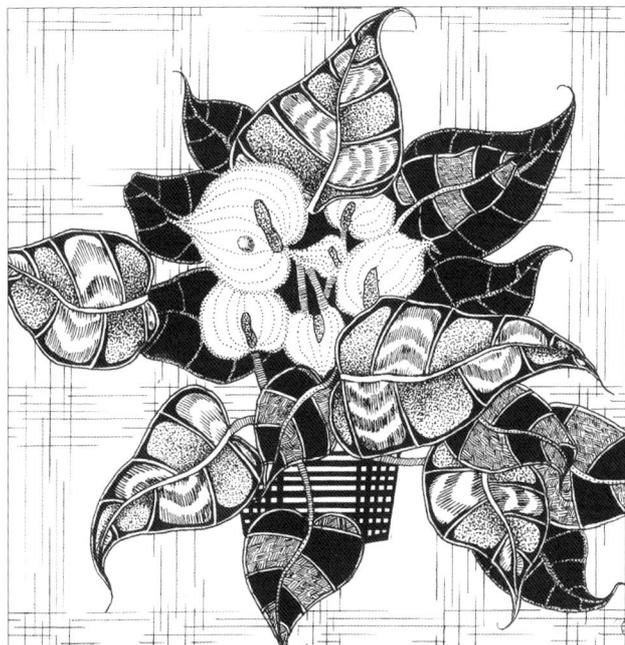

图7-1 植物外形特点图例一

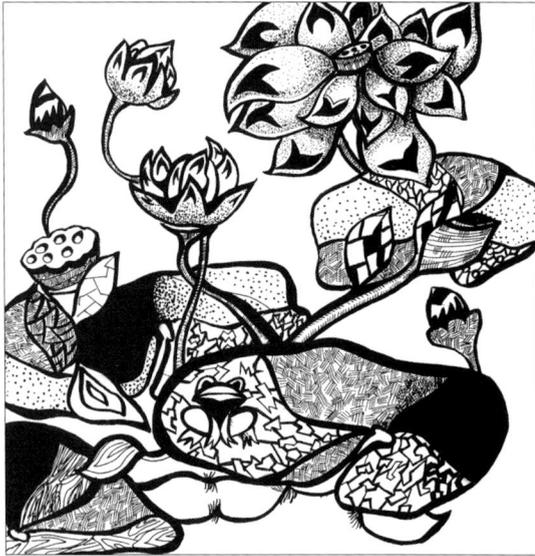

图7-3 植物外形特点图例三

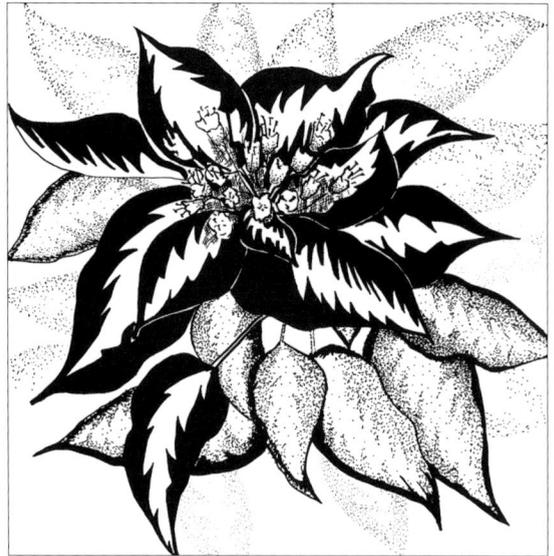

图7-4 植物外形特点图例四

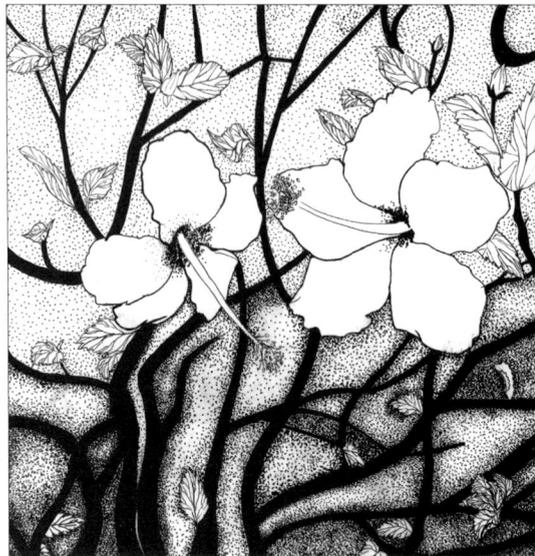

图7-5 植物外形特点图例五

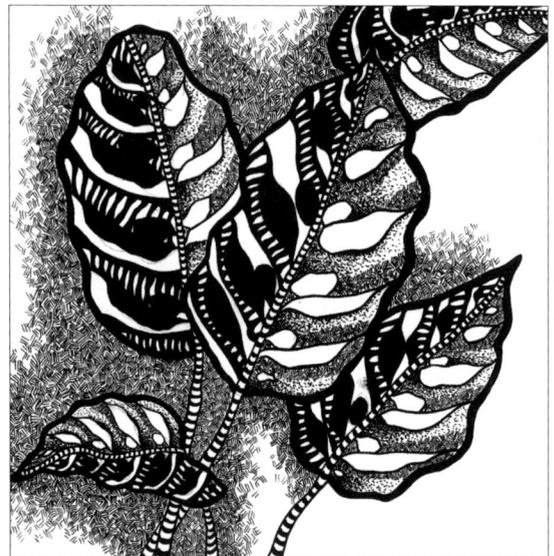

图7-6 植物结构和表面纹理图例一

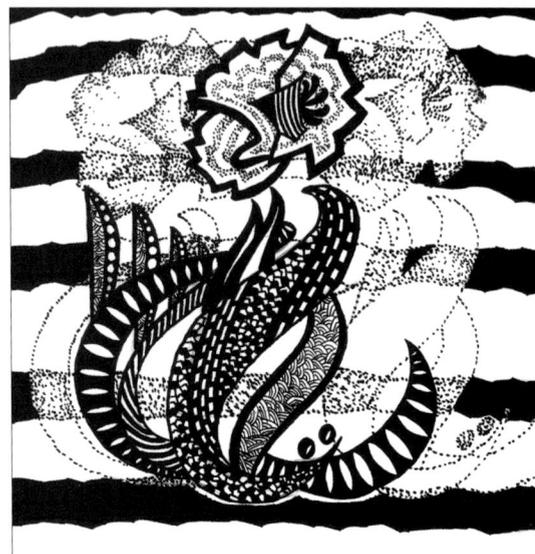

图7-7 植物结构和表面纹理图例二

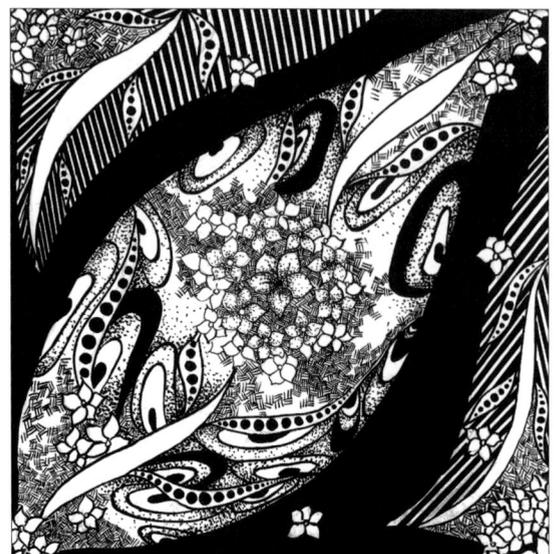

图7-8 植物结构和表面纹理图例三

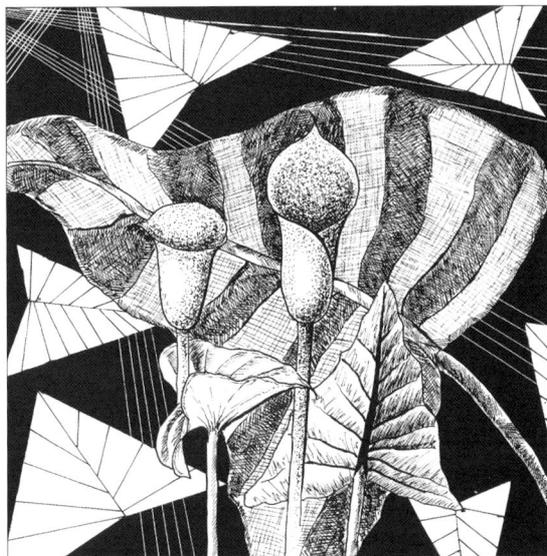

图7-9 植物结构和表面纹理图例四

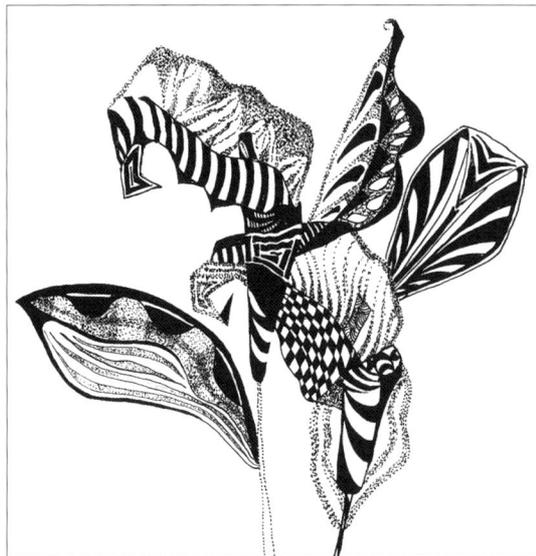

图7-10 植物结构和表面纹理图例五

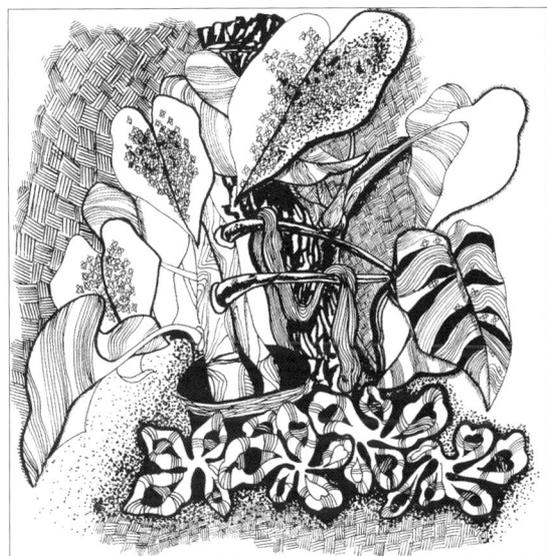

图7-11 植物写生与变化图例一

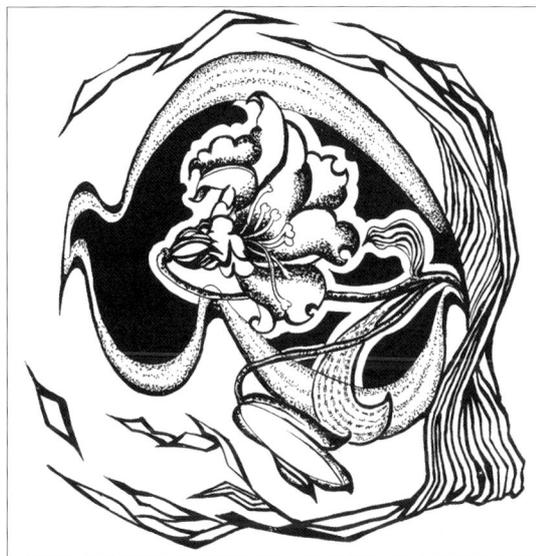

图7-12 植物写生与变化图例二

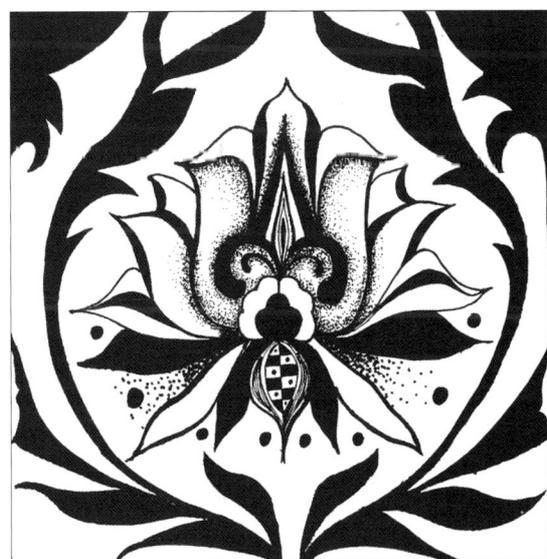

图7-13 植物写生与变化图例三

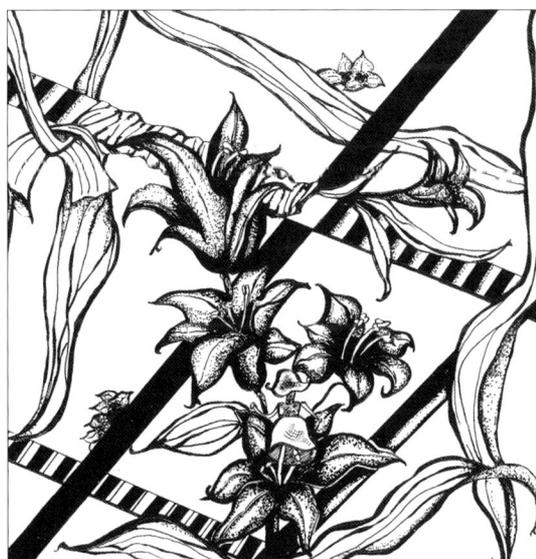

图7-14 植物写生与变化图例四

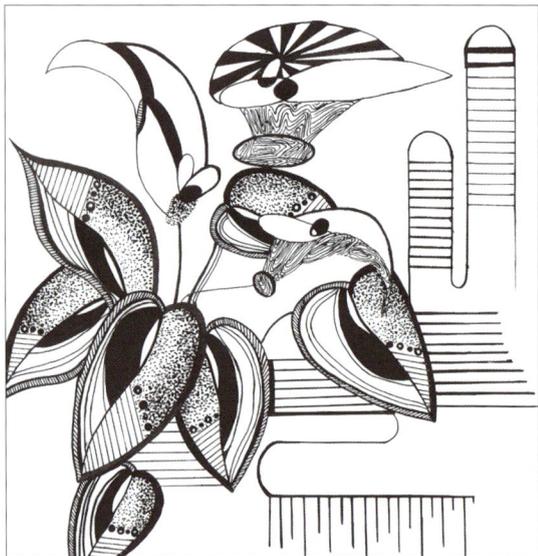

图7-15 植物写生与变化图例五

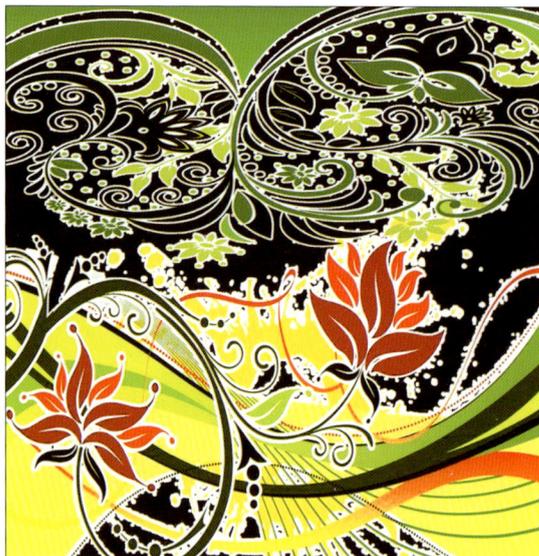

图7-17 植物图案创作二

另外，在图案创作中，有时要打破自然的比例关系。自然形象本身的比例关系在图案变化时应根据设计的意图加以改变，可以将小的放大、长的缩短、粗的减细等。我们需要有很好的写实造型能力，但在图案创作中又要摆脱它的制约。

现实中的时空观念对于图案设计来讲也不必拘泥。图案可以把不同季节的植物组合在一幅画面中，也可以将不同空间的植物并存在一起，如民间剪纸、刺绣图案中经常出现一条枝干上长出几种不同的花卉，使图案更具浪漫色彩和超自然的艺术魅力（图7-16、图7-17、图7-18、图7-19、图7-20）。

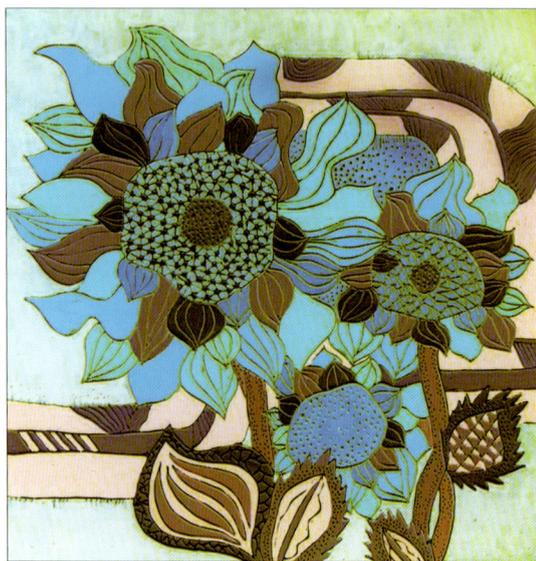

图7-18 植物图案创作三

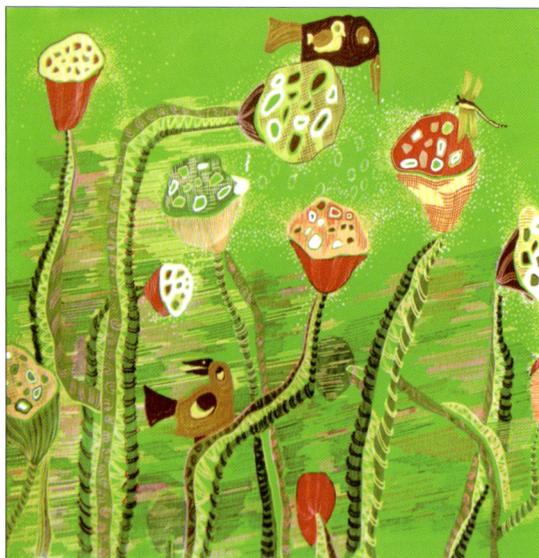

图7-16 植物图案创作一

图7-20 植物图案创作五

图7-19 植物图案创作四

7.2 动物

动物的形态结构比植物要复杂许多，动态的变化也更为生动。动物有着各自不同的生活习惯和性格特征，具有生动的表情，因此，动物图案的变化要更加注重动物神韵的传达和个性化的造型以及动态特点的夸张。由于动物自身的特点，我们在写生和图案变化中尤其要注意：

7.2.1 记忆默写

动物的许多优美形态是在运动中产生的，它们转瞬即逝，我们很难把它完整地描绘下来，这就需要靠记忆与默写来完成（图7-21、图7-22）。

7.2.2 利用摄影和绘画作品中的动物素材

摄影和绘画作品是经过作者精心观察和推敲产生的，其中既有传神的瞬间动态又有对形象结构的真实体现。这些相对静止的动物形象，很便于我们直接利用（图7-23、图7-24）。

7.2.3 形象归类

动物虽然种类繁多、形象复杂，但每一类别的动物都有相似的形体结构。如：食草类动物四肢细长，头部咬肌发达；食肉类动物肢短爪大，头部较小；啮齿类动物体形较圆，腿脚前短后长等。掌握了动物的类别特征，就为动物图案表现打下了良好的基础（图7-25、图7-26）。

7.2.4 色彩特点

动物的色彩特征主要体现在皮毛上，它是动物区别于其他物种的标志，又可作为很好的装饰素材。有些小的昆虫没有什么复杂的结构和动态，却有十分绚丽的外形色

图7-22 记忆默写动物形态二

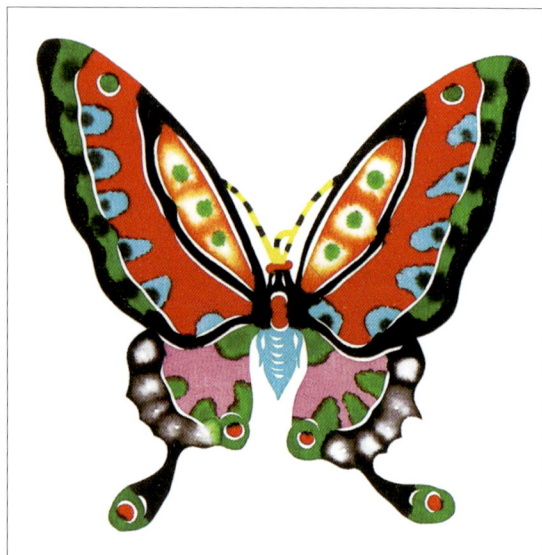

图7-23 利用绘画作品绘制的蝴蝶图案

图7-21 记忆默写动物形态一

图7-24 利用摄影作品绘制的飞鱼图案

图7-25 动物类别特征图例一

图7-26 动物类别特征图例二

彩，如：蝴蝶和蜻蜓。有些动物的色彩特征还体现在皮肤纹理上，如：鳄鱼、犀牛、刺猬等。夸张表现动物绚丽的皮毛和皮肤肌理，具有很好的装饰效果（图7-27、图7-28）。

7.2.5 动态特征

动物的动态具有较高的表现难度，但在那绚丽多姿的动态中体现了动物的生命美感，越高级的动物，动态越复杂。动物动态可分为一般动态和典型动态：一般动态是所有动物共有的常规的动态，如：站立、躺卧、行走、奔跑等；典型动态是指动物特有的个性动作，如：仰天长鸣的仙鹤、扭转颈项的天鹅、飞身扑跃的虎豹、弓膝抵角的牛羊等，这些典型动态很适宜进行夸张及强化表现（图7-29、图7-30）。

7.2.6 性格特征

动物图案在创作上要求形神兼备，动物的精神状态往往是动物性格的反映，动物的性格是生命进化的结果，凶猛、温和、聪明、憨厚、奸滑、迟钝各不相同。在表现时，要运用不同的色彩、形状、线条等视觉语言表达各种神韵。此外，受不同地区风俗文化的影响，人们会给动物赋予更多象征的含义，如：龟象征长寿、狼象征凶残、蛇象征狠毒等（图7-31、图7-32、图7-33）。

7.2.7 卡通表现

现代社会卡通形象被广泛应用到许多生活用品的装饰上，如：服饰、玩具、广告等，有时甚至用作吉祥物，以象征国家和企业的文化精神面貌。卡通动物造型大多线条

流畅单纯，外形与结构简洁、概括、高度归纳，并且特征鲜明、重点突出，有很强的整体形象感。卡通动物形象有时会用拟人化表现，身体动态往往模仿人类特有的动作姿态来表现，头和四肢仍保持动物原有的外形特征，这种拟人化的表现手段使动物形象变得十分可爱。另外，卡通动物造型往往头部很大，表达了人类追求童趣的心愿。在五官处理上的大胆移位安排，更加强了滑稽感和幽默感（图7-34、图7-35、图7-36、图7-37）。

综合以上七种表现手段可以创作出优美的动物图案（图7-38、图7-39、图7-40、图7-41）。

图7-27 动物色彩特点图例一

图7-28 动物色彩特点图例二

图7-29 动物动态特征图例一

图7-30 动物动态特征图例二

图7-31 动物性格特征图例一

图7-32 动物性格特征图例二

图7-33 动物性格特征图例三

图7-34 动物卡通表现图例一

图7-35 动物卡通表现图例二

图7-36 动物卡通表现图例三

图7-37 动物卡通表现图例四

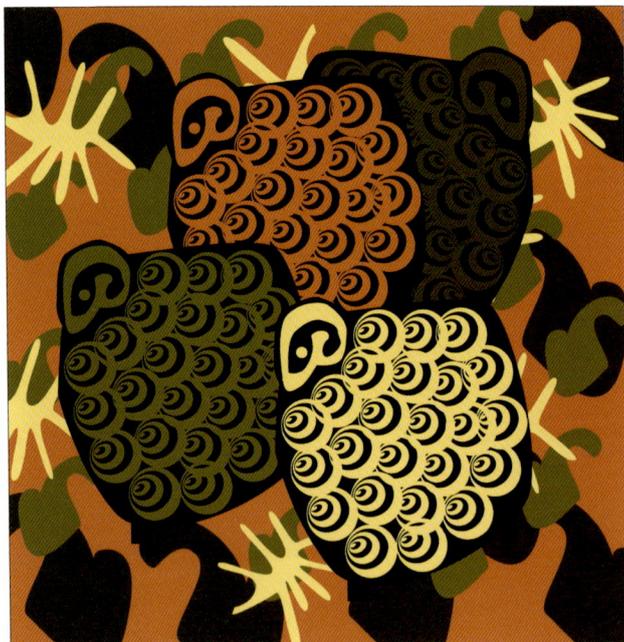

图7-38 动物图案创作一

图7-39 动物图案创作二

图7-40 动物图案创作三

图7-41 动物图案创作四

7.3 人物

人乃万物之灵，是社会的主宰，很多艺术形式都以人物题材为重要表现内容。人物图案是人类表现自身和美化生活的一个重要艺术手段。它内涵丰富、情趣生动，比植物和动物题材更为复杂。人物图案的设计需要注意以下四点：

7.3.1 人物图案的特点

人物图案要求形象概括鲜明，动态夸张且富于装饰性和浪漫色彩，其特点是：

7.3.1.1 人有社会属性

除了男、女、老、幼等自然属性之外，人还有古今之分和种族之别，在当今社会中，由于国家、民族、职业、性格的不同，还造成了人们形体、穿戴及社交活动的差异。另外，由于人的高智商和高社会化的生活经历，又使得人有着十分复杂的内心活动和丰富的表情与神态（图7-42、图7-43）。

7.3.1.2 人能创造动态

除了坐、卧、跑、跳等基本动态之外，人们还创造了各种运动和娱乐形式，如体育、舞蹈、戏剧、武术、杂技、游戏等，这些人体动态极具节奏韵律感，造型生动完美，为我们提供了非常直接的人物变化素材（图7-44、图7-45）。

图7-42 人物社会属性图例一

图7-44 人物动态图例一

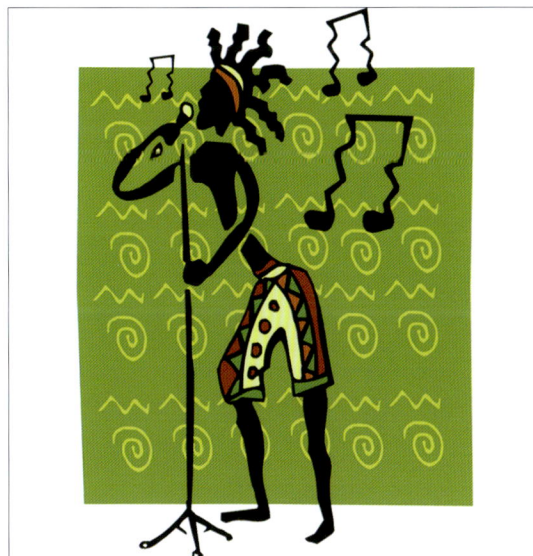

图7-43 人物社会属性图例二

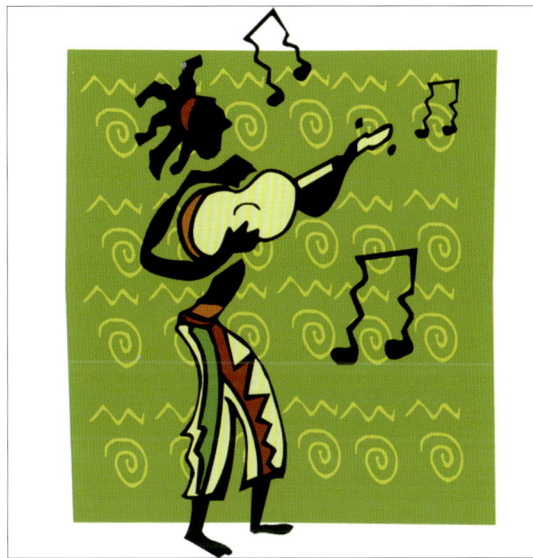

图7-45 人物动态图例二

7.3.1.3 人能自我美化

人非常善于美化自己，在各个历史时期，世界各地的不同民族拥有各自独特的发型、饰物和服装，它们造型优美、色彩绚丽，具有很好的装饰效果（图7-46、图7-47、图7-48、图7-49）。

7.3.2 人物图案的变化途径

首先，是写生变化。一般以人物速写为主要写生手段，写生时应大胆地概括归纳，抓住形象的外形和动态特征。同时，要注意装饰细节的刻画，如：饰物的造型、服装的款式、鞋帽的样式等，这样在进行人物装饰变化时，才能有丰富适用的素材。其次，要注意学习中外传统及民间的装饰人物图形，通过欣赏、分析、临摹，认真地看、想、画、写，从中找出人物装饰造型、形式美感和程式化表现手法的规律。如我国的人物装饰造型极具特色，从中国商、周时期青铜器上的人物造型，到明、清年画、剪纸、皮影戏中的人物造型，都凝聚着东方人的独特审美观。还有传统戏曲人物造型的程式化表演动作、石窟石刻、陶俑艺术、民间刺绣等。通过这些学习，能加深学生对祖国传统艺术的了解和感情，提高装饰艺术方面的修养，填补知识领域中的空白，为深入学习打下非常有益的基础。另外，还有肖像的变化。人的面孔结构对称、五官清晰、神态各异，受民族、年龄、性别、职业、情绪等的影响，造就了人物头部极为丰富的差异与变化。装饰肖像应采用夸张的手法使形象更典型、更具装饰性。在设计时要加强特征部位的表现，如：发式变化、头部饰物、面部神态等（图7-50、图7-51、图7-52、图7-53、图7-54）。

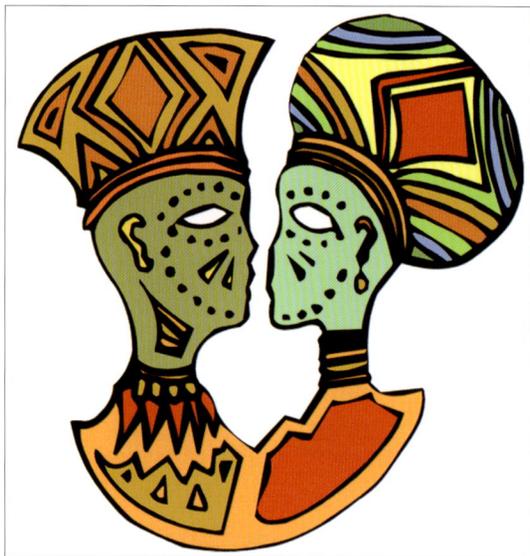

图7-47 非洲土著人物装饰

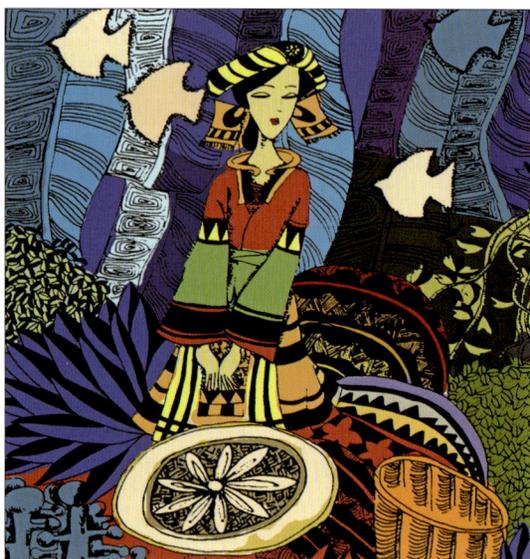

图7-48 中国少数民族人物图案创作一

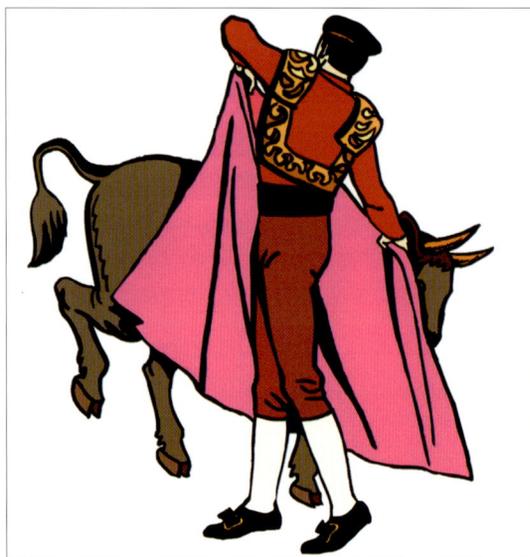

图7-46 西班牙斗牛士

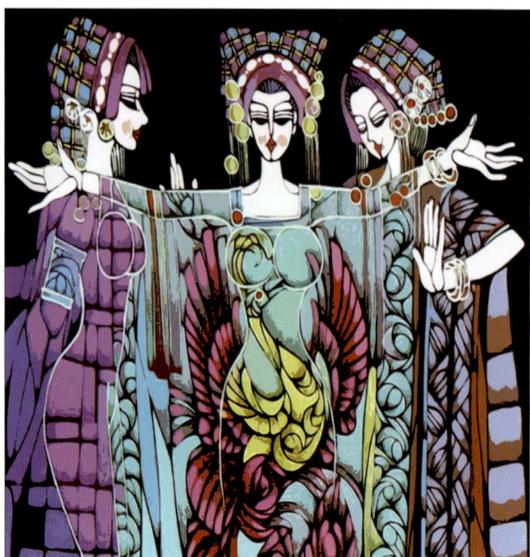

图7-49 中国少数民族人物图案创作二

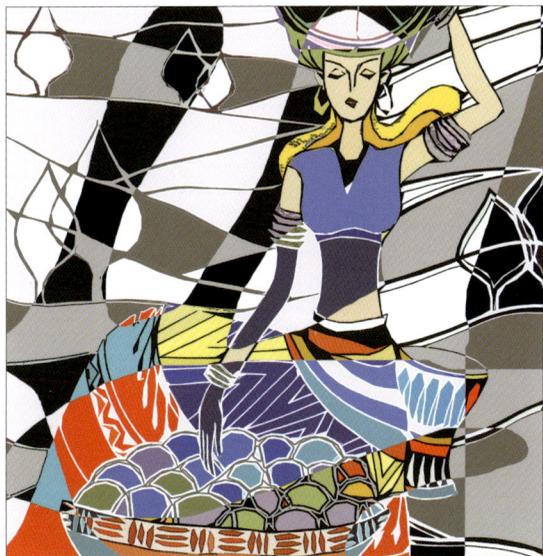

图7-50 人物图案创作一

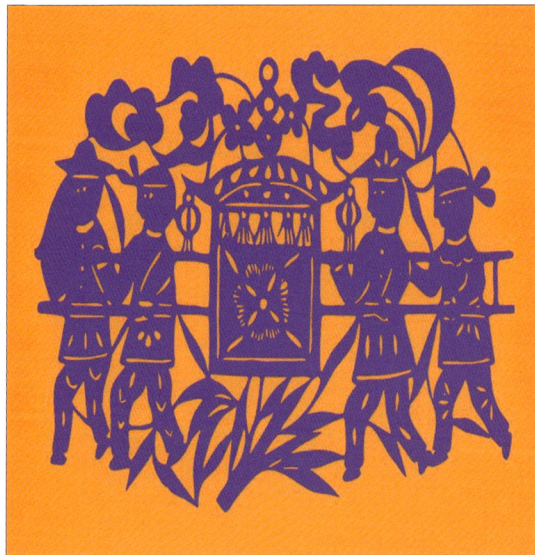

图7-51 人物图案创作二

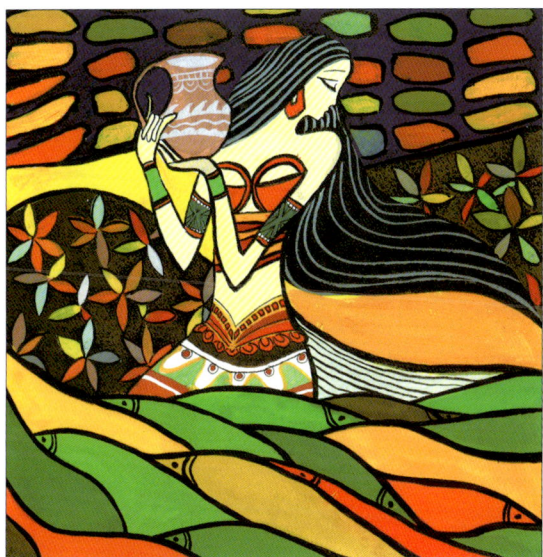

图7-52 人物图案创作三

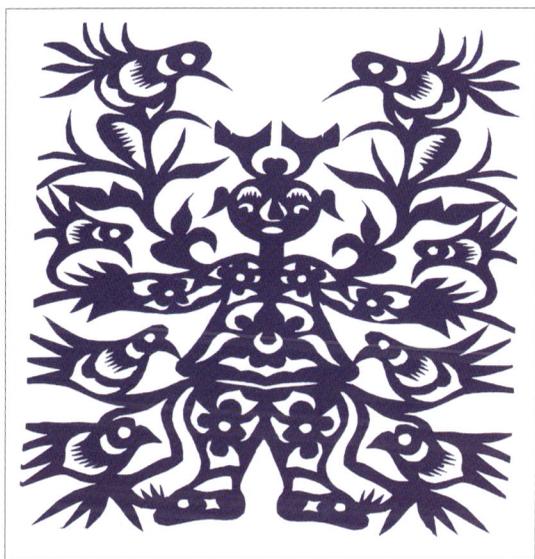

图7-53 人物图案剪纸一

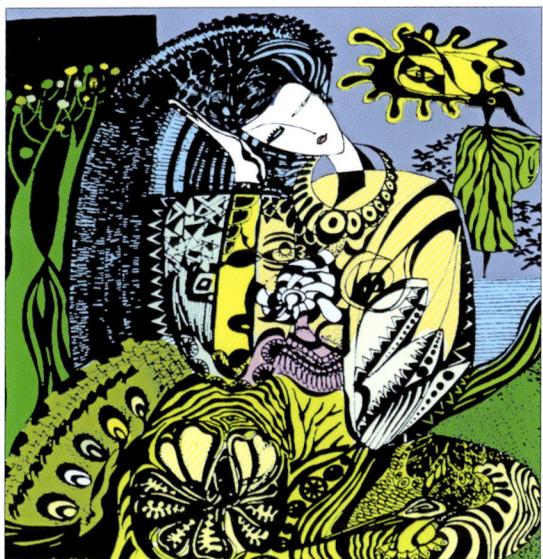

图7-54 人物图案剪纸二

7.3.3　人物图案的装饰美感

　　人物图案要通过美的变形表达美的神态和美的情趣。创作中要夸张人物的某些特征(比例、结构、形态等)，从而得到自然状态中所没有的美感表现。如：在装饰的语言表现中，阴柔曲线代表女性，所以在表现以女性为题材的装饰绘画中把女性的主要生理特征和情感结合起来，把女性的主要曲线特点加以夸张变形，使画面更加丰富感人。夸张的目的是为了使人物形象更加优美，而不是离奇古怪，这点与漫画中的夸张是有区别的。人物造型结构复杂，形态多变，为了追求外形的单纯和简洁，有时将人物各部分的比例有意识地夸大或缩小以增加人物各部分形体的对比结合，使人物形象更具节奏感；或将微妙的曲线归纳成大弧线，用几何形去表现人

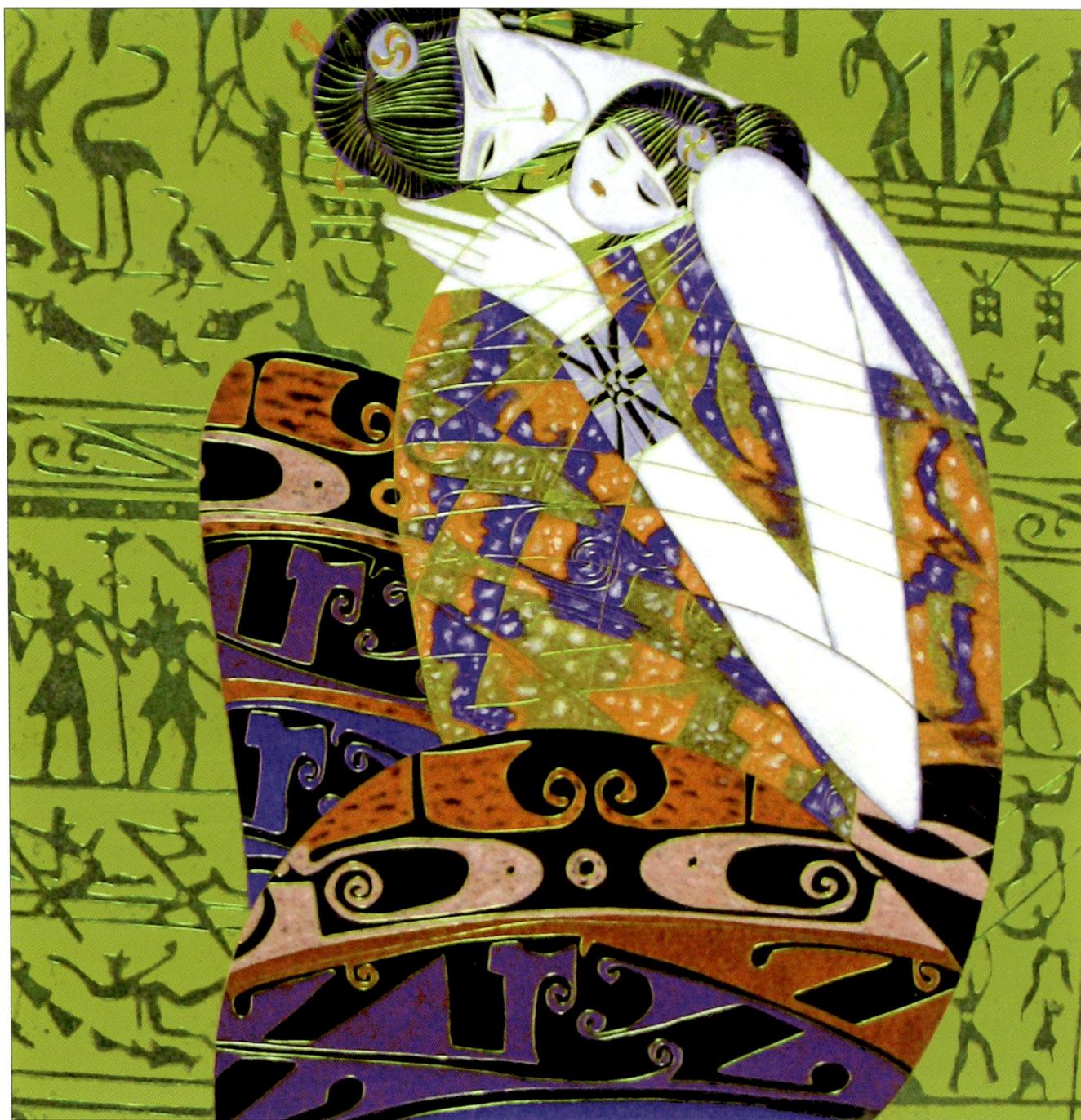

图7-55 具有装饰美感的人物图案一

物各部分的自然形态等。这些处理方法是达到图案装饰美的有效手段。动态夸张也是人物装饰美的重要内容，人物图案的神韵往往是通过动态来体现的，动态夸张可以大大超越人体运动范围的极限，构成极为生动的优美形态。还有图案的平面化处理，将立体的人物造型平面化，能大大加强图案的装饰美感。平面化使人物的光影变化和外形结构变得单纯和完整（图7-55、图7-56、图7-57、图7-58、图7-59、图7-60、图7-61）。

7.3.4　人物图案的表现手法

7.3.4.1　民间传统手法

民间传统人物图案是具有高度艺术性和浓郁人情味的传统文化资源，其自身醇厚的艺术语言和活泼多彩的表现形式，能给机械时代的人们以心灵的抚慰，让人们怀念故乡的温暖，燃起对家园故土的眷恋。这类人物形象造型粗犷有力，结构虽不够科学但造型却十分严谨，组织看似松散却安排匀称、合理，再结合浪漫美好的寓意联想、大胆的黑白对

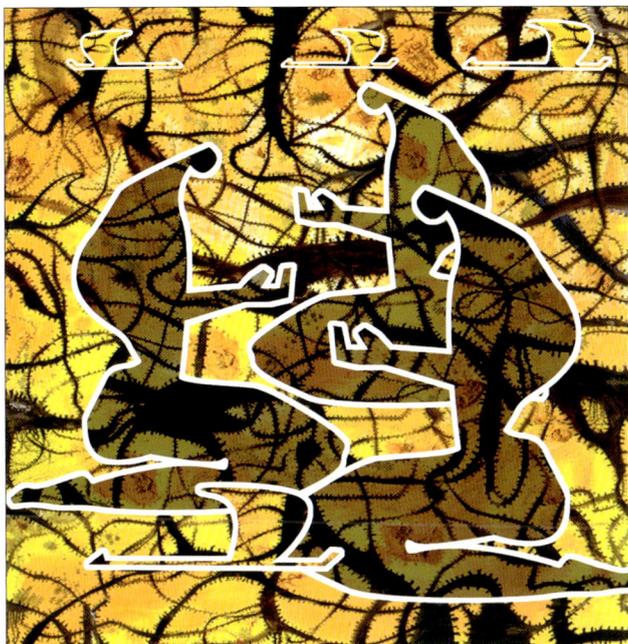

图7-56　具有装饰美感的人物图案二

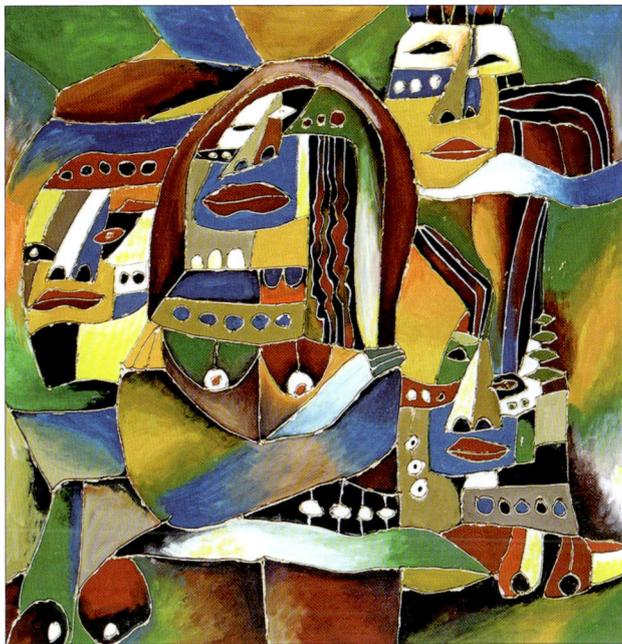

图7-57　具有装饰美感的人物图案三

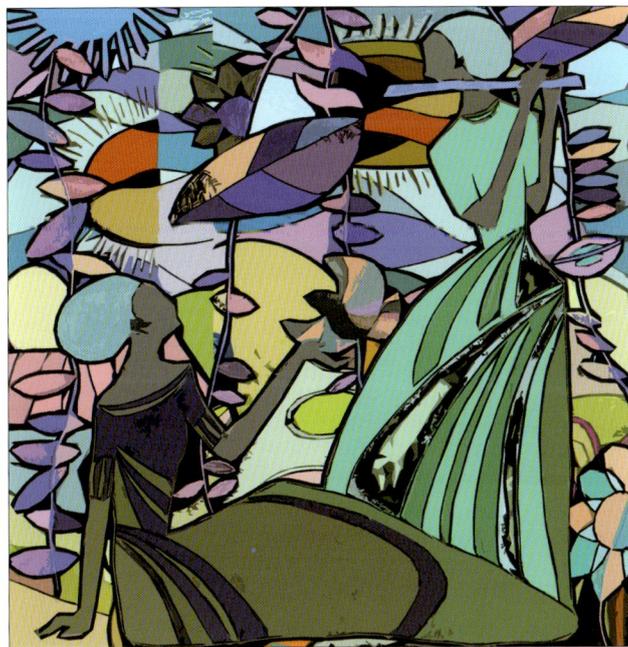

图7-58　具有装饰美感的人物图案四

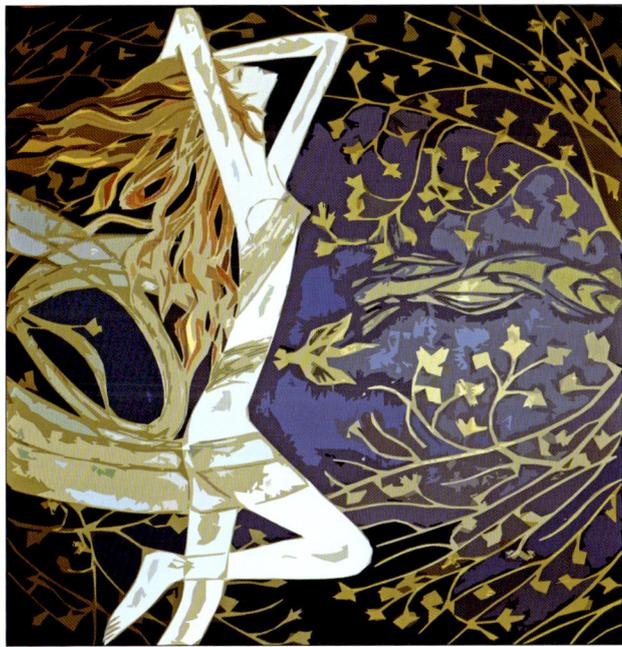

图7-59　具有装饰美感的人物图案五

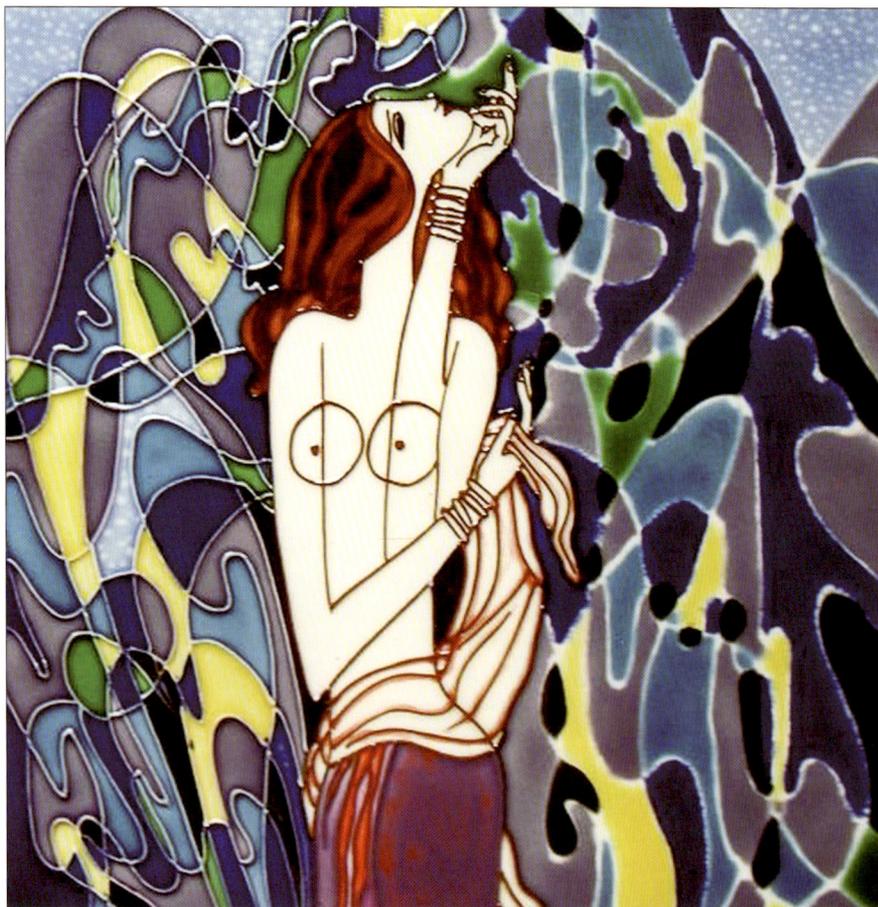

图7-60 具有装饰美感的人物图案六

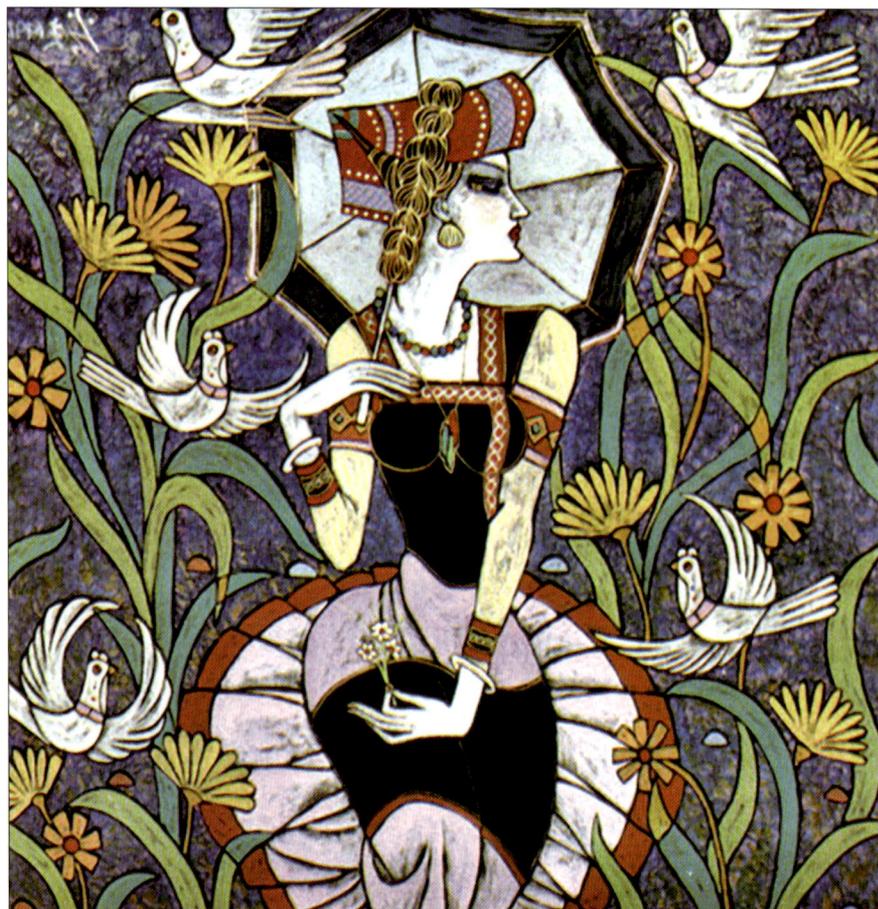

图7-61 具有装饰美感的人物图案七

比，使形象有很强的视觉冲击力（图7-62、图7-63）。

7.3.4.2 现代装饰手法

现代装饰人物形象往往结合现代构成的原理，在结构比例上更加科学和灵巧，造型和组织上追求几何化，在表现手法上更加富于变化，点、线 、面形式多样，黑、白、灰层次丰富，装饰风格更趋多样性（图7-64、图7-65、图7-66）。

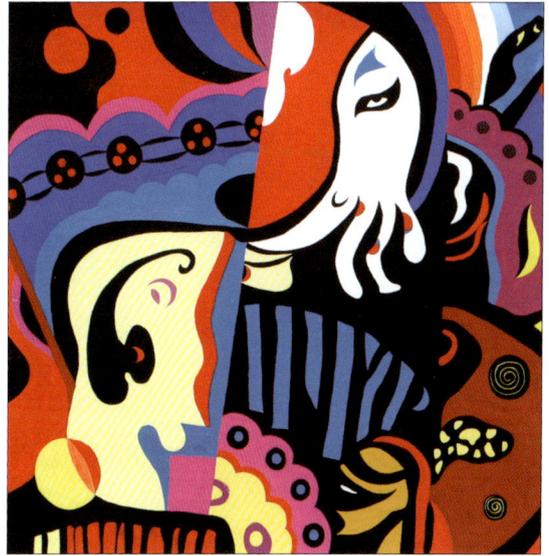

图7-64 现代装饰人物图案

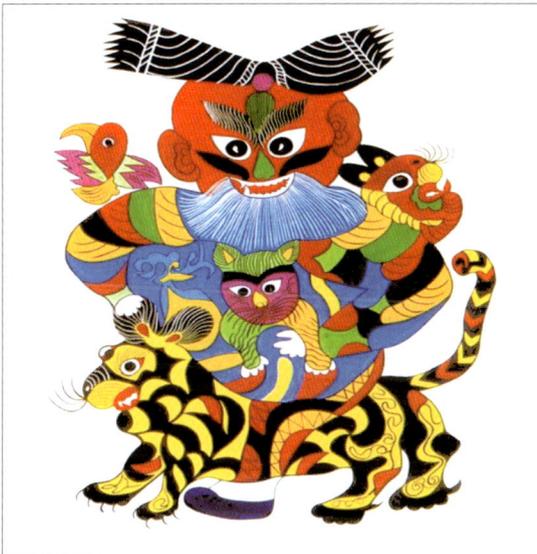

图7-62 中国农民画

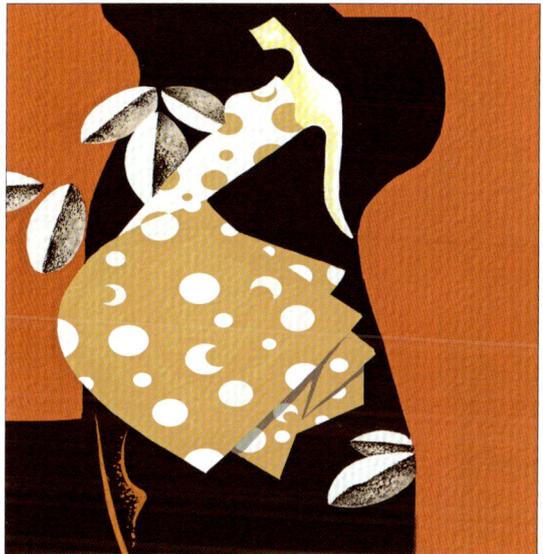

图7-65 现代装饰人物图案

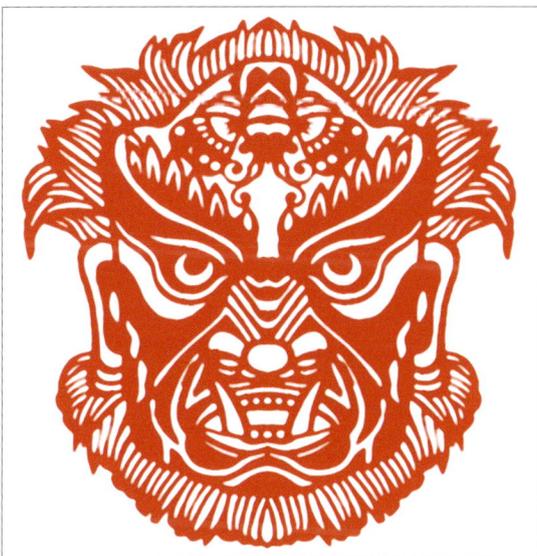

图7-63 中国民间剪纸脸谱

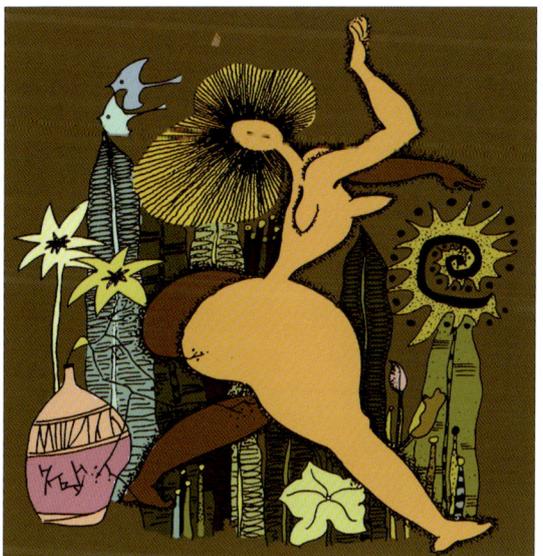

图7-66 现代装饰人物图案

7.4 风景

风景图案涉及的内容极为广泛，行云流水、长河落日、大漠孤烟、古刹雄关、小桥流水、山石草木、车船建筑、日月星辰、江河云雾等，都是图案设计取材的范围。近有祖国名山大川、江河湖海、亭台楼阁，远有世界各国的风情景物，都可纳入风景图案的表现内容，但因地理条件的限制，我们只能采用近处写生，远处则通过收集绘画及照片资料来进行取材。当然，所收集资料也应是一些较有特点的风景、建筑为好，如桂林山水、苗家木楼、国外的城堡、教堂等，都是风景装饰中很有特点的题材。风景图案的形象内容可分为自然景物和人造景物为两大类。自然景物包括山、石、云、水、树等，它们形象丰富、结构复杂、变化多样，重点是要将它们进行秩序化的归纳、整理和修饰。人造景物包括亭、台、楼、阁、车、船、路、桥等。人造景物经过精心设计建造而成，本身已具有较完美的形式，在图案表现中只需在结构透视等方面进行简化处理，在造型上进一步夸张、美化，并注意与自然景物相结合，使其更富于生命活力。

风景图案的设计，有其创作的规律，我们可以从构图和表现两方面入手。

7.4.1 风景图案的构图

风景图案的构图形式与风景绘画、摄影有所不同，在表现的视点和角度以及组织结构上，比较自由灵活，并有独特的程式化格式。

7.4.1.1 散点式构图

散点式构图是采用中国山水画中的散点透视法，打破正常的空间次序和透视关系，把不同视点观察到的景物进行有机的组合，根据画面的需要来安排景物的比例和前后关系。这种构图形式尤其适用于多景物的表现，在壁画创作中经常使用。其优点是可以任意选择物象的最佳视点，表现其最理想的体面关系。自由而随意的空间组合使画面奇异而有趣，表现出特别的意味，并给人以轻松、畅达之感。散点式构图可以兼有立体与平面空间两种表现形式，但需要注意的是发挥它们各自的长处，做到主从关系有序、虚实空间比例恰当，才能把看似相互矛盾的透视关系统一于整体的布局之中。散点式构图有很强的形式感，但在组织画面时应注意景物组合的主次关系，形态对比变化，切忌平均处理（图7-67、图7-68）。

7.4.1.2 分割式构图

分割式构图强调画面的构成美感，在风景图案中，

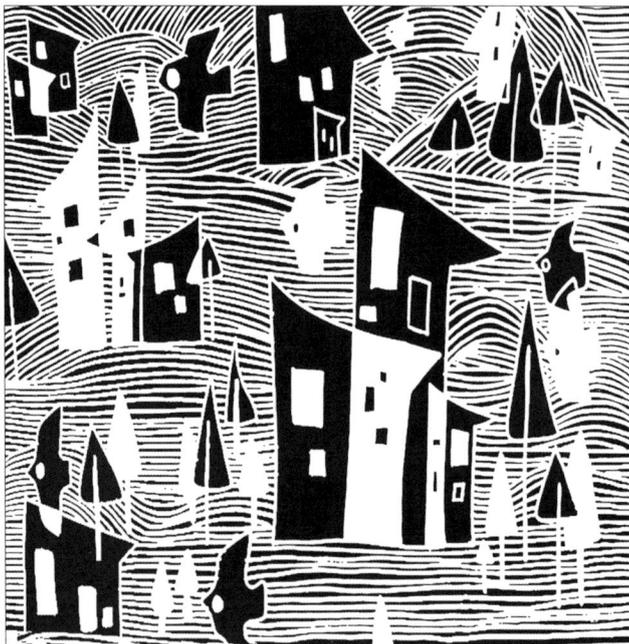

图7-67 散点式风景构图一

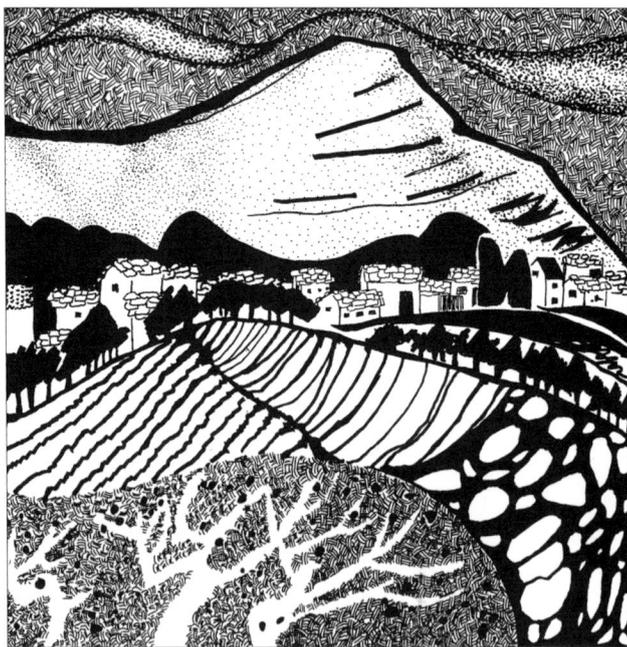

图7-68 散点式风景构图二

先将画面自由分割，形成面积不同的若干部分，再将风景图形填入其中。分割式构图充分利用画面的空间对比关系，使风景图案具有强烈的平面装饰感（图7-69、图7-70）。

7.4.1.3 摄影机构图

摄影机构图是一种模仿真实空间的构图形式，图案视野开阔，空间感强。它应用了科学的透视原理，具有西方绘画的真实感。这种构图真实而自然，颇似通过窗户或取景框看到的现实生活中的情景，符合人们的视觉经验，较

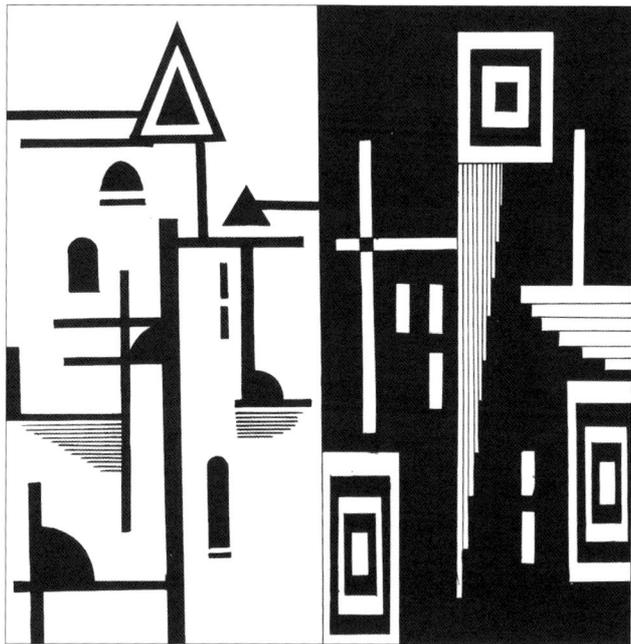

图7-69 分割式风景构图一

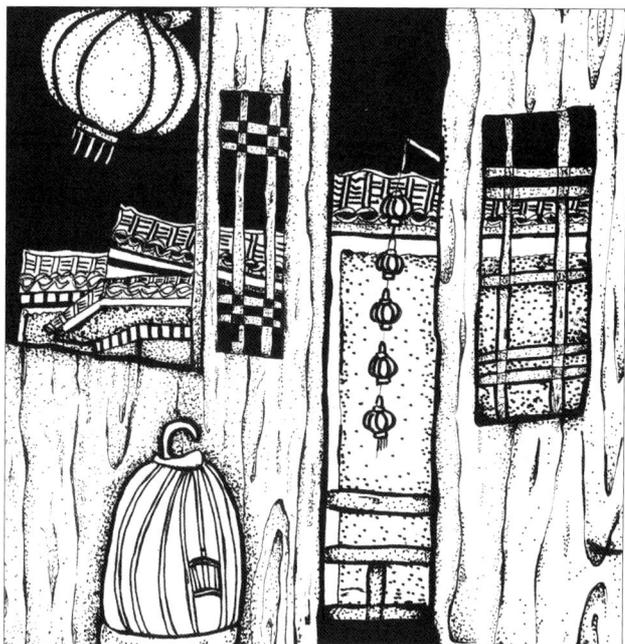

图7-70 分割式风景构图二

易获得大多数人的接受（图7-71、图7-72）。

7.4.2　风景图案的表现

　　风景图案在表现上运用景物的形态对比和造型布局变化，如面积的大小变化．聚散安排、虚实处理等，使图案错落有致、主次分明。在变化处理上应遵循以下几方面的规则。

7.4.2.1　景物形象的装饰性

　　风景图案在景物的造型变化上追求单纯化、平面化，

以便于形象的穿插组合。在景物形象的处理上，采用归纳简化、夸张、添加等装饰性规律，并注意整体形式风格的统一。装饰的词意中含有改变原有面貌的意思。从总体看，风景图案的每一部分设计都具有整体上的装饰效果。从造型艺术角度去理解，装饰造型就是以自然形象为参照而更多地加入创作者的主观意图，对现实中的″原形″作程式化的处理，使所有形象都纳入一种设定的形式秩序之中。另外，现存的很多装饰化图形是为了某些实用的需

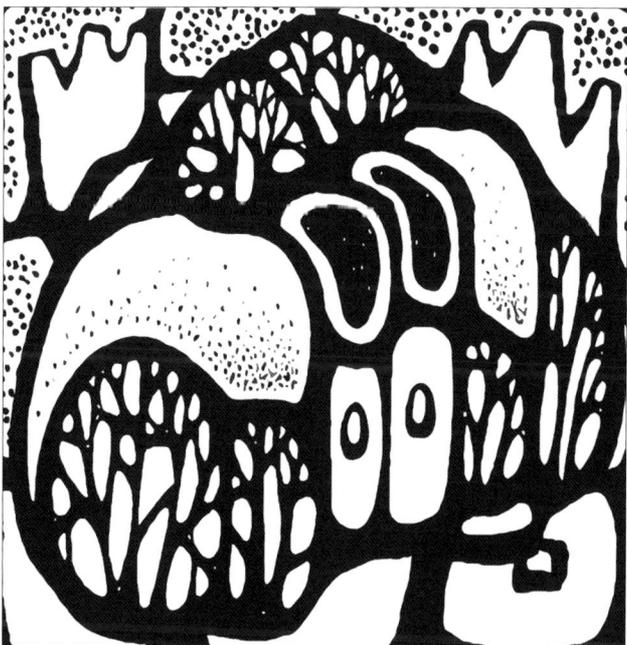

图7-71 摄影机风景构图一

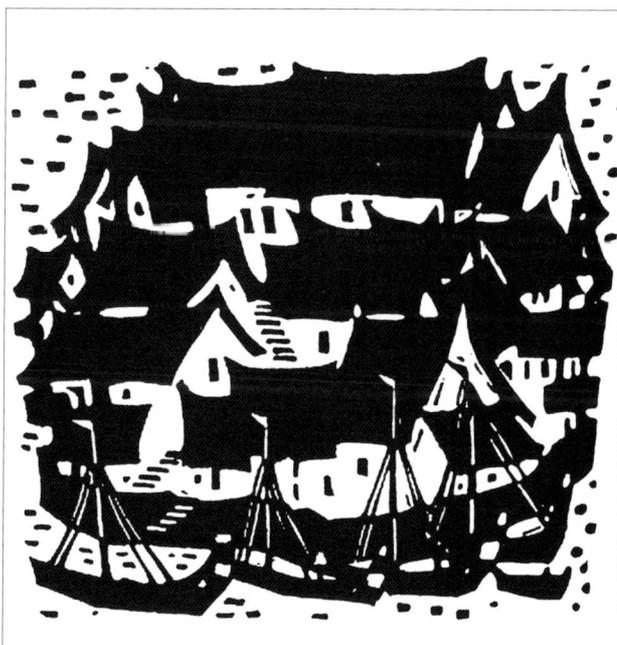

图7-72 摄影机风景构图二

要，如建筑上的装饰，织物、绣品上的装饰，以及一些器皿上的装饰等，随物体的立体或平面形状的不同，装饰的图形、风格也迥异。从古至今，装饰风格多种多样，如地域风格、民族风格、时代风格等。这些前人创造的艺术成果，成为设计家在景物装饰化造型设计上借鉴、吸收的营养。如要表现某个地域或某个特定历史时期的特点，可以从那一地区或那段历史时期的整体的装饰艺术风格方面寻找设计创作的切入点，而不是简单地抄袭。掌握了装饰造型的基本规律就可以举一反三，达到真正意义上的创作自由以及个性化的体现（图7-73、图7-74）。

7.4.2.2 打破正常的比例关系

风景图案中景物的大小，可根据需要自由设定，不必受自然比例关系的局限，但要注意景物形象之间的组合美与整体美，要从整体画面的构成考虑，合理安排各个形象的比例关系，达到和谐的效果（图7-75、图7-76）。

7.4.2.3 渐变和透叠

风景图案注重的是景物形象的大结构和外形美。在组织中，为体现形象的完整性和层次感，使图案效果变化丰

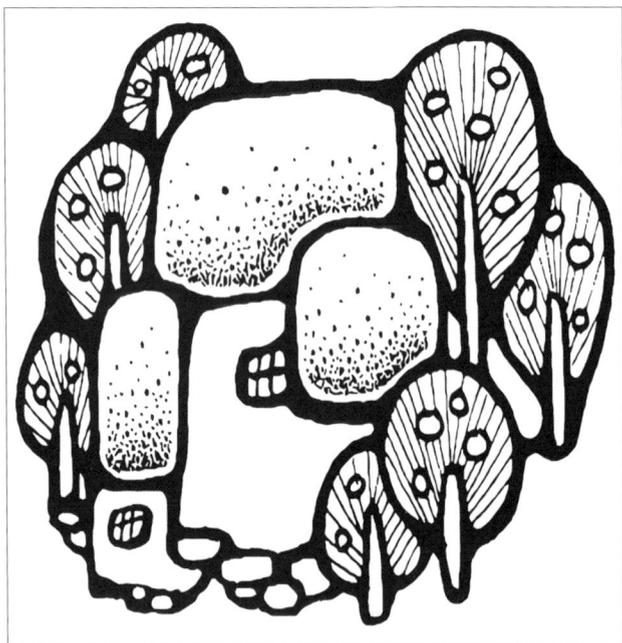

图7-73 归纳概括的风景构图一

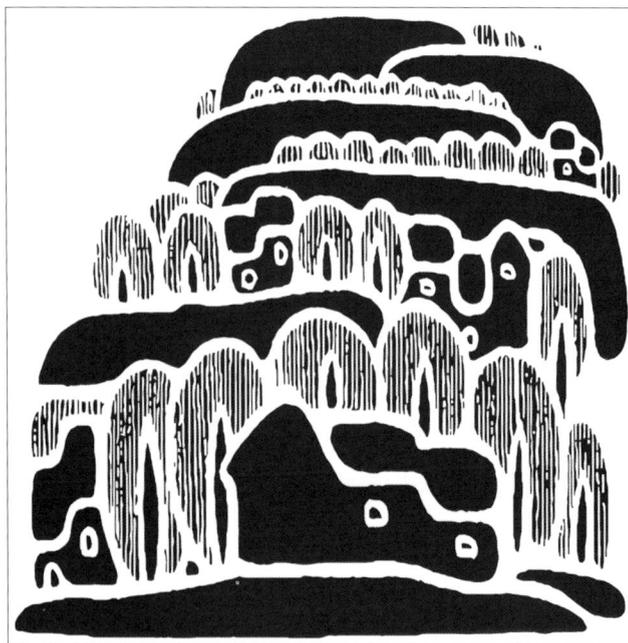

图7-74 归纳概括的风景构图二

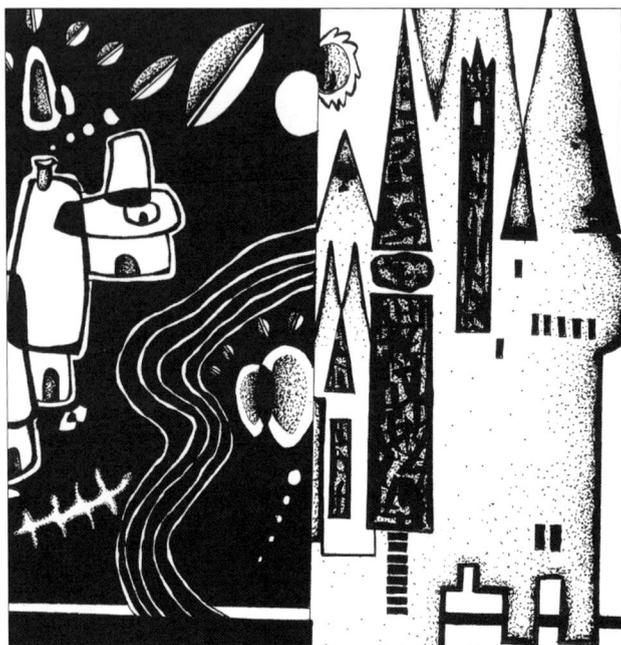

图7-75 合理安排景物的比例关系一

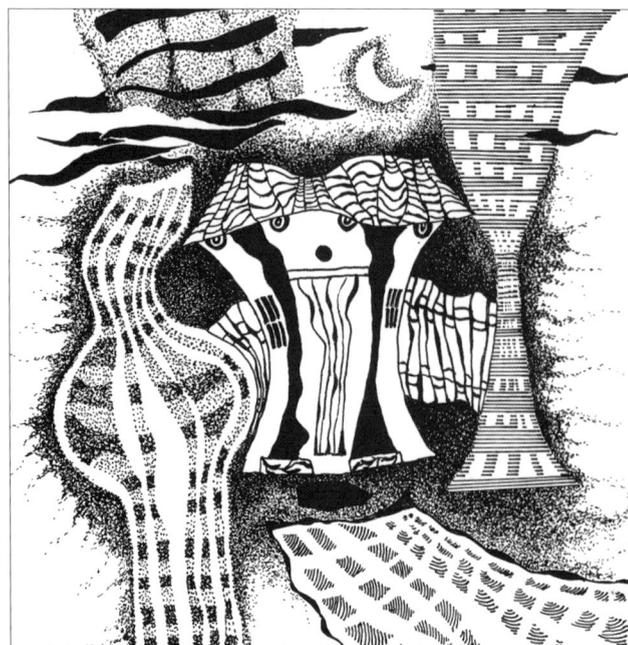

图7-76 合理安排景物的比例关系二

富而不失条理，可采用渐变与透叠的处理手法。渐变是将景物形象依远近关系层层安排，体现一种层次感，表现出一种合理的秩序，使形象更富于变化。透叠是在形象发生部分重叠时，通过色彩替换，使重叠区域形成新的图形而不破坏原有形象的轮廓。透叠有一种透明效果，可使画面产生丰富的偶然性变化，在形式上有极强的统一性（图7-77、图7-78）。

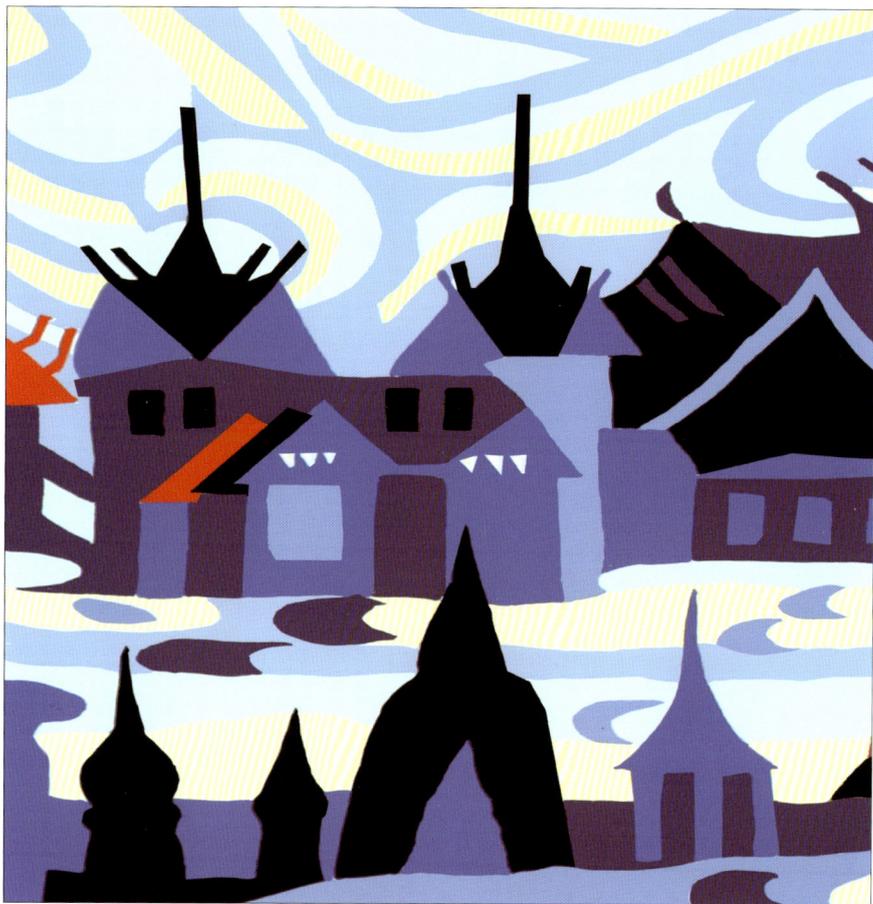

图7-77　渐变和透叠一

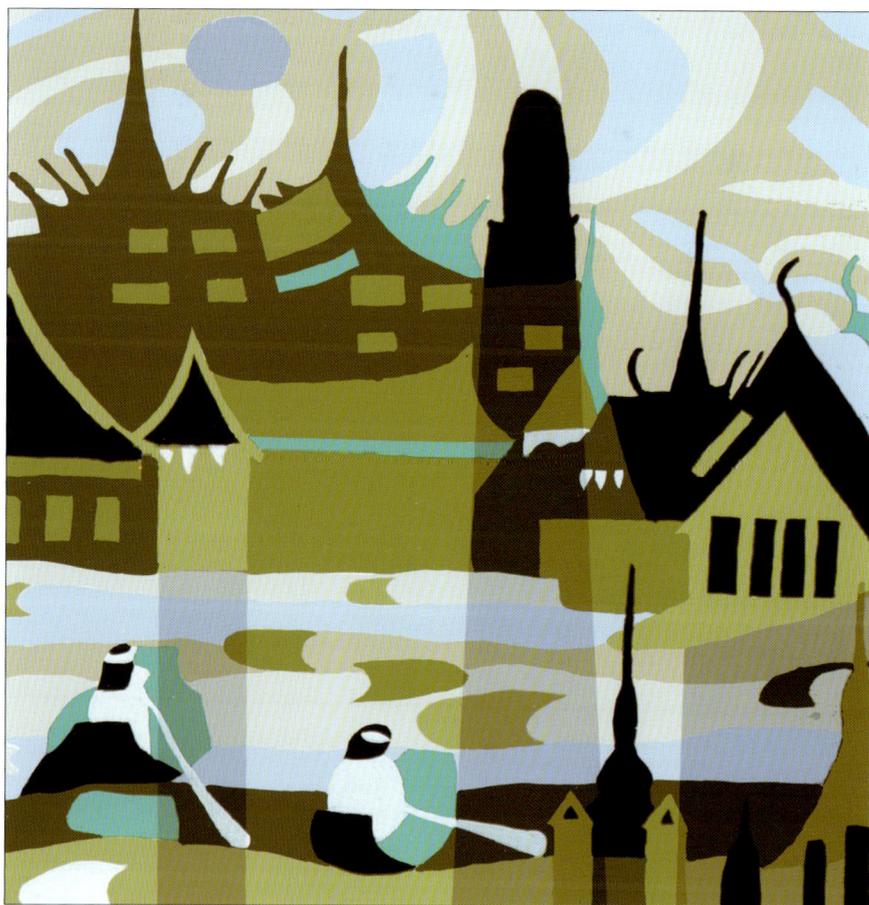

图7-78　渐变和透叠二

7.4.2.4 色调的处理

风景图案内容丰富、繁杂，在色调处理上就更应遵循统一与和谐的原则。在颜色设计上应遵照图案色彩的配色规律，运用调和色、对比色的搭配方法和处理技巧，实现画面色调的统一与和谐（图7-79、图7-80、图7-81）。

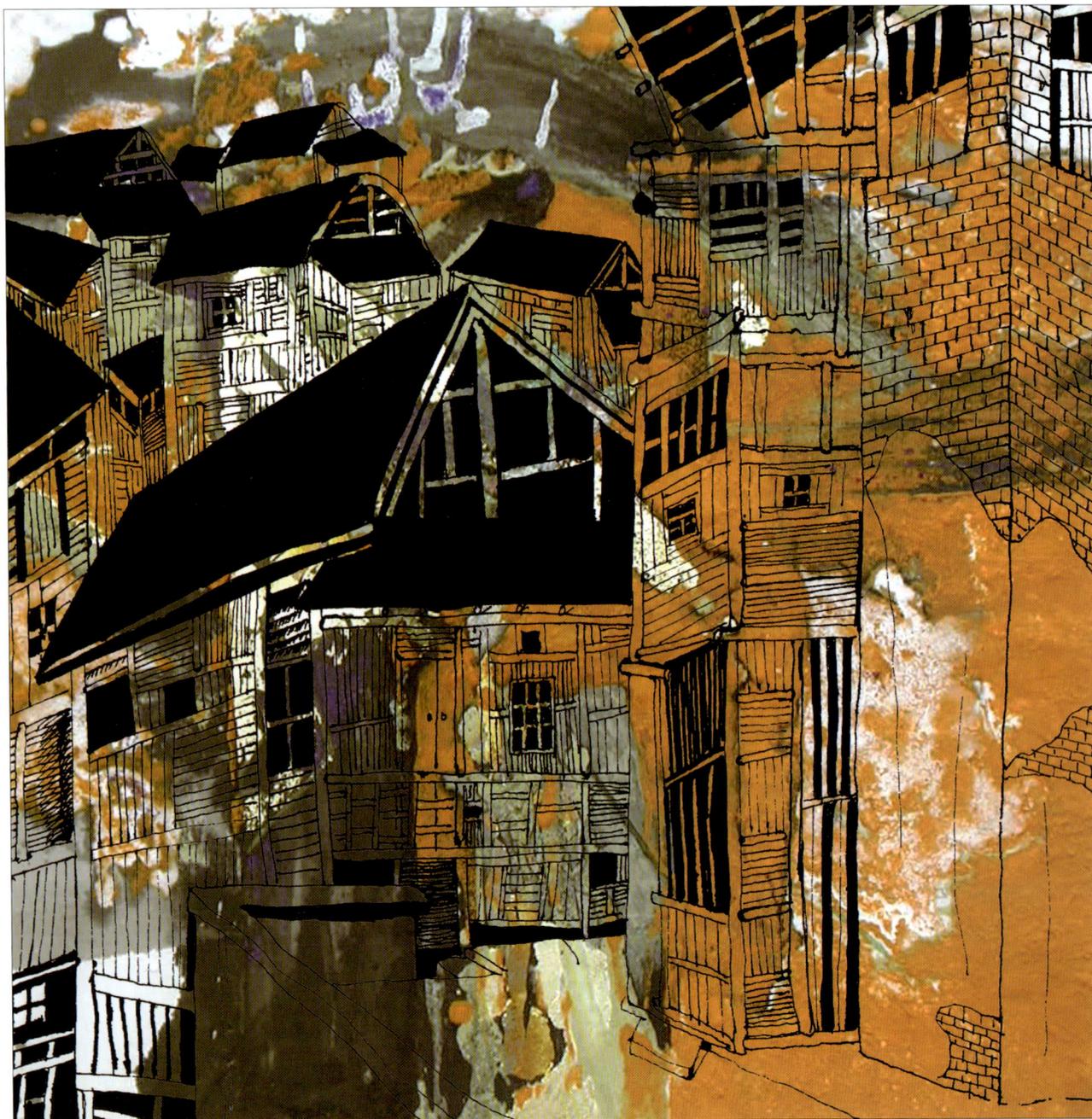

图7-79 黄色调风景图案

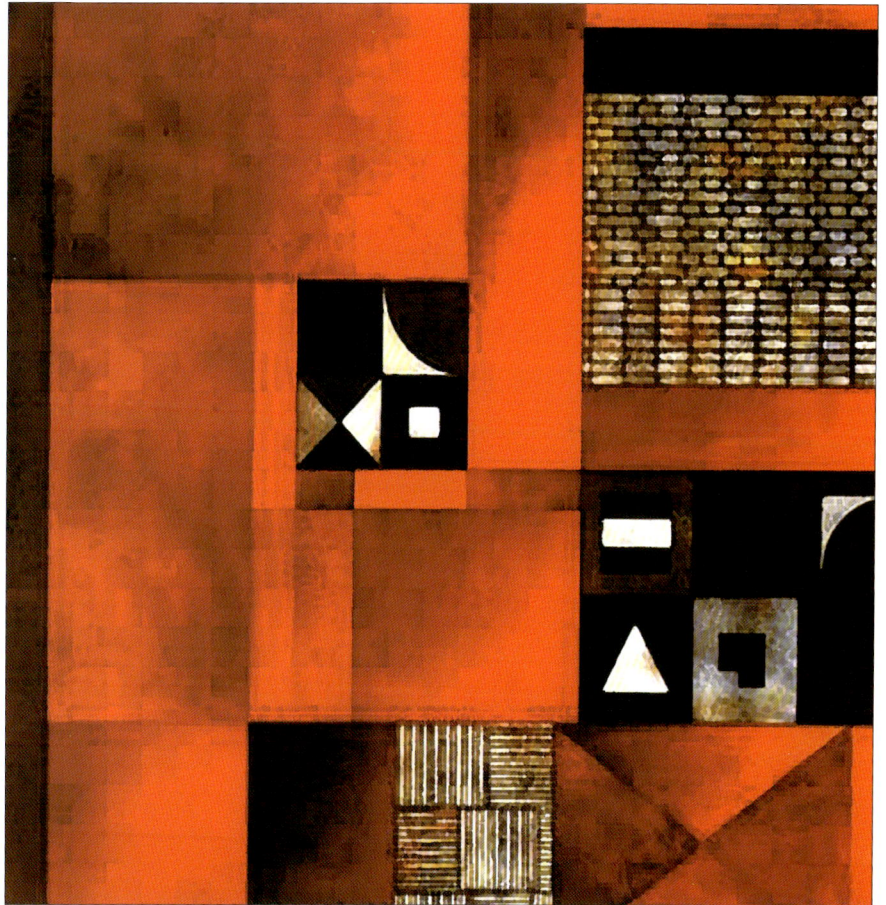

图7-80 红色调风景图案

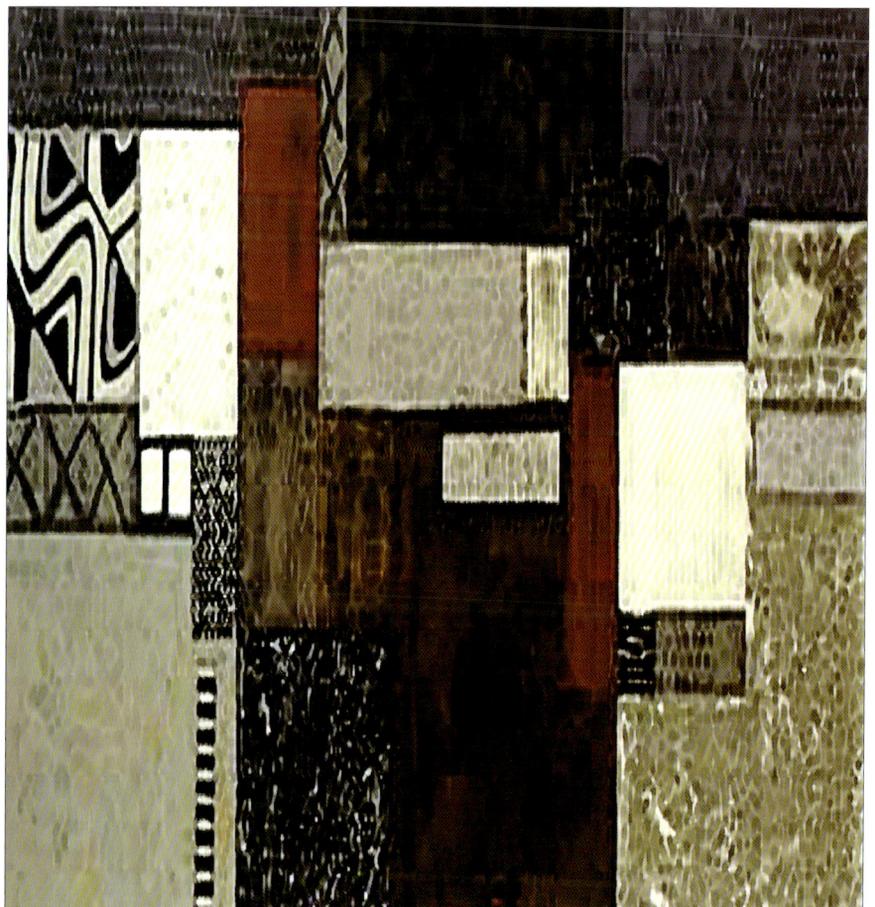

图7-81 灰色调风景图案

第8章　装饰画设计

装饰画是一种富于变化夸张的艺术形式，它高度概括和体现了作者的创作意识和审美观念。装饰画来自客观现实的生活，在创作中我们必须大胆地运用形式美的法则，用夸张、变形等手法，把自然形象装饰处理，经过去伪存真、去粗取精，使之更加程序化、理想化，成为一个完整的更典型的装饰性形象，以美化社会，美化人们的生活。

它不以模仿自然为最终目的，而是倾注了作者自己的感情和理想，使之远远超脱于自然的原始风貌。

8.1　装饰画与图案的区别

装饰画从广义上讲应属于图案的范畴，但其应用目的

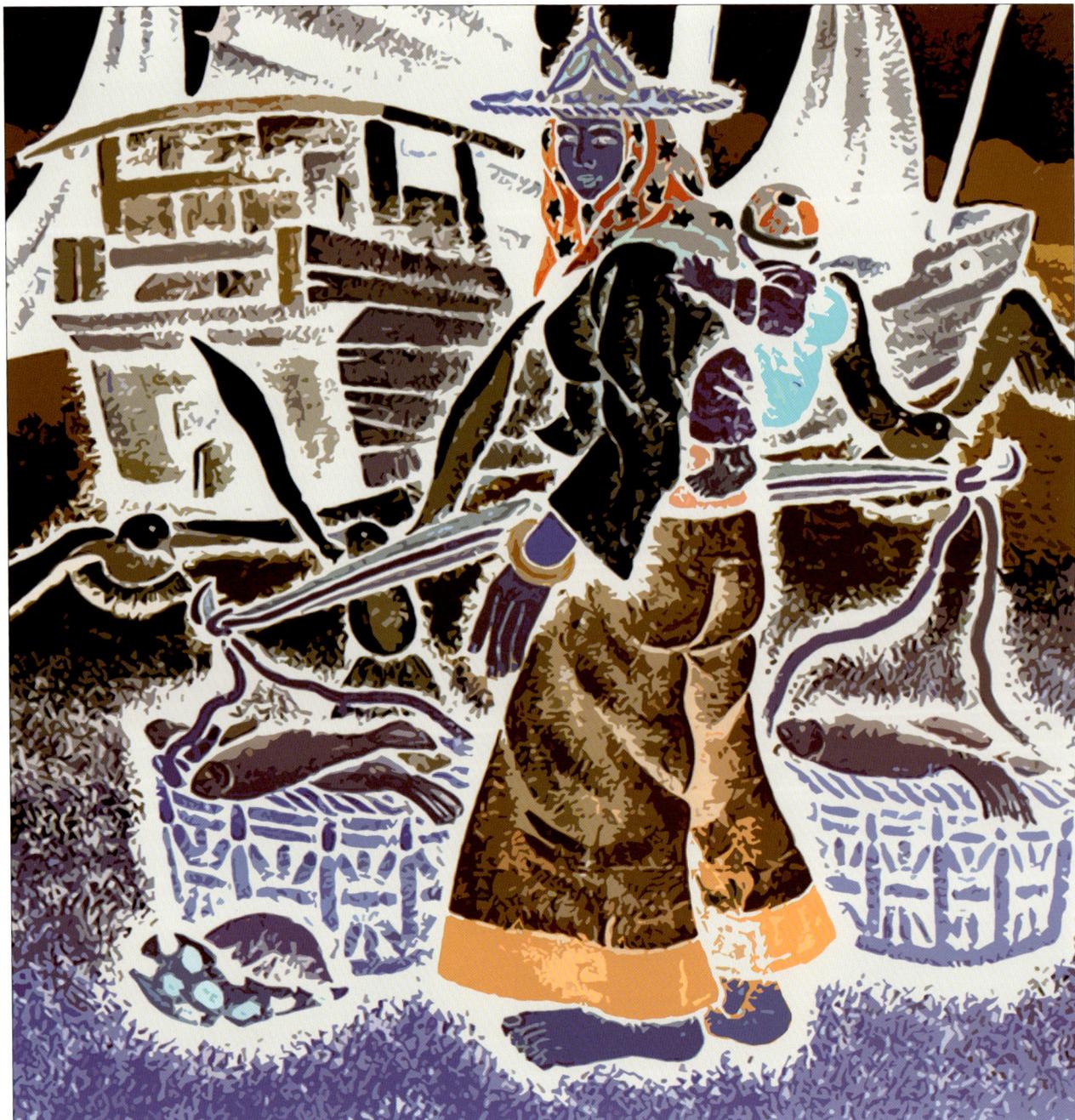

图8-1《收获》体现了渔家女的生活场景

和从属性质与图案有所差异。图案基本上从属于器物这一母体，例如一把茶壶，尽管其图案纹样十分美丽，其主体仍然是茶壶，而不会是图案。而装饰画在装饰属性之外还具有独立的观赏价值。例如敦煌石窟中的壁画，原是为了宗教目的而对石窟进行的装饰，可如今，壁画的艺术价值已远远超过了壁画对石窟的装饰意义。因此，装饰画的创作要求比图案要高，它蕴含着更加丰富的艺术创造力，更具有令人神往的艺术魅力。

8.2 装饰画设计手法

8.2.1 要有立意

在装饰画的创作中，要首先抓住主观的感觉，使形象和色彩的组织为表达意境而服务。将视觉感知的美的因素提炼出来，按照一定的变化和组织规律，完成对于主观创作意识的表现（图8-1）。

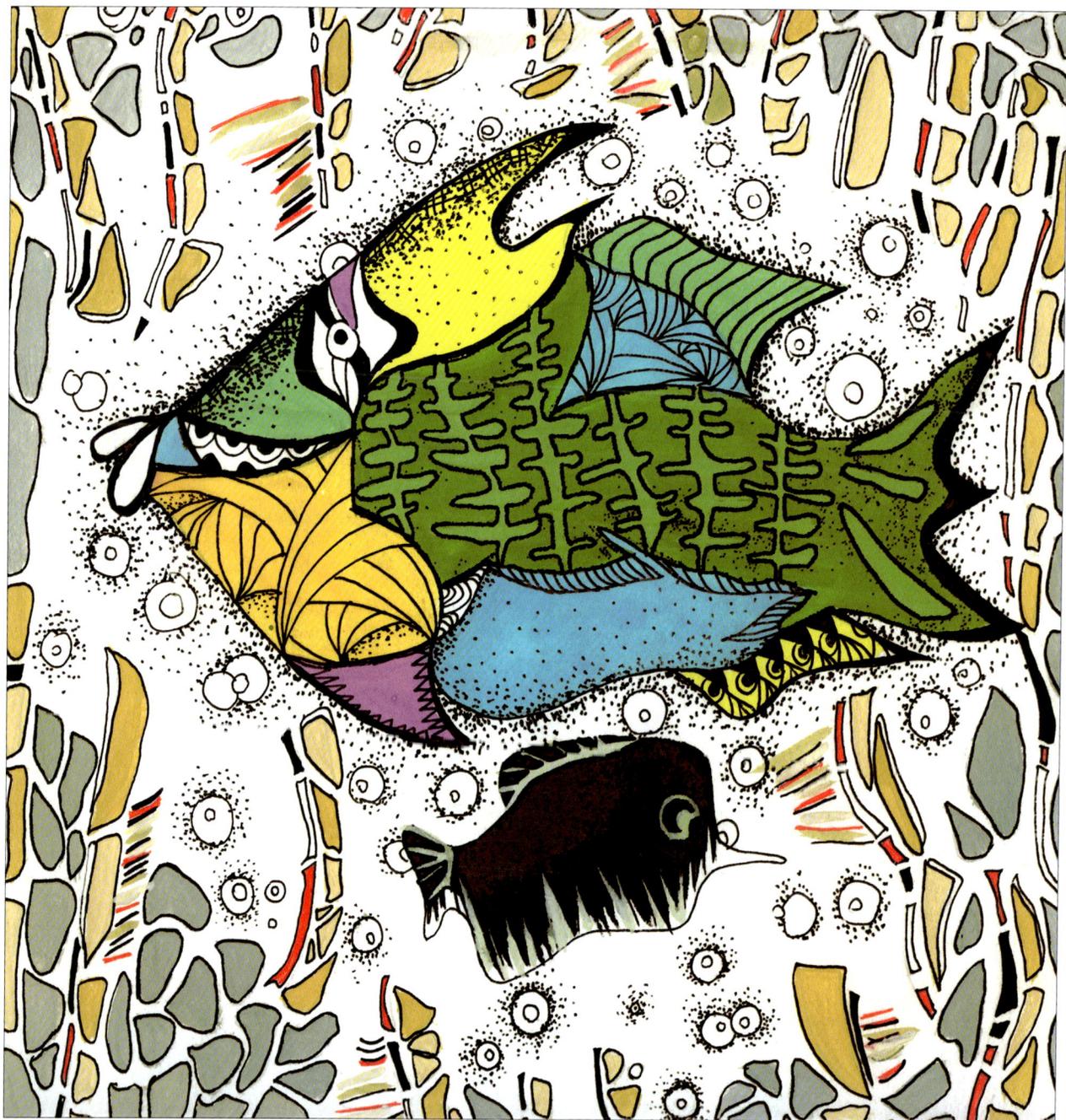

图8-2《鱼》具有强烈的构成感

8.2.2 强调构成

现代装饰画中常常体现出很强的构成形式，例如重叠、减缺、近似、特异、矛盾空间、图底转换等 (图8-2)。

8.2.3 模仿绘画大师风格

用绘画大师的风格和表现技巧表现的装饰画，格调深邃、高远。如：梵·高、毕加索、克利姆特等大师们的绘画风格，本身就有很强的艺术感染力，不但能加强装饰画的视觉效果，还能唤起我们对于艺术和人生的理解与思考 (图8-3)。

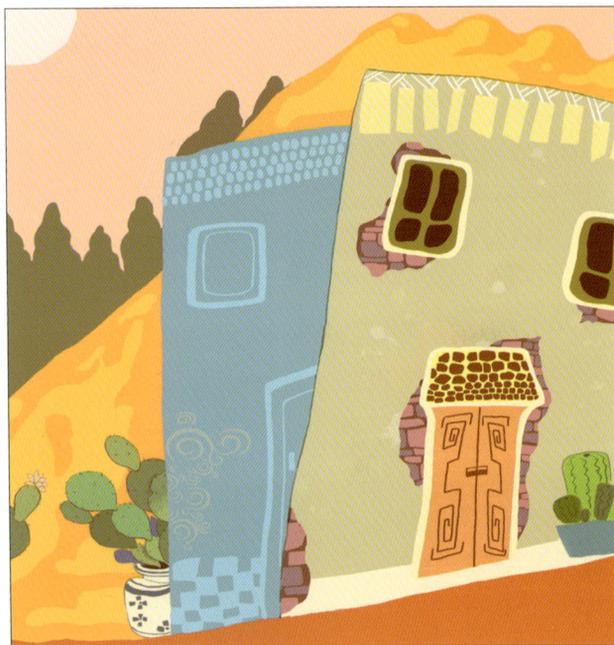

图8-3 《家》借用了抽象派的表现技巧

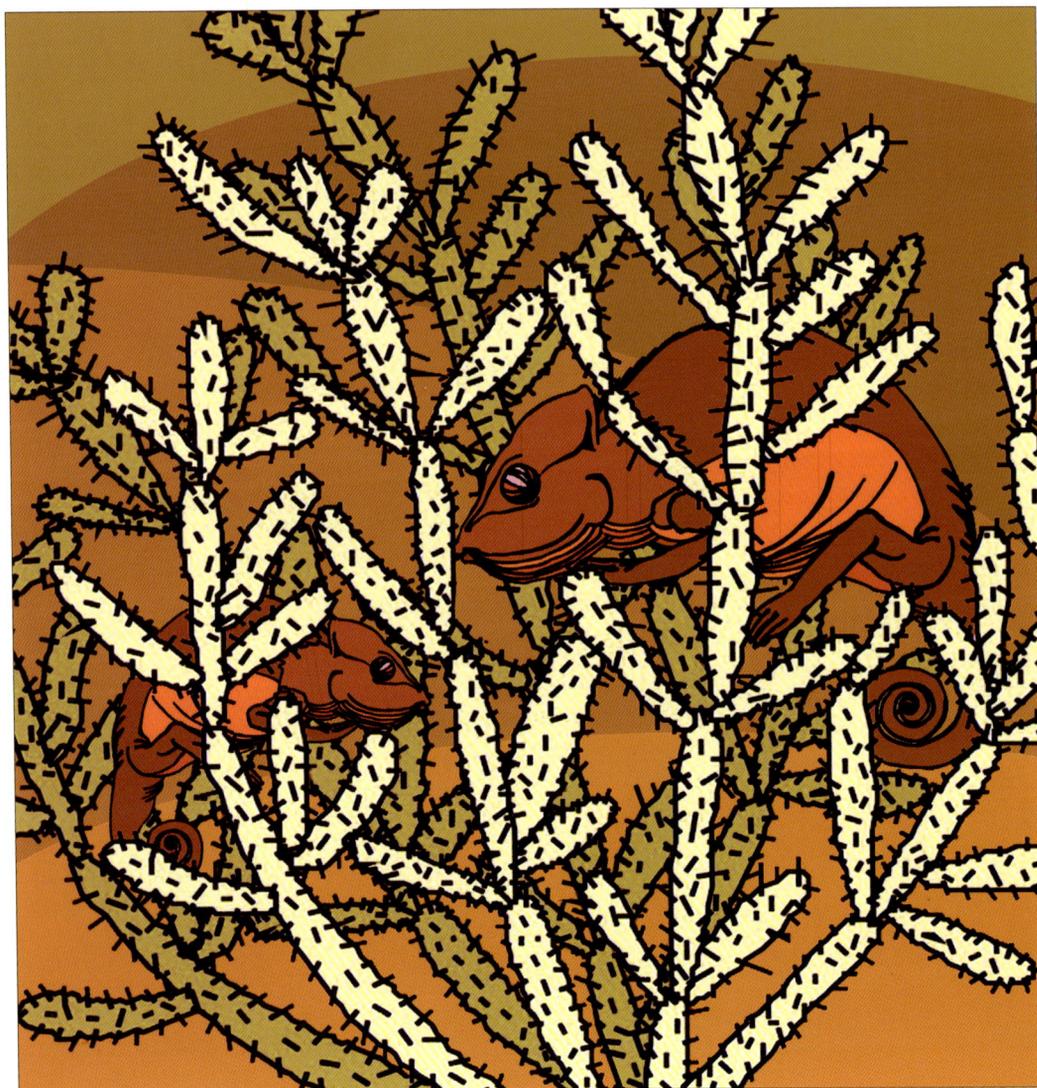

图8-4 《午后》真实表现了沙漠生物的生存环境

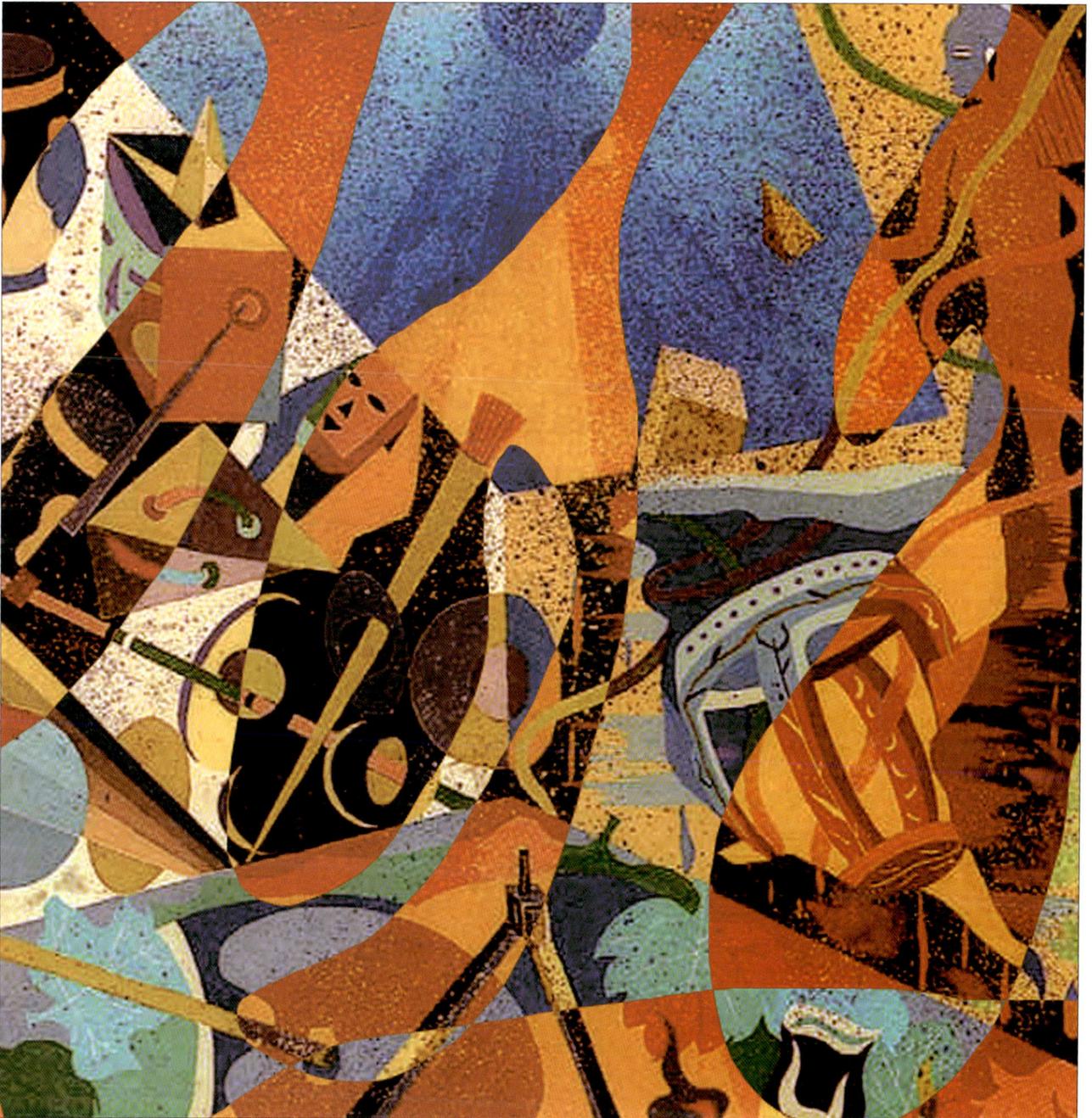

图8-5 《流淌的画笔》有意打破了正常逻辑关系，给人以超时空的联想

8.2.4 真实逻辑与任意逻辑

真实逻辑就是模仿自然生态的之间的合理逻辑关系，比如：母与子、男与女、鱼与水、月亮与夜晚、大海与礁石等。任意逻辑则是有意打破甚至违反正常逻辑关系，如：火在水中燃烧、鱼在天空飞翔等，从而创造出形式新颖、具有反叛精神和现代气息的装饰图形（图8-4、图8-5）。

8.2.5 感知认同与状态附加

感知认同是指装饰画的形象和色彩给人以真实的、内在的心理感受。如：喜、怒、哀、乐、悲、欢、离、合等。状态附加是在物体的形态中加入某些外在因素，如旋律、节奏、速度等，可使图形具有律动感、空间感，并具有自然的生命力（图8-6）。

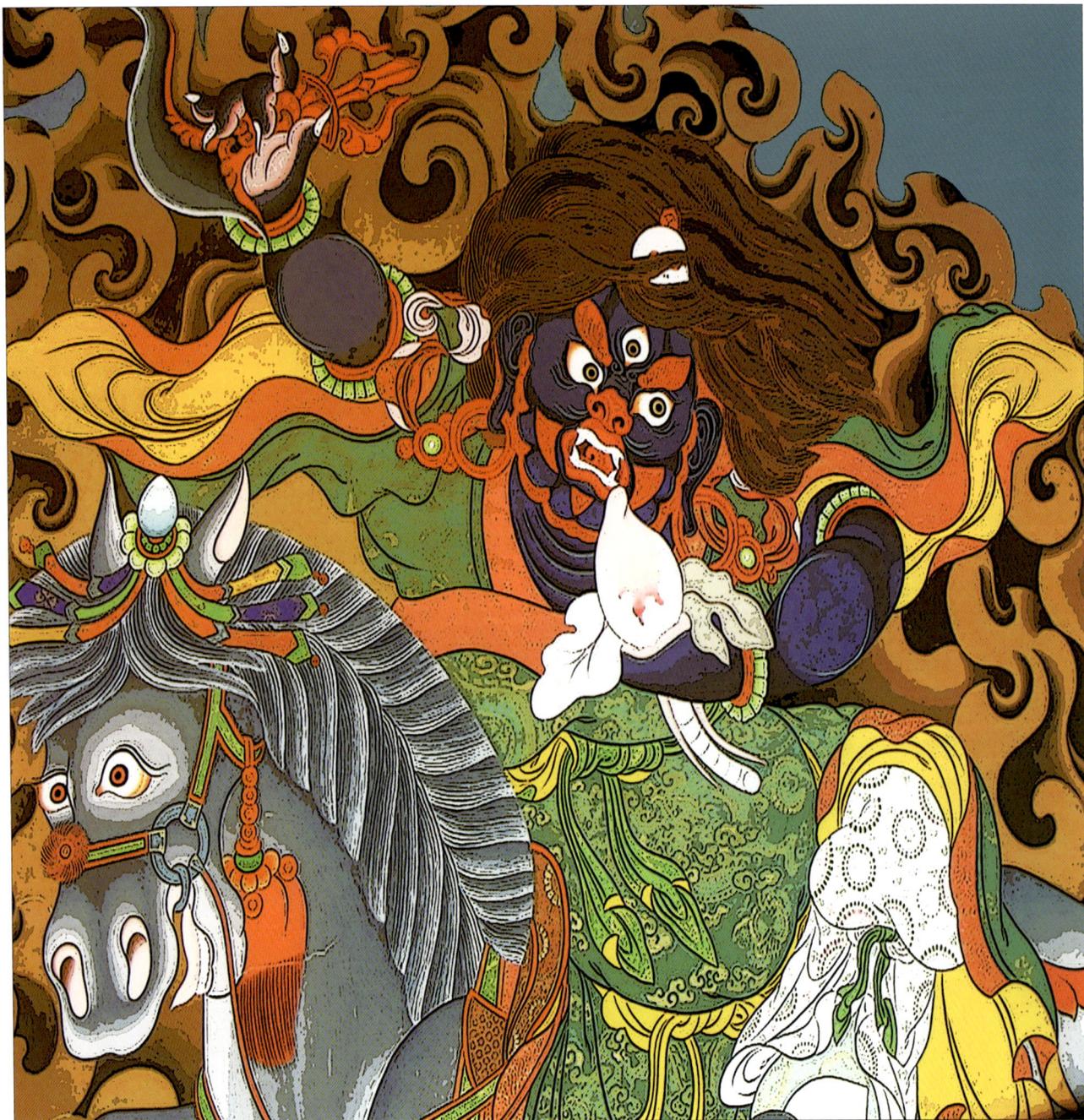

图8-6 《藏族壁画》赋予人物张扬的个性特征

8.3 装饰画构图

8.3.1 平视构图

构图以平视、正视、全侧视或垂直俯视、垂直仰视等透视法来安排画面的整体结构,这样的画面外形单纯,但内部结构形成丰富变化(图8-7、图8-8)。

8.3.2 展开式构图

画面可以无限延伸、展开,可以每段一个内容,但必须有统一的形式感;也可以一种内容进行多种组合,如屏风的构图形式(图8-9)。

8.3.3 适合构图

这种画面有一定的外形限制,内容要适合于外形,随外形的变化而变化,在有限的空间里设置完整的形象(图8-10)。

8.3.4 立体式构图

这种构图带有透视线并表现三维空间(图8-11、图8-12)。

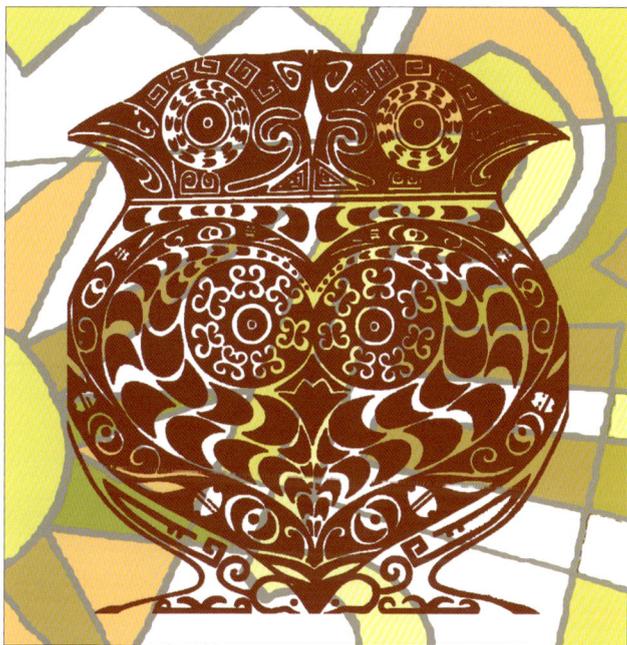
图8-7 平视构图装饰画

图8-8 平视构图装饰画

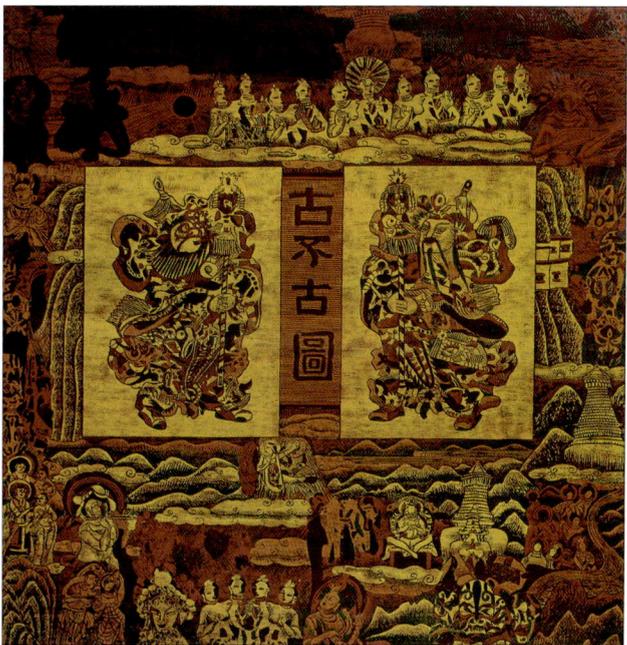
图8-9 展开式构图装饰画

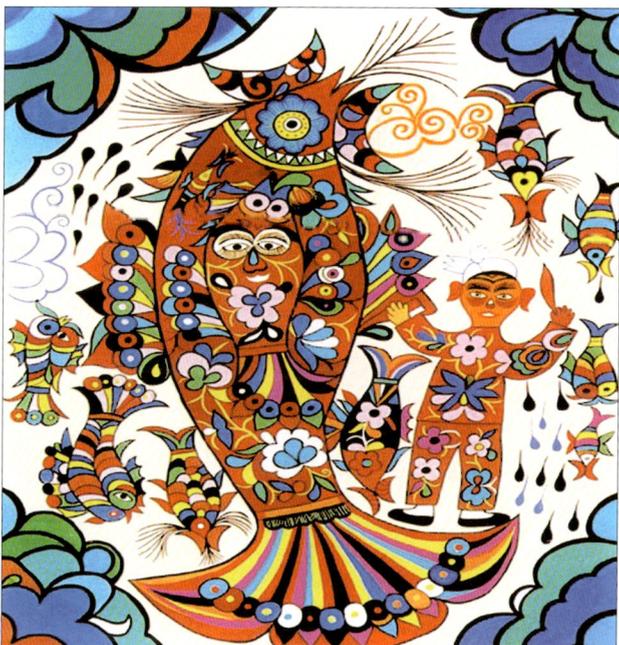
图8-10 适合构图装饰画

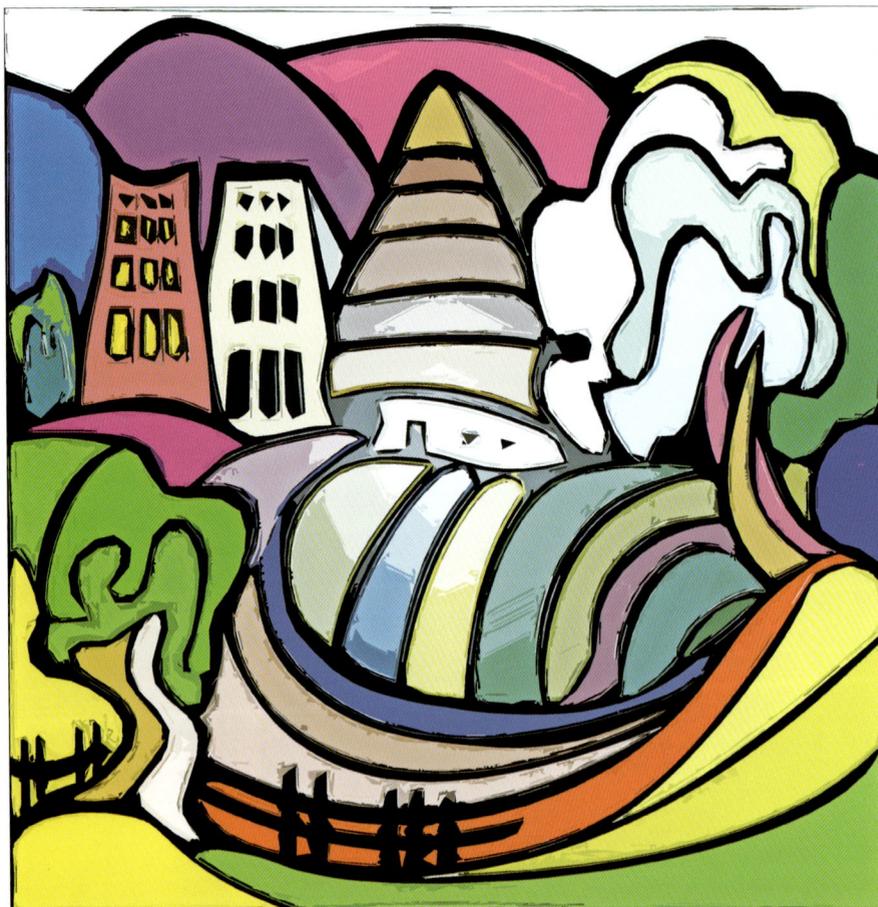

图8-11 立体式构图装饰画一

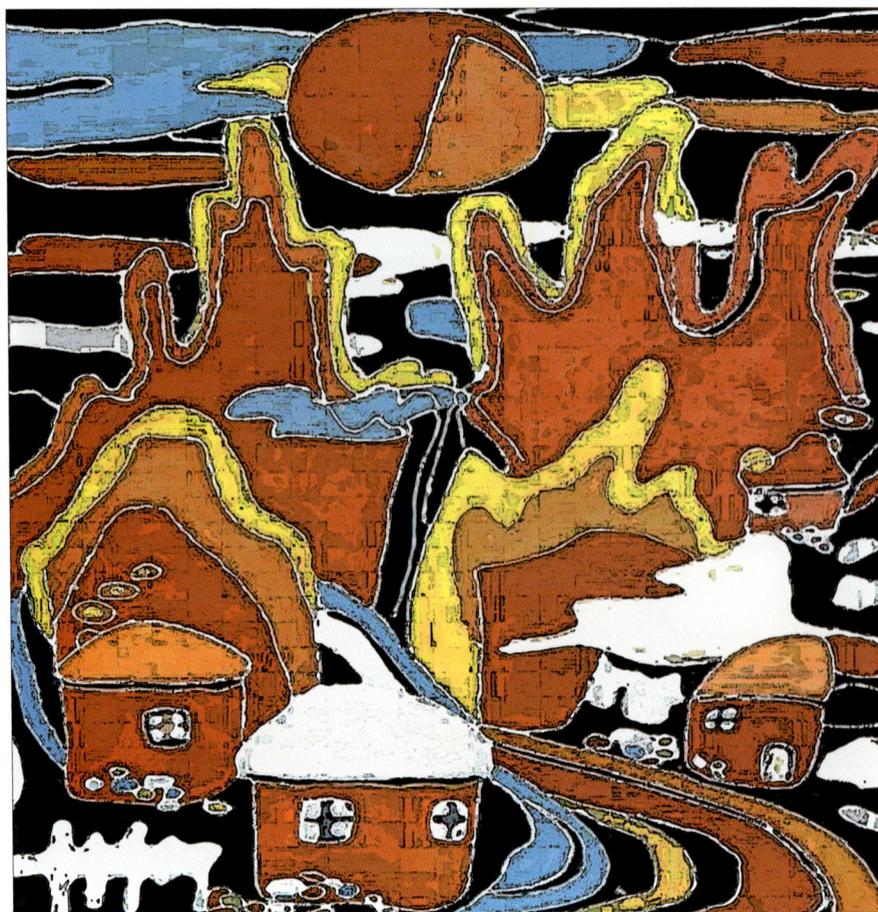

图8-12 立体式构图装饰画二

8.3.5 重叠式构图

　　把两个或两个以上的形象布置在画面中，使画面中的形与形交错、重叠，出现新的形，同时出现共用形或共用线（图8-13）。

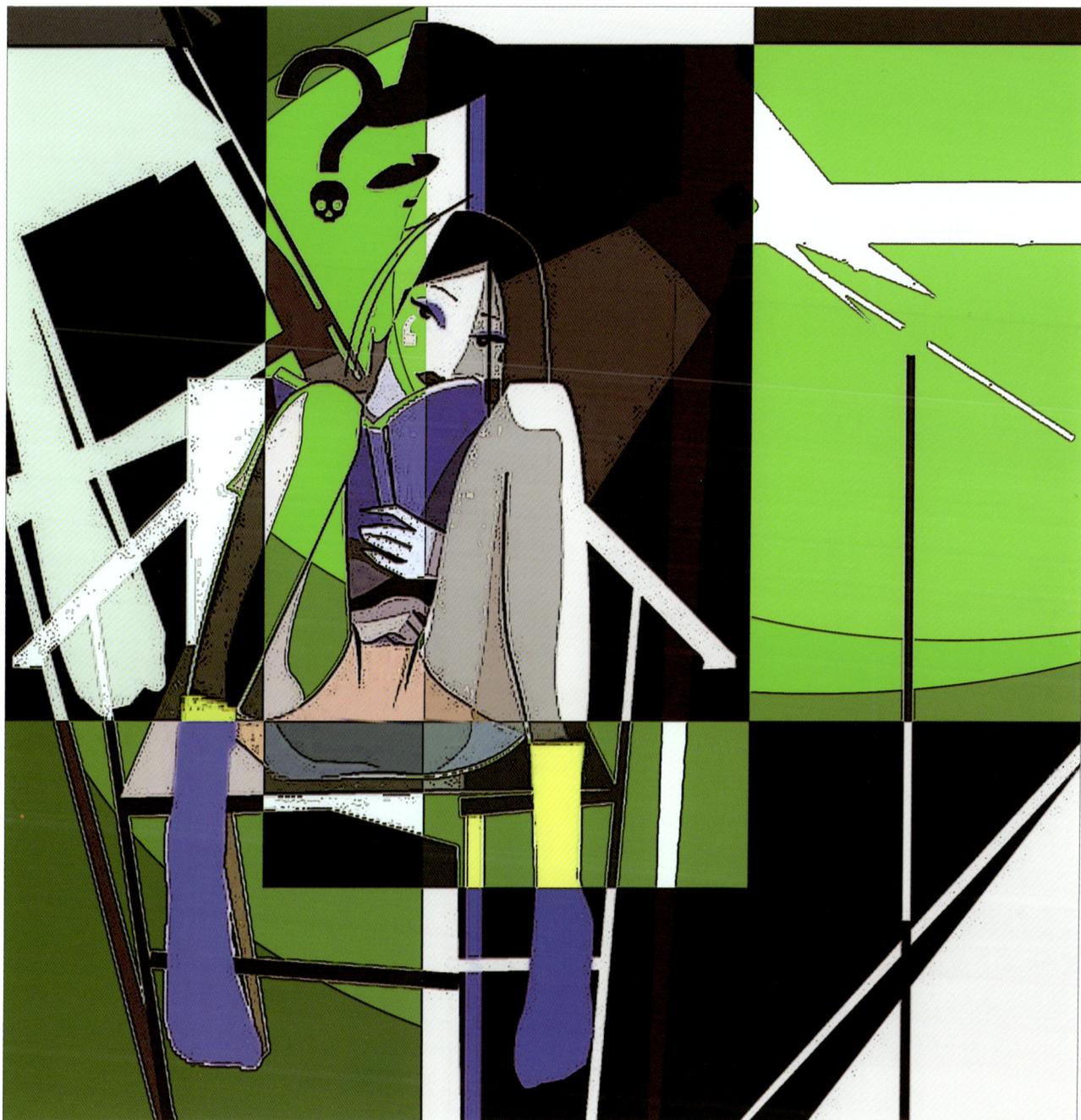

图8-13 重叠式构图装饰画

第9章　作品欣赏

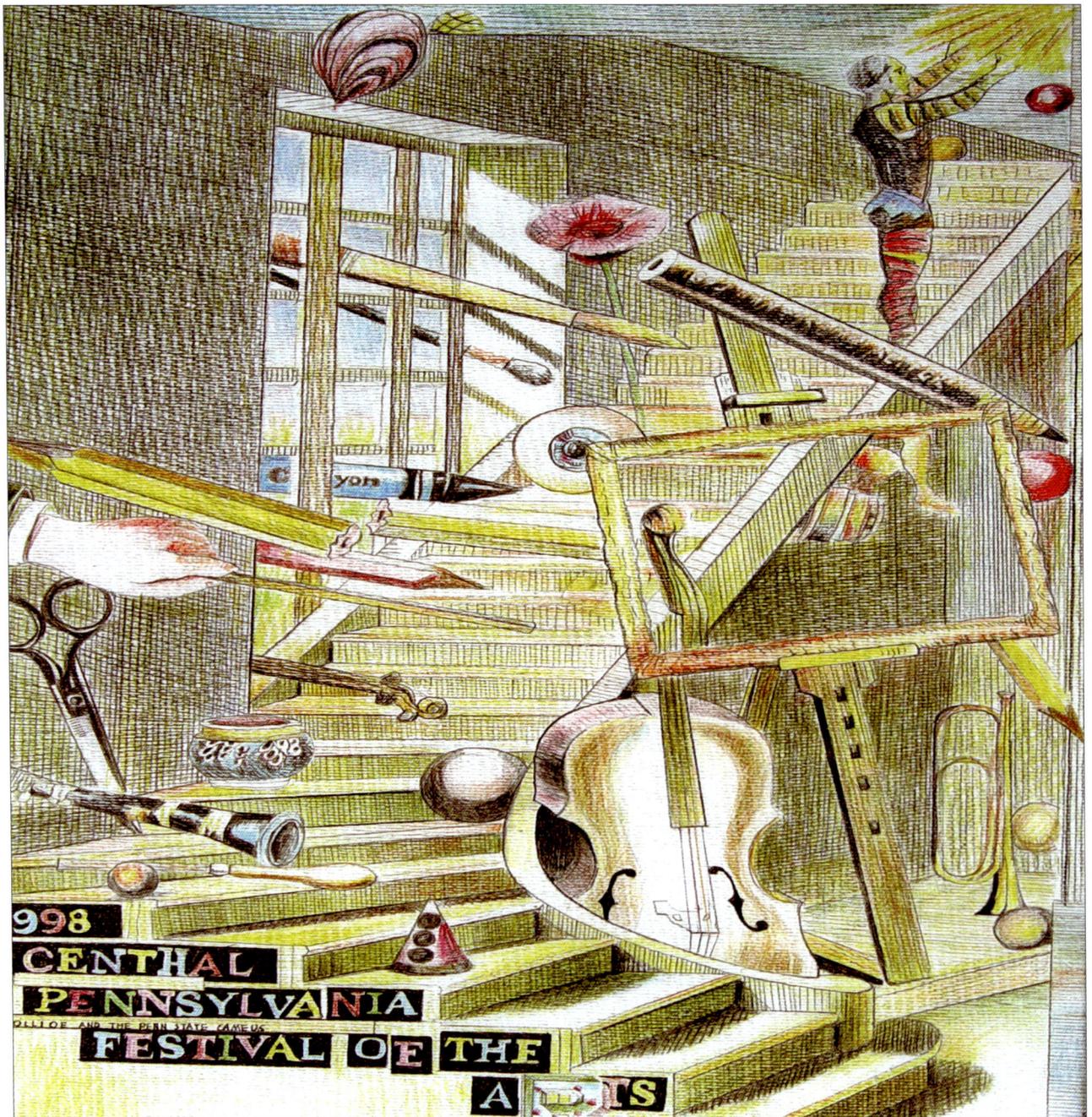

图9-1 记忆

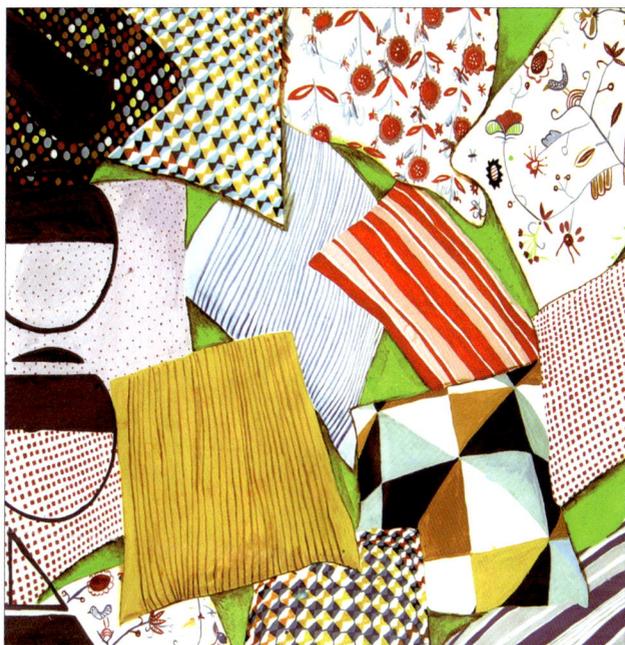

图9-2 靠背

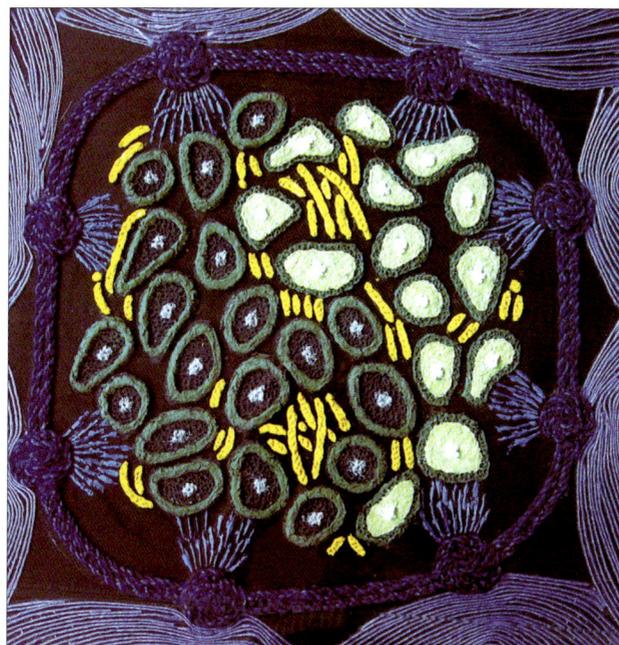

图9-3 路

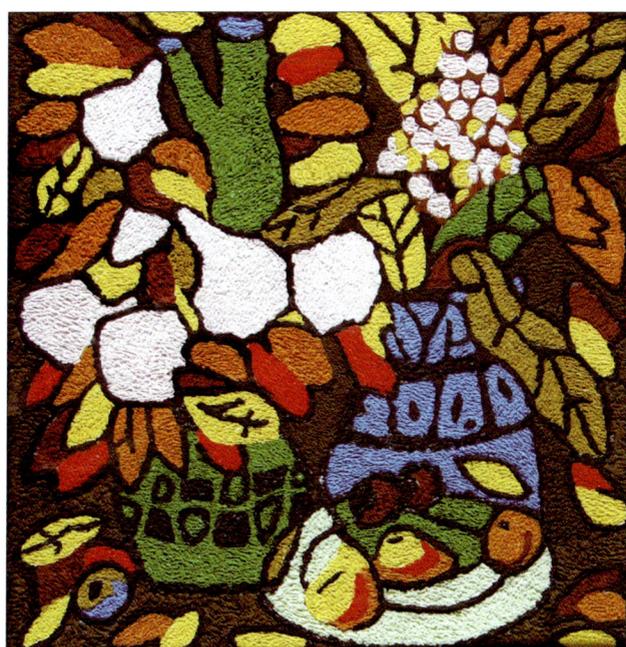

图9-4 秋日

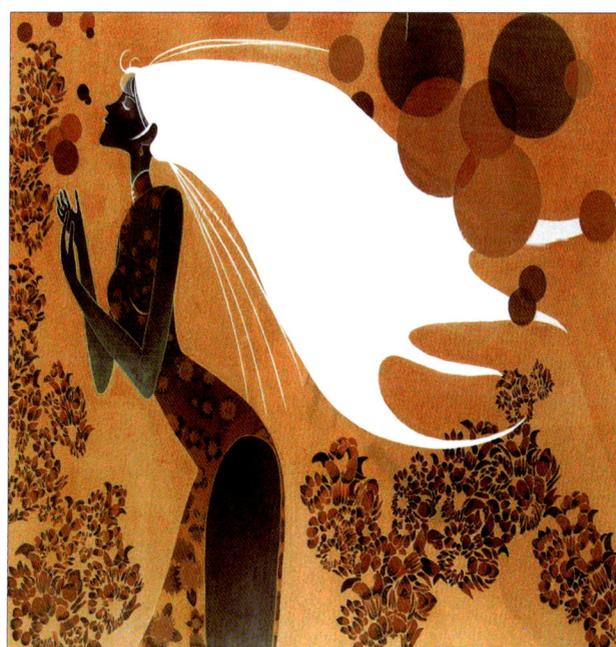

图9-5 花样年华

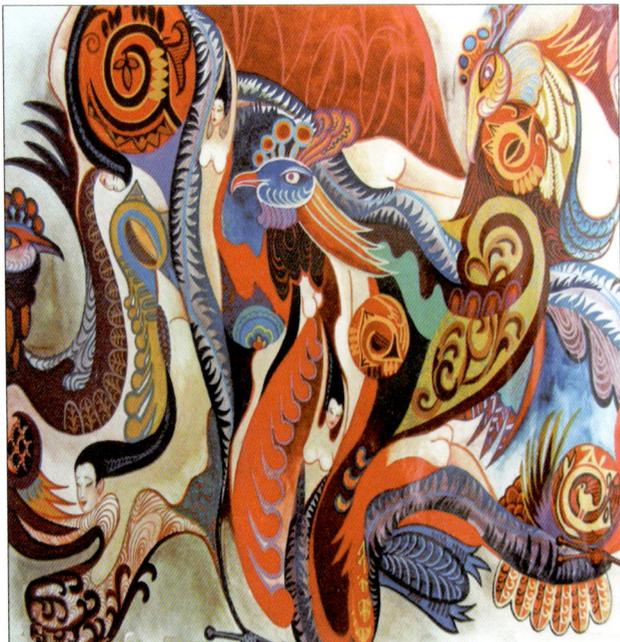

图9-6 神鸟

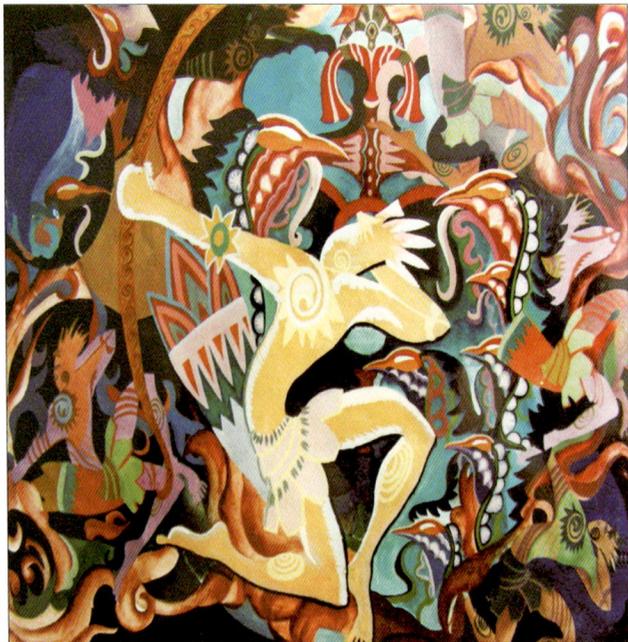

图9-7 射日

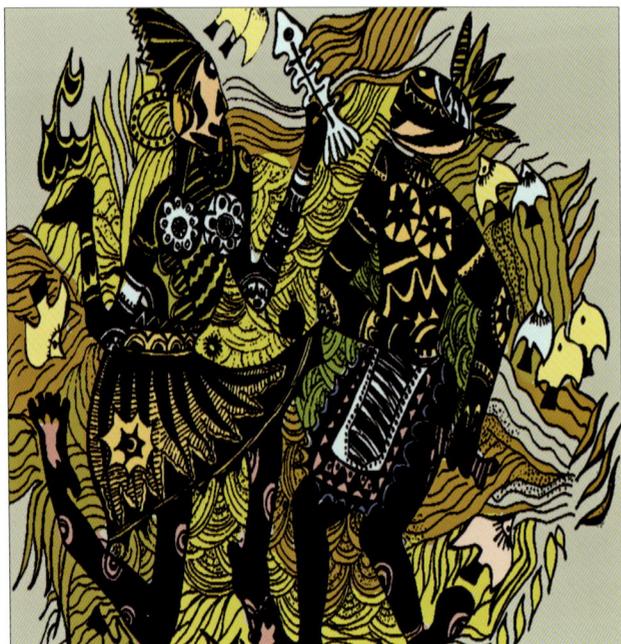

图9-8 舞

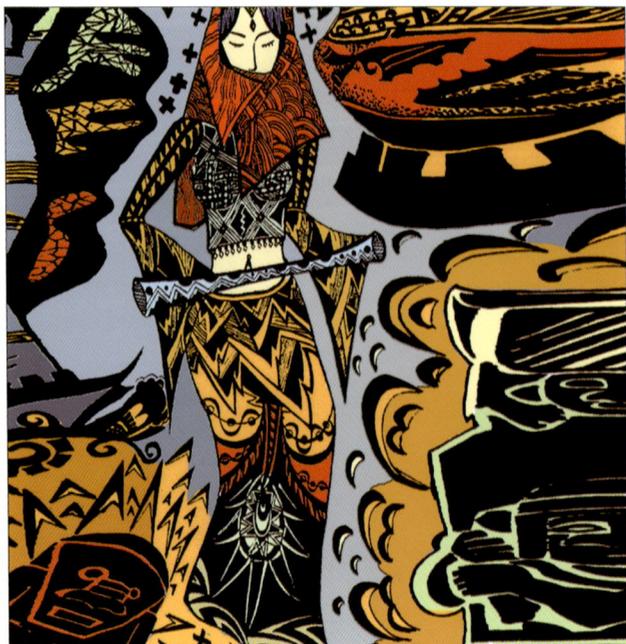

图9-9 红头巾

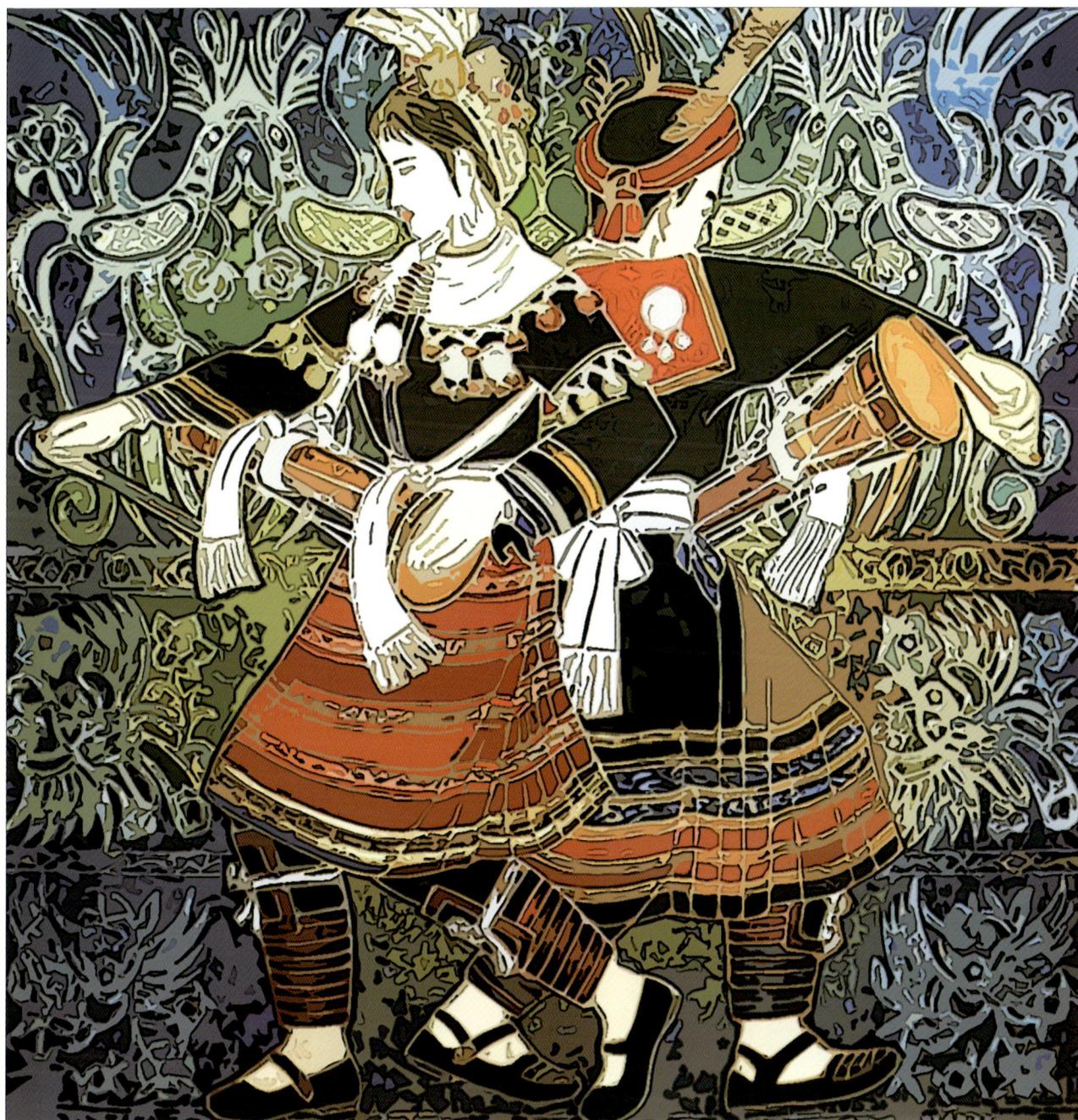

图9-10 节日

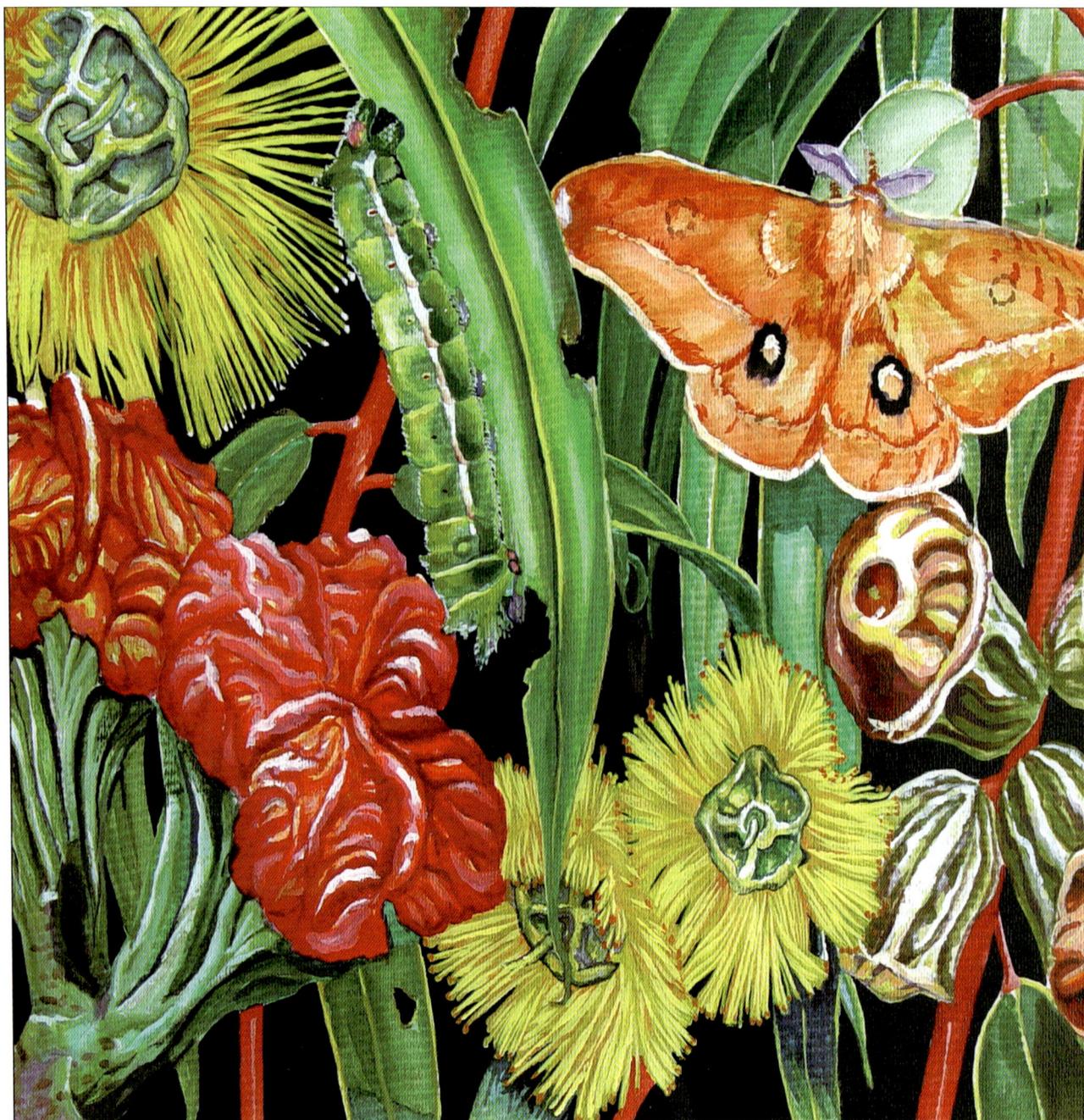

图9-14 蝶变

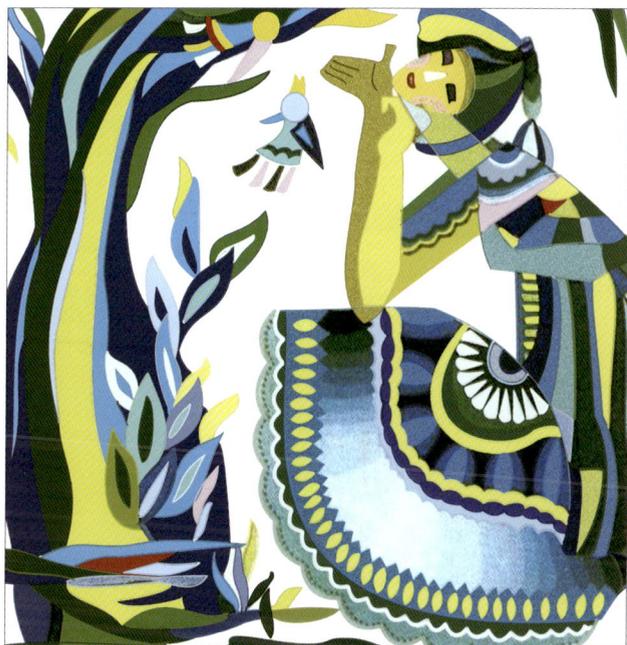

图9-11 私语

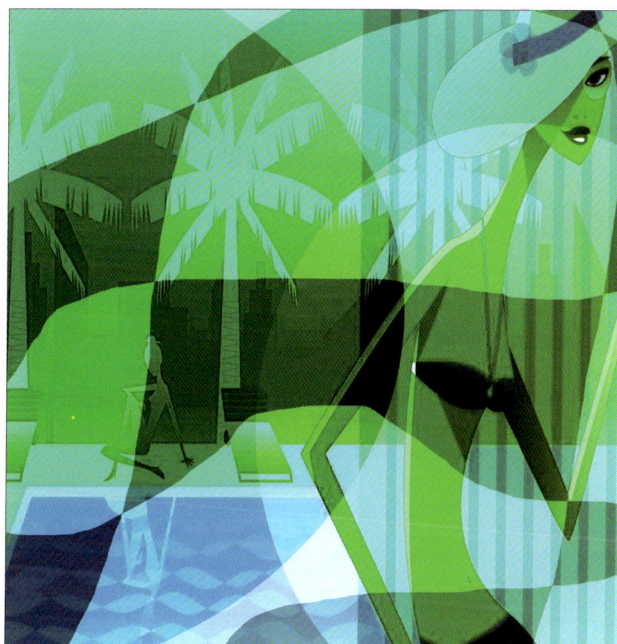

图9-12 夏日

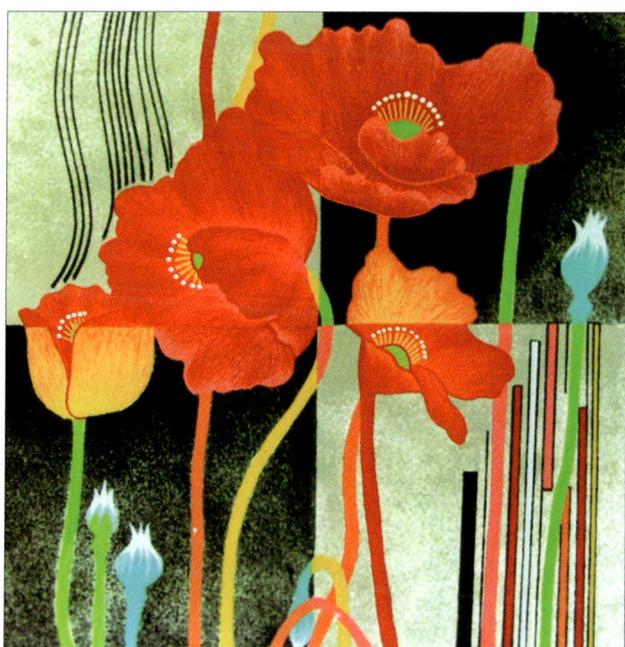

图9-13 红与黑

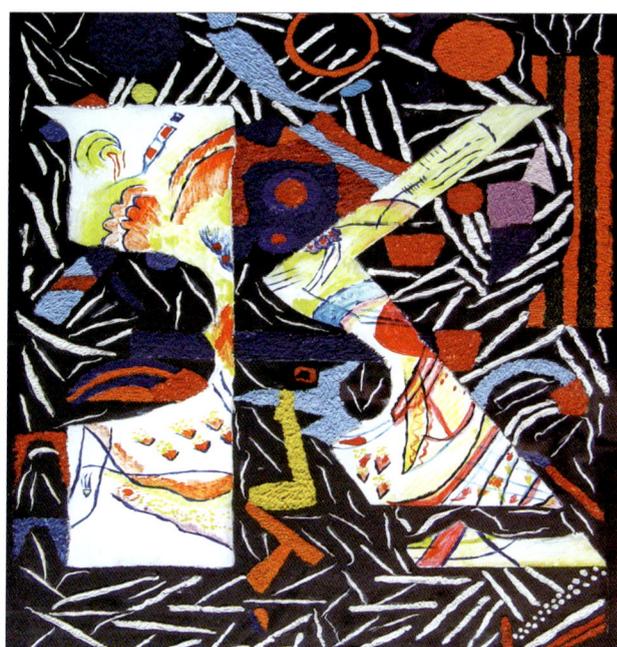

图9-15 太极

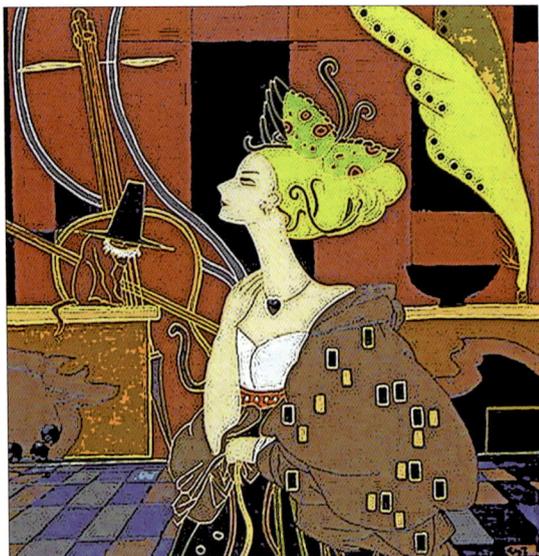
图9-16 蝴蝶夫人

图9-17 跳龙门

图9-18 思念远方

图9-19 酿酒

图9-20 牛娃

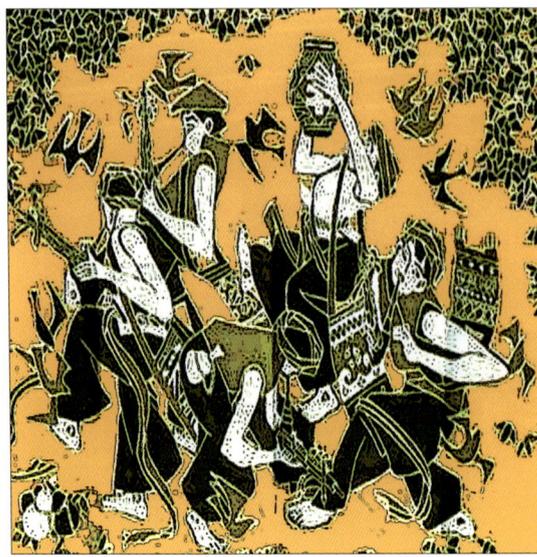
图9-21 苗家乐

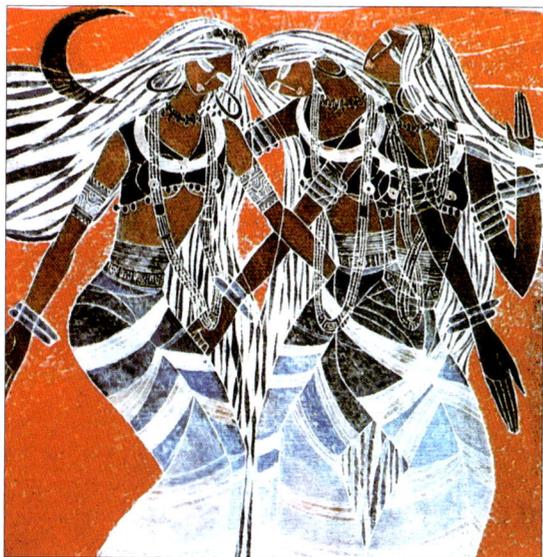

图9-22 傣女夜舞

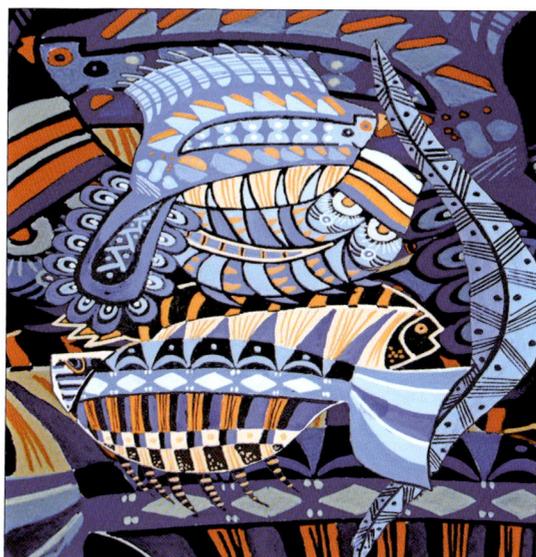

图9-23 大海深处

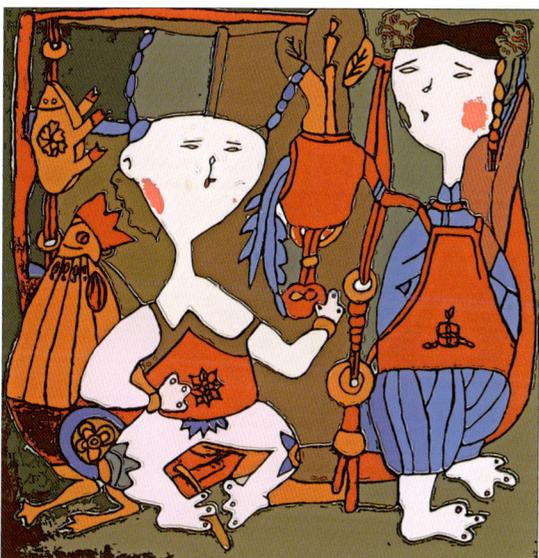

图9-24 肚兜娃

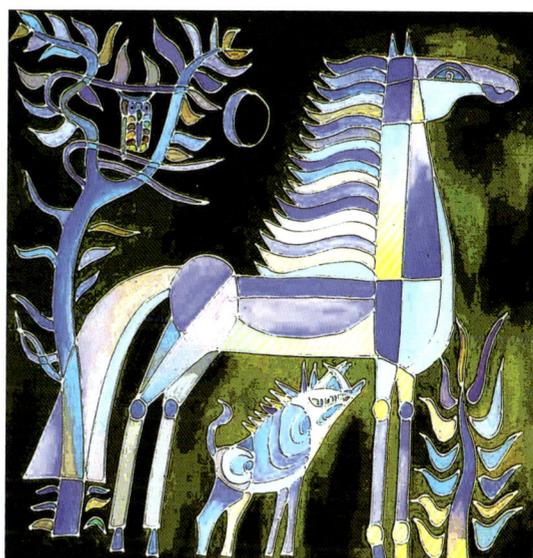

图9-25 志在千里

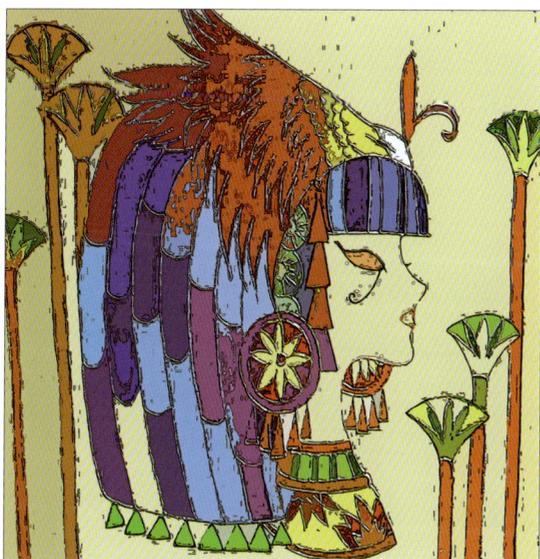

图9-26 印第安女人

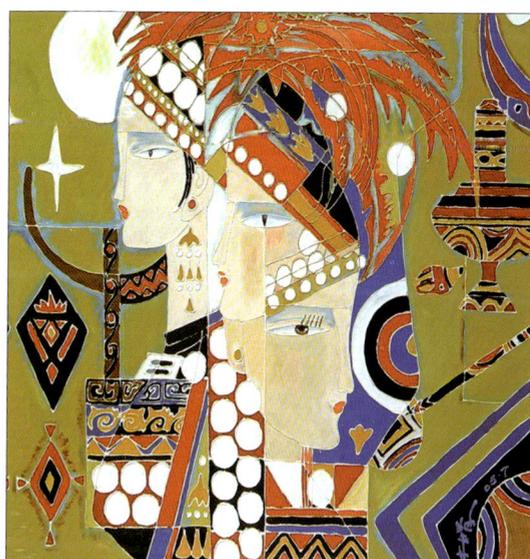

图9-27 苗家女